HISTORIC PHOTOS OF
DETROIT

TEXT AND CAPTIONS BY MARY J. WALLACE

Turner®
Publishing Company
Nashville, Tennessee • Paducah, Kentucky

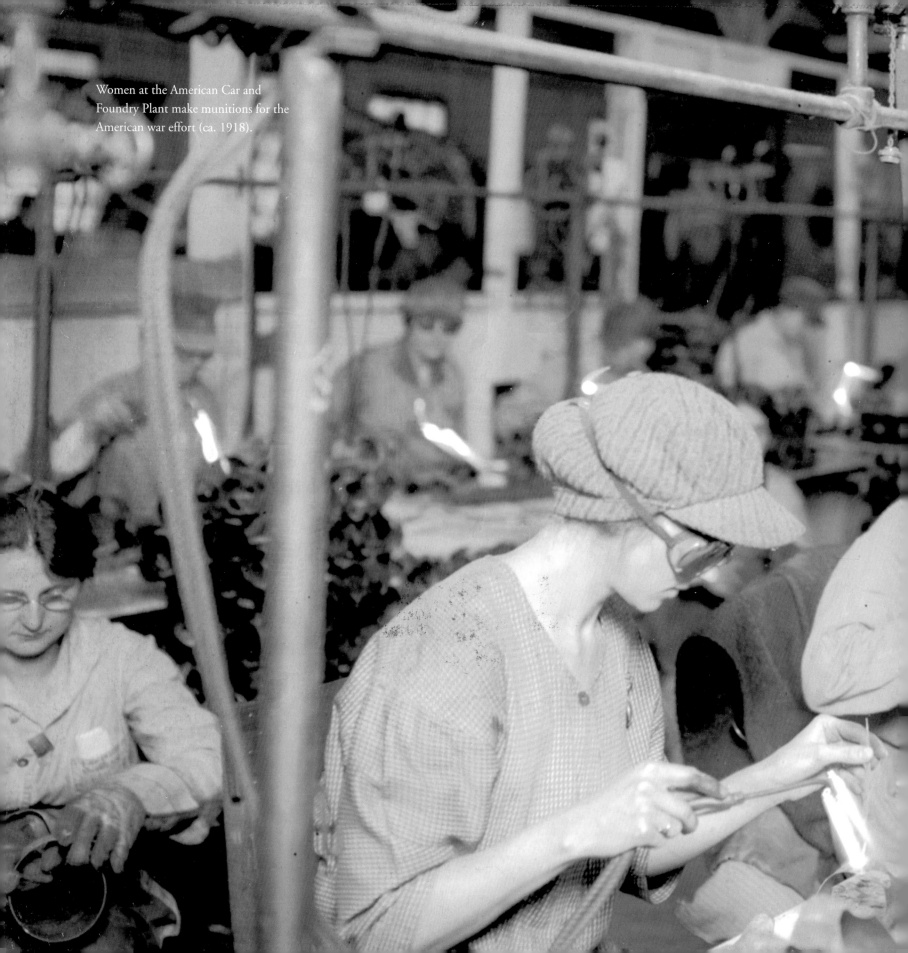
Women at the American Car and Foundry Plant make munitions for the American war effort (ca. 1918).

HISTORIC PHOTOS OF
DETROIT

Turner Publishing Company

200 4th Avenue North • Suite 950 412 Broadway • P.O. Box 3101
Nashville, Tennessee 37219 Paducah, Kentucky 42002-3101
(615) 255-2665 (270) 443-0121

www.turnerpublishing.com

Library of Congress Control Number: 2006909504

ISBN: 1-59652-312-3

Printed in the United States of America

0 9 8 7 6 5 4 3 2 1

CONTENTS

ACKNOWLEDGMENTS .. VII

PREFACE ... VIII

FROM THE CIVIL WAR TO HENRY FORD
 (1860–1899) .. 1

BUILDING INDUSTRY AND COMMUNITY
 (1900–1919) ... 53

FROM SOARING SKYSCRAPERS TO STOCK MARKET CRASH
 (1920–1941) ... 85

HOPING FOR RENEWAL IN MOTOR CITY
 (1942–1969) .. 165

NOTES ON THE PHOTOGRAPHS ... 200

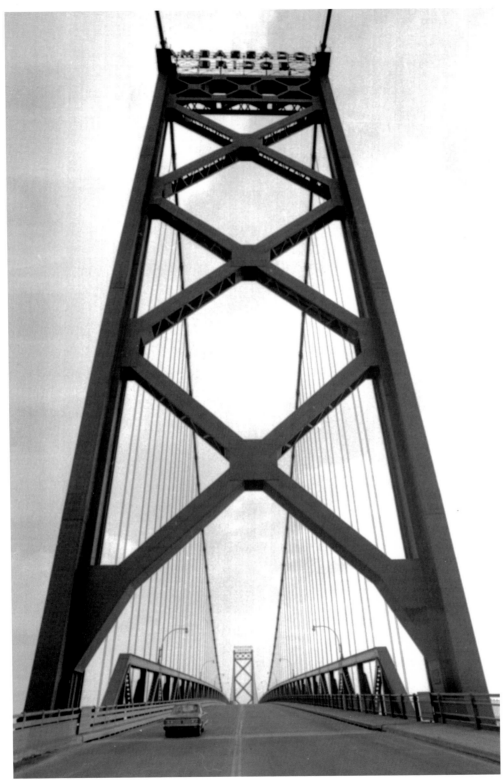

The Ambassador
Bridge on its fortieth
anniversary, 1969.
That year the bridge
was improved with
the installation of new
wiring, new mercury
vapor lamps, and new
electrical transformers.

ACKNOWLEDGMENTS

This volume, *Historic Photos of Detroit,* is the result of the cooperation and efforts of many individuals, organizations, and corporations. It is with great thanks that we acknowledge the valuable contribution of the following for their generous support:

The Walter P. Reuther Library, Wayne State University (WSU)
The Burton Historical Collection, The Detroit Public Library (DPL)

We would also like to thank the following individuals for valuable contributions and assistance in making this work possible:

Joseph and Lillian Adragna, Historians
Alberta Asmar, Secretary, Walter P. Reuther Library, WSU
Mark Bowden, Assistant Manager, Burton Historical Collection, DPL
Elizabeth Clemens, Audiovisual Archivist, Walter P. Reuther Library, WSU
Dawn Eurich, Assistant Manager, History and Travel Department, DPL
Thomas Featherstone, Audiovisual Archivist, Walter P. Reuther Library, WSU
Mark Patrick, Coordinator for Special Collections, DPL
Kathleen Schmeling, Associate Director, Walter P. Reuther Library, WSU
Mike Smith, Director, Walter P. Reuther Library, WSU

On a personal note, the author would like to thank Jim Wallace for his encouragement, assistance, and support.

PREFACE

Detroit has thousands of historic photographs that reside in archives, both locally and nationally. This book began with the observation that, while those photographs are of great interest to many, they are not easily accessible. During a time when Detroit is looking ahead and evaluating its future course, many people are asking, "How do we treat the past?" These decisions affect every aspect of the city—architecture, public spaces, commerce, infrastructure—and these, in turn, affect the way that people live their lives. This book seeks to provide easy access to a valuable, objective look into the history of Detroit.

The power of photographs is that they are less subjective than words in their treatment of history. Although the photographer can make decisions regarding subject matter and how to capture and present it, photographs do not provide the breadth of interpretation that text does. For this reason, they offer an original, untainted perspective that allows the viewer to interpret and observe.

This project represents countless hours of review and research. The researchers and writer have reviewed thousands of photographs in numerous archives. We greatly appreciate the generous assistance of the individuals and organizations listed in the acknowledgments of this work, without whom this project could not have been completed.

The goal in publishing this work is to provide broader access to this set of extraordinary photographs that seek to inspire, provide perspective, and evoke insight that might assist people who are responsible for determining Detroit's future. In addition, the book seeks to preserve the past with adequate respect and reverence.

With the exception of touching up imperfections caused by the damage of time and cropping where necessary, no other changes have been made. The focus and clarity of many images is limited to the technology and the ability of the photographer at the time they were taken.

The work is divided into eras. Beginning with some of the earliest known photographs of Detroit, the first section

records photographs through the end of the nineteenth century. The second section spans the beginning of the twentieth century through World War I. Section Three moves from the 1920s to the 1940s. The last section covers the World War II era to recent times.

In each of these sections we have made an effort to capture various aspects of life through our selection of photographs. People, commerce, transportation, infrastructure, religious institutions, and educational institutions have been included to provide a broad perspective.

We encourage readers to reflect as they go walking in Detroit, strolling through the city, its parks, and its neighborhoods. It is the publisher's hope that in utilizing this work, longtime residents will learn something new and that new residents will gain a perspective on where Detroit has been, so that each can contribute to its future.

Todd Bottorff, Publisher

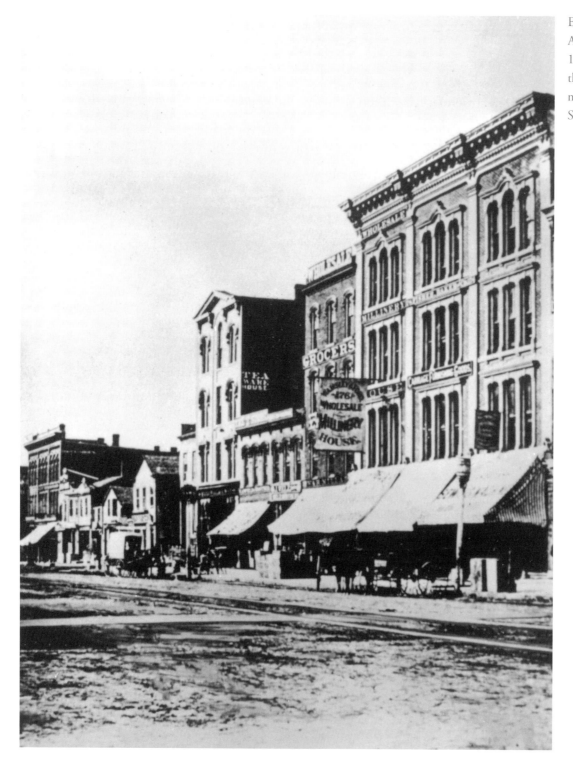

East side of Woodward Avenue, north of Gratiot (ca. 1870s). In 1911, it became the site of the well-known and now demolished J. L. Hudson Store.

FROM THE CIVIL WAR TO HENRY FORD

1860–1899

Founded in 1701 by a team of French explorers led by Antoine de la Mothe Cadillac, Detroit was established as an important link in the lucrative European fur trade. Detroit's location on the river allowed easy access to the East via water and, because it was located on a high bluff at the narrowest point of the Detroit River, any establishment built there would be easy to defend. Cadillac and his party built Fort Pontchartrain there, and thus began the modern history of the city of Detroit.

By the mid nineteenth century, Detroit no longer belonged to the French, and the substantial revenue from the fur trade was long gone. Because of the vast resources to which the "city of the straits" had access, Detroit continued to thrive.

In 1837, Michigan was officially admitted to the Union as the 26th state. In the 1840s, the capital of the state was moved from Detroit to Lansing and the city's population surpassed 10,000. European immigration helped fill the city with people, some of whom used their native expertise to start new businesses. German immigrants began more than twenty breweries in the city. As the century marched on, industries arose that were based on Detroit's access to iron mined from Michigan's upper peninsula, leading to the manufacture of railroad cars, iron stoves, and steel rails. A varnish, a pharmaceuticals, and a seed company broadened the city's industrial ranks.

The physical appearance of the city was changing too. A new city hall was built in 1871. The city's tallest building, the 10-story Hammond Building opened in 1889, and in 1896, the 14-story Majestic Building replaced it as the tallest building in Detroit. Crowding in Detroit's streets was alleviated as the Detroit City Railway laid tracks downtown for its growing horse-drawn street railway system. By the 1890s, horse-drawn streetcars had been replaced by electric. The City of Detroit also purchased an island in the middle of the Detroit River, Belle Isle, with in mind creating a place for families to picnic and enjoy nature.

The Civil War touched Detroit when the city sent approximately 6,000 men to fight. In 1861, thousands of Detroiters gathered in the center of town, Campus Martius, for a formal ceremony to give the newly trained soldiers of Michigan's First Regiment a proper send-off. After the war, the city commemorated the sacrifice of those who served, by erecting a Soldiers and Sailors Monument at the city center, a shrine that still stands today.

In 1896, Detroiters saw Charles King drive the first automobile on city streets. That same year, a little-known engineer from Edison Illuminating Company, Henry Ford, devised his first car in a workshop on Bagley Street, west of downtown. In those waning days of the nineteenth century, no Detroiter would have suspected that the unfamiliar new vehicle called the automobile would so profoundly transform their city and shape its destiny for generations to come.

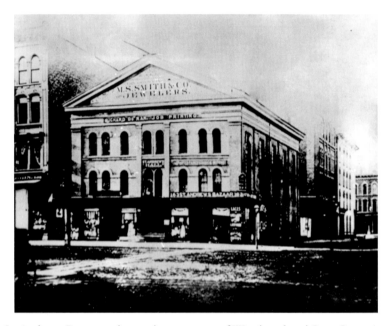

St. Andrews Bazaar at the southwest corner of Woodward and State Street (ca. 1869). Woodward Avenue had been a Native American path but soon became Detroit's main artery. It was named for Judge Augustus Brevoort Woodward.

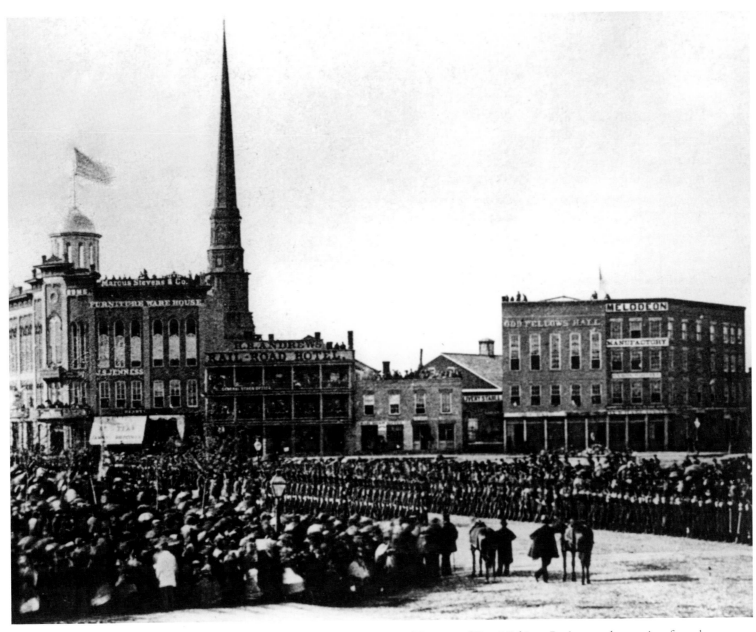

The men of First Michigan Regiment take part in a formal ceremony at Campus Martius two days before leaving for the war front. After the attack on Fort Sumter, Michigan troops were among the first to respond to President Lincoln's call for volunteers. (May 11, 1861)

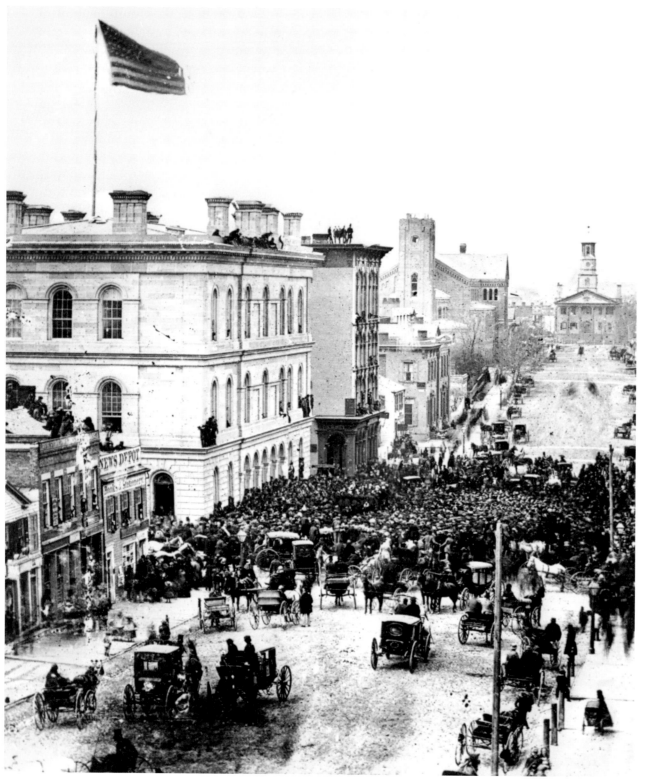

Crowds gather in front of the federal post office in April 1861 for news about the Civil War.

4

Stephen Smith Boots and Shoes, at the northwest corner of Woodward
and Larned (ca. 1860s)

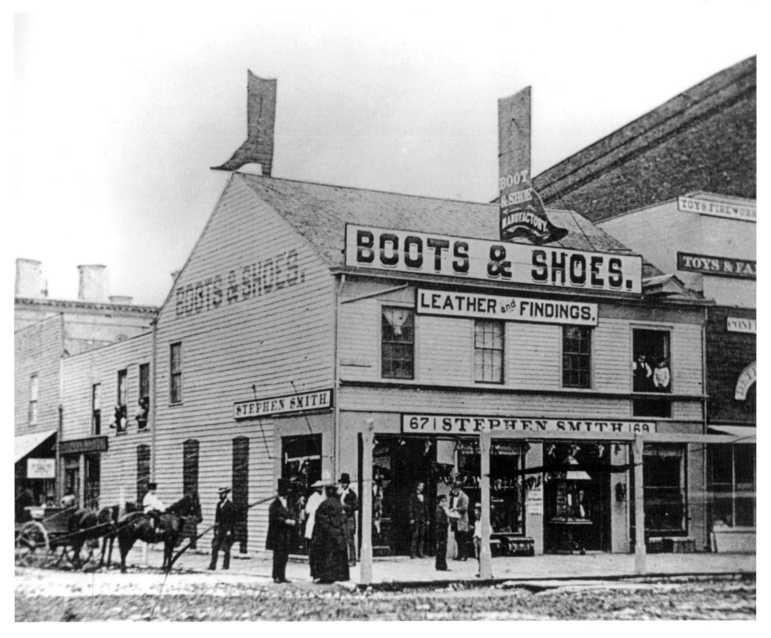

Old Russell House hotel on Woodward Avenue near Campus
Martius (ca. 1860)

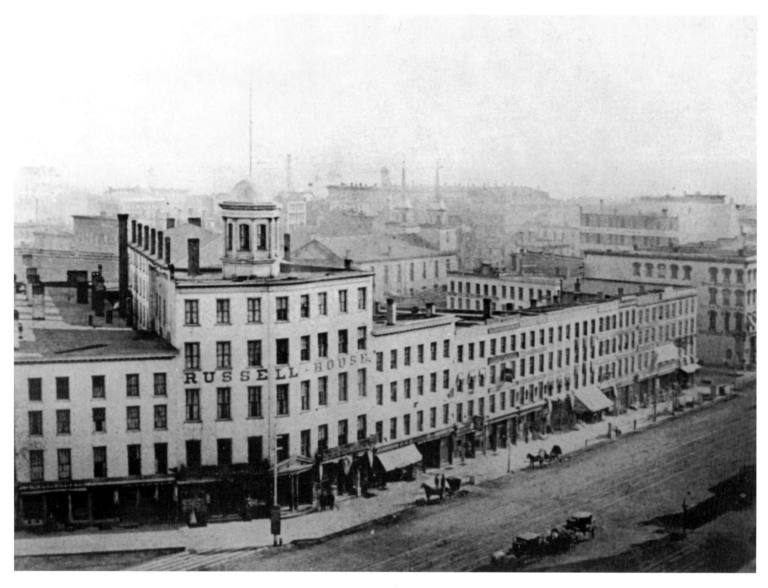

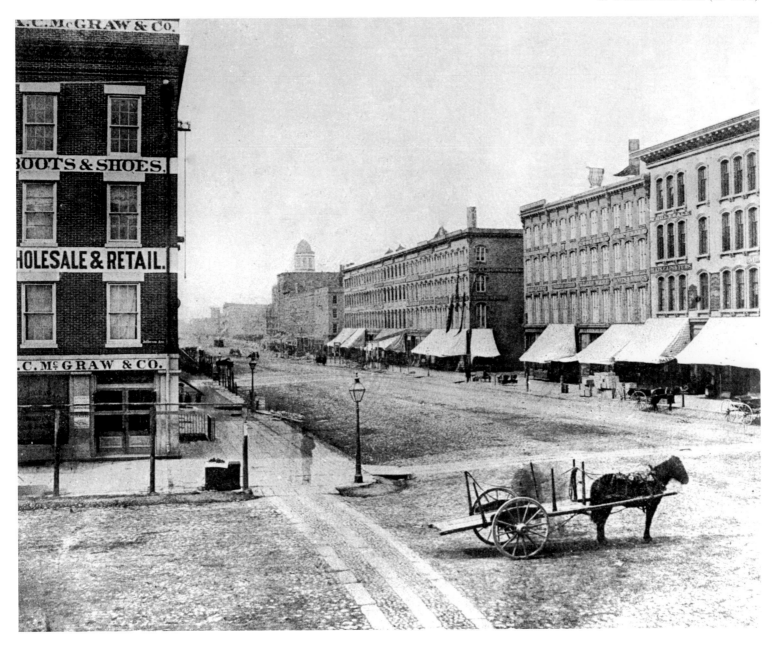

Looking west down Jefferson Avenue
at Woodward Avenue (ca. 1870)

East side of Woodward Avenue between State Street and Grand River (ca. 1876)

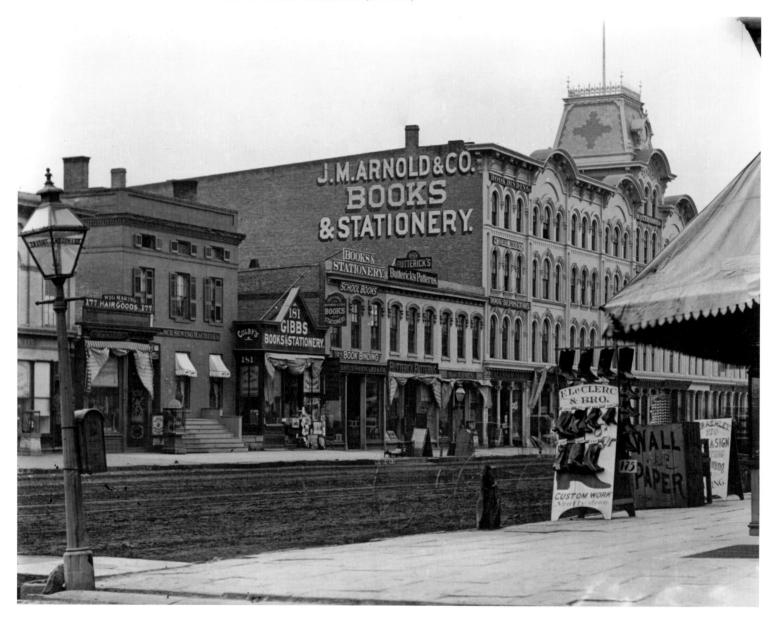

Looking west down Jefferson at Griswold

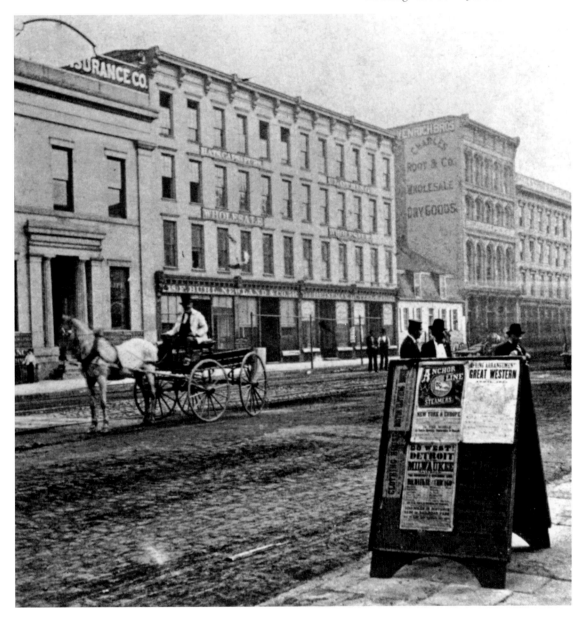

The east side of Woodward Avenue (ca. 1867)

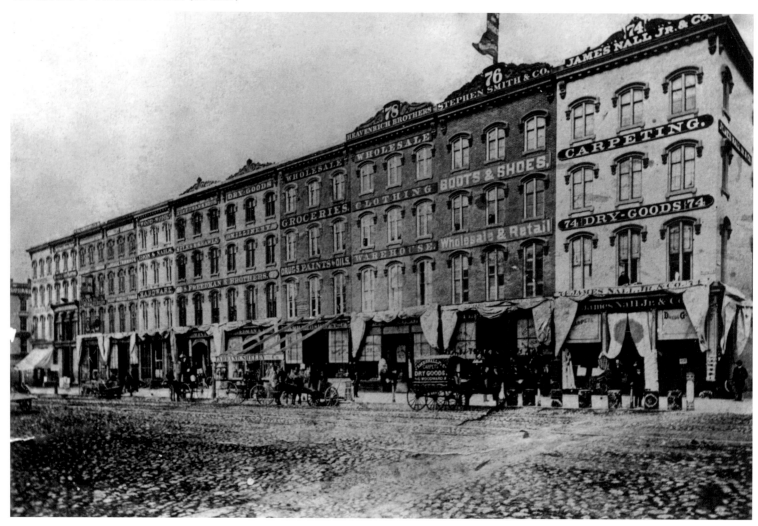

Image of an early
streetcar, perhaps
Detroit's first

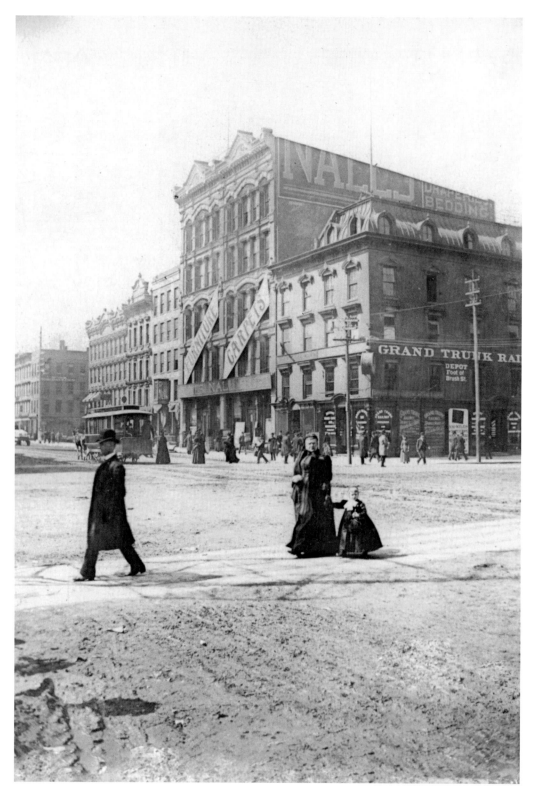

Webster School at 1280 Twenty First Street (ca. 1870s)

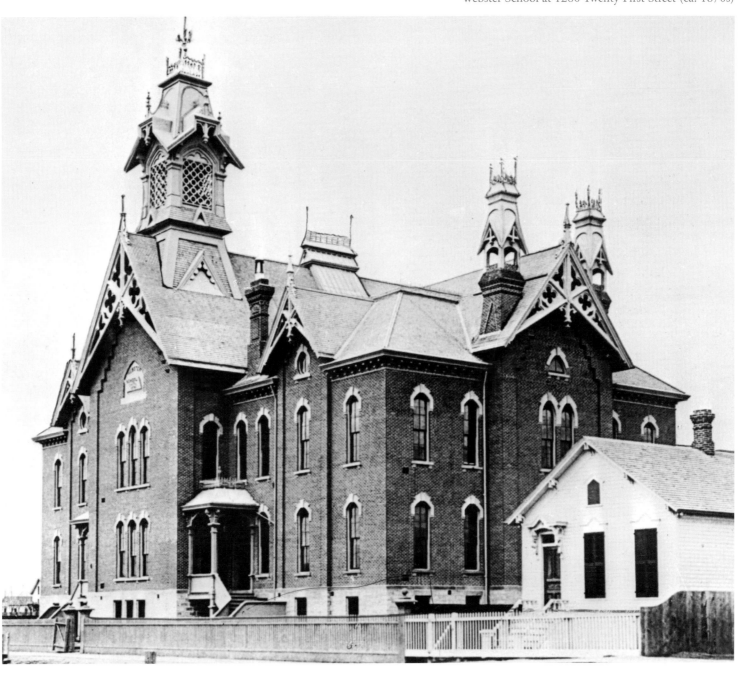

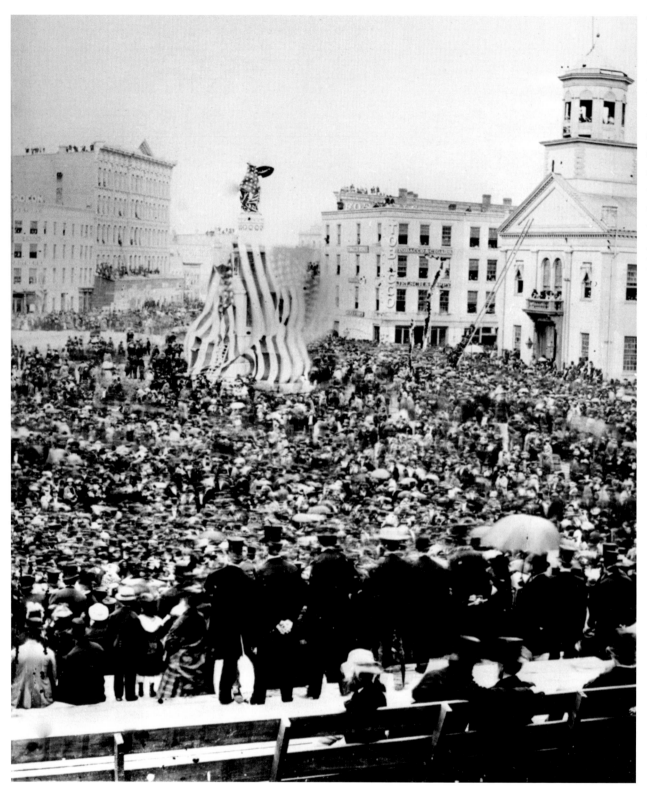

The unveiling of the Soldiers and Sailors Monument on Campus Martius. It was commissioned to honor those who served in the Civil War and was made public on April 9, 1872, the 7th anniversary of Lee's surrender to Grant at the Appomattox Court House.

Detroiters hurry to board the *Grand River* streetcar on Woodward Avenue at Campus Martius. (ca. 1872)

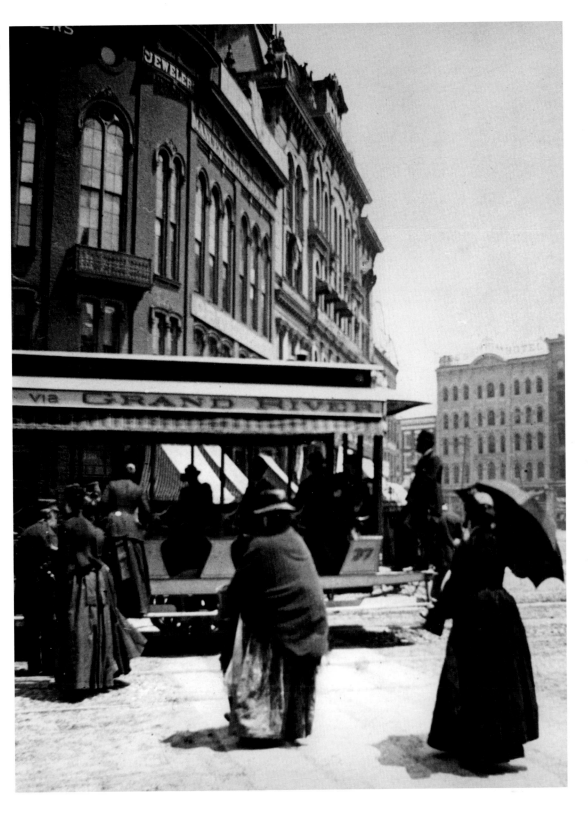

View of the Central Market at Cadillac Square (ca. 1875)

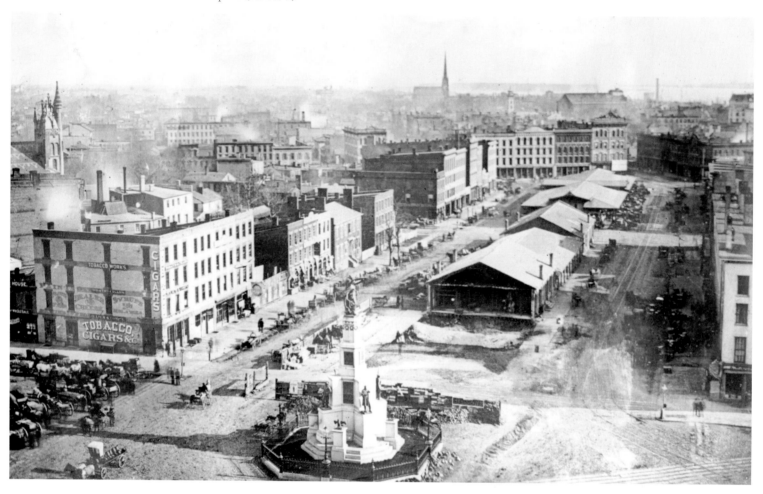

The west side of Woodward between Grand River and Clifford Street. At right is the store where James Vernor sold his famous Vernor's ginger ale, which, along with a popular root beer, shares title to being America's oldest soft drink.

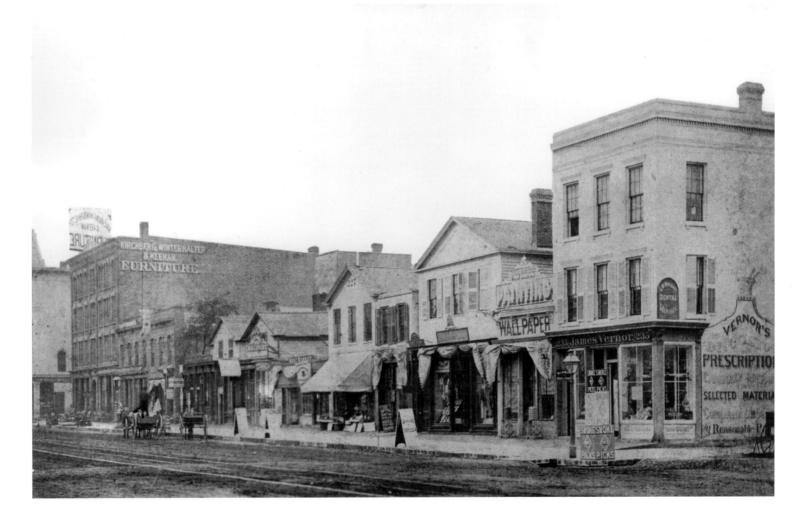

The Fire Department Building on Bates Street (ca. 1870s)

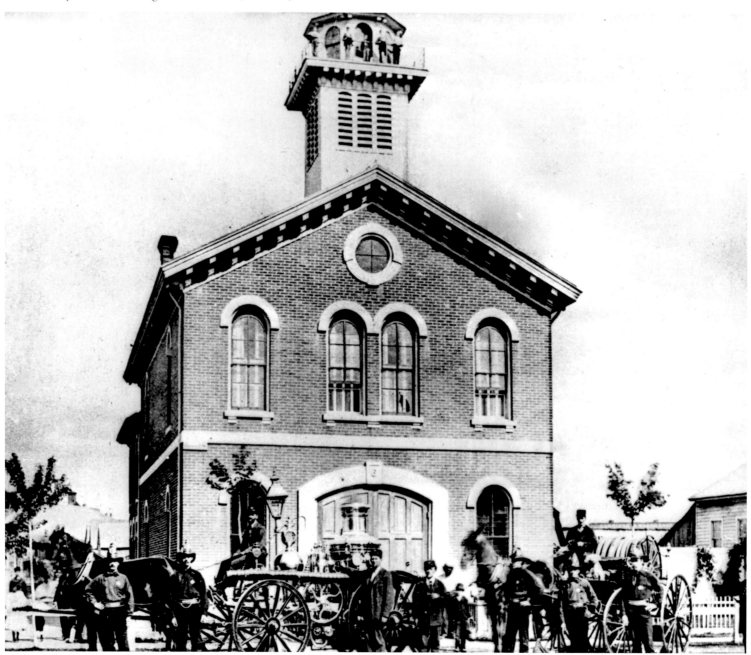

A view of the Central Market at Cadillac Square in 1885

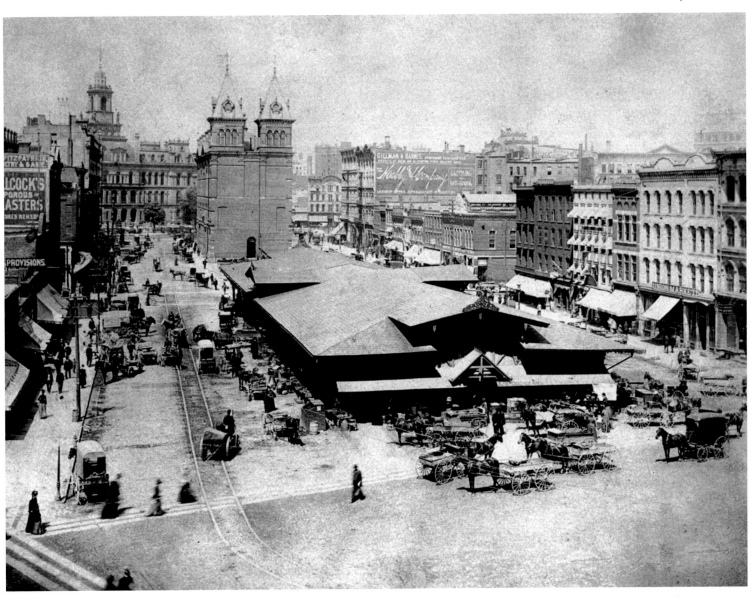

Sharp's Famous Chop House and Saloon, also known as a "sporting and political headquarters."

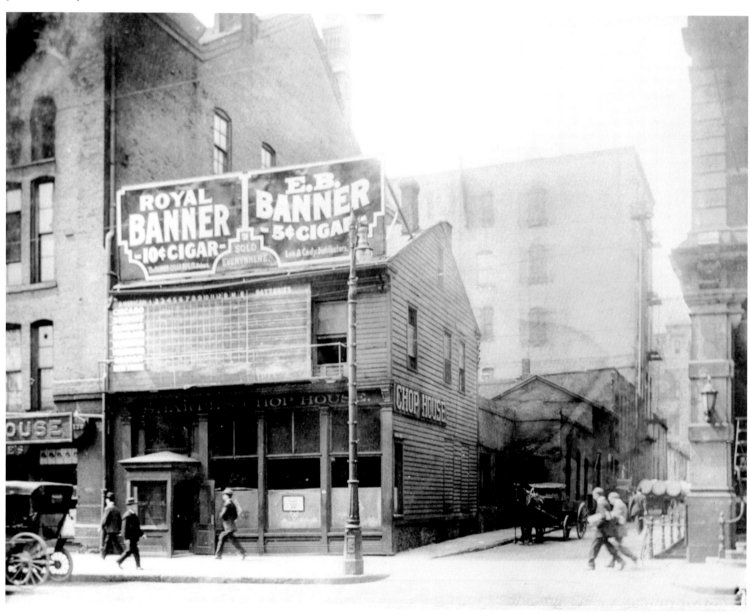

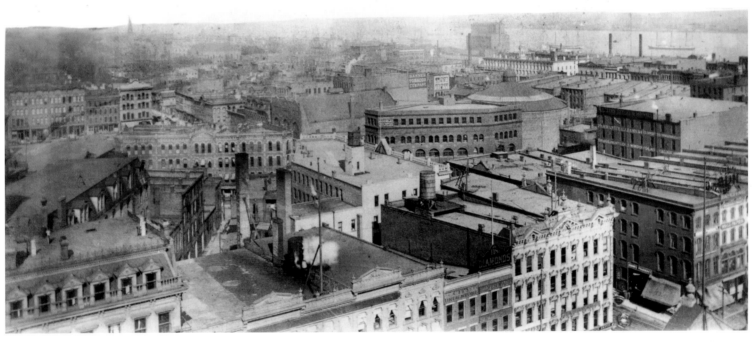

View of Detroit from the City Hall tower, looking west. A sailing ship on the Detroit River is visible in the distance. (ca. 1877)

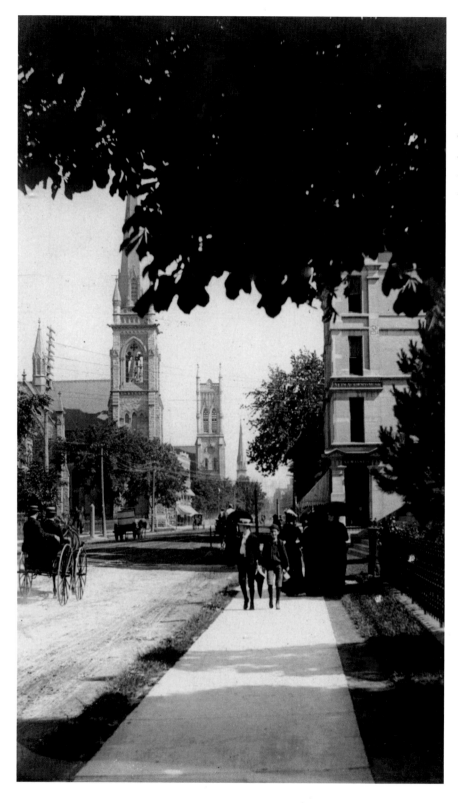

Two boys stroll past a group of women on Woodward, perhaps on their way home from one of the churches behind them on Woodward, in 1880. The churches on the left are Woodward Avenue Baptist, St. John's Episcopal, and Central Methodist Episcopal.

Streetcar at the corner of
Woodward and Grand
River (ca. 1880)

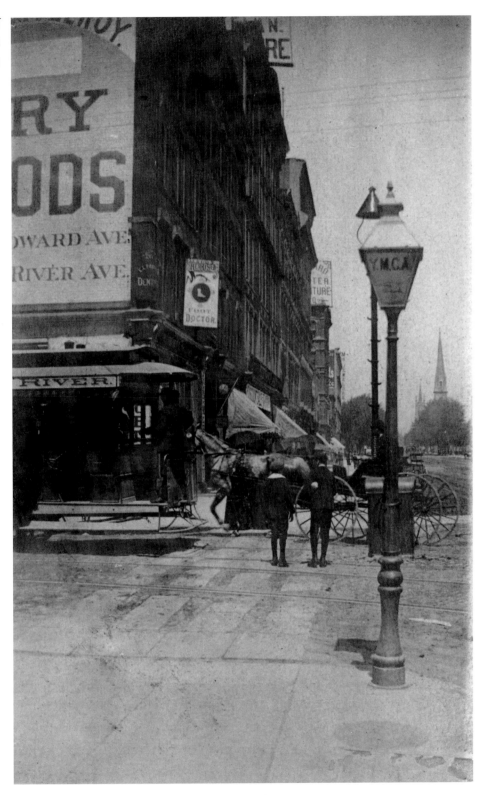

Woodward Avenue (ca. 1885). Mabley and Company's Bazaar is at right. Joseph L. Hudson worked here before leaving to start his own store in 1881.

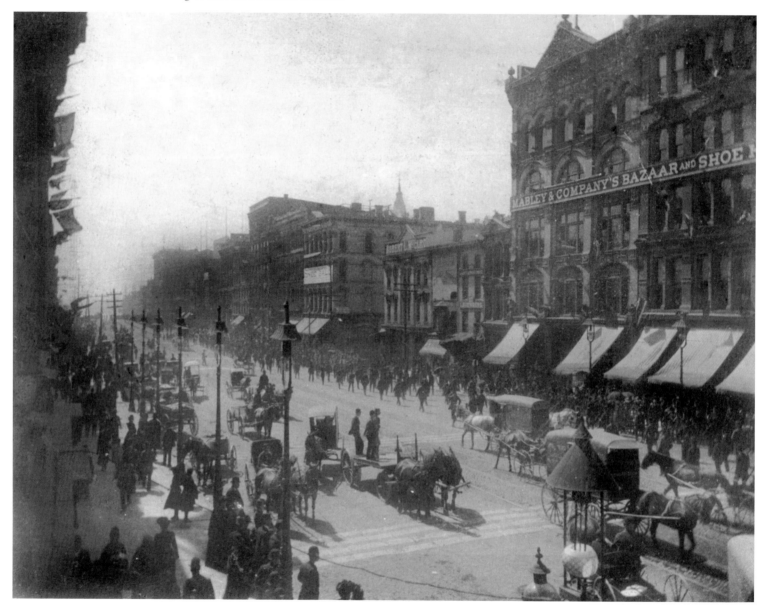

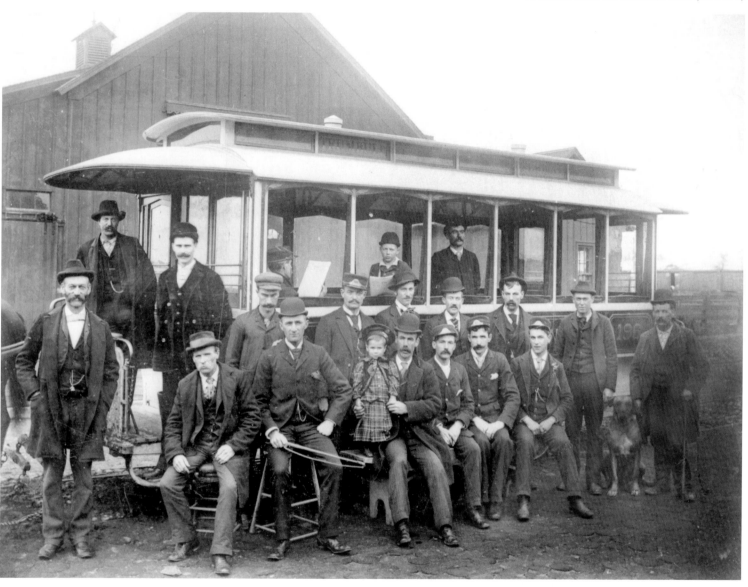

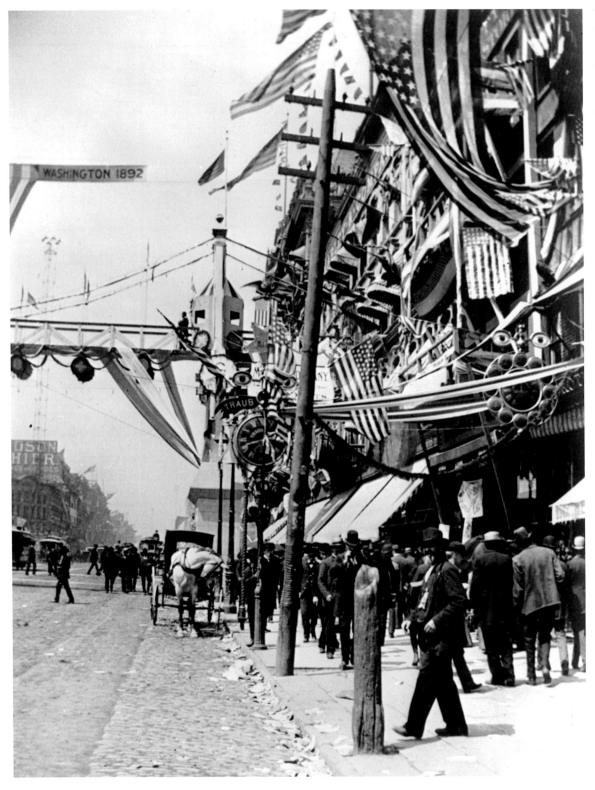

Woodward Avenue in 1892. The arch that looks like a bridge (at left) went up across Woodward for a parade commemorating the Grand Army of the Republic's 25th Encampment. The GAR was a veterans organization made up of Union army veterans.

Detroit Opera House (ca. 1890s). Shown here is one of the 125-foot light towers that helped illuminate the city at night. Considered by some to be ugly and useless, the towers nevertheless stayed in use for nearly 30 years.

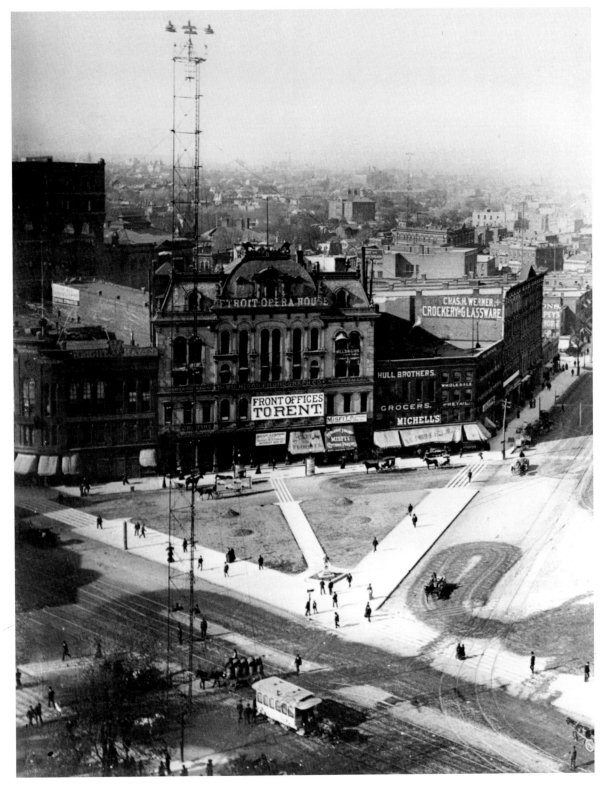

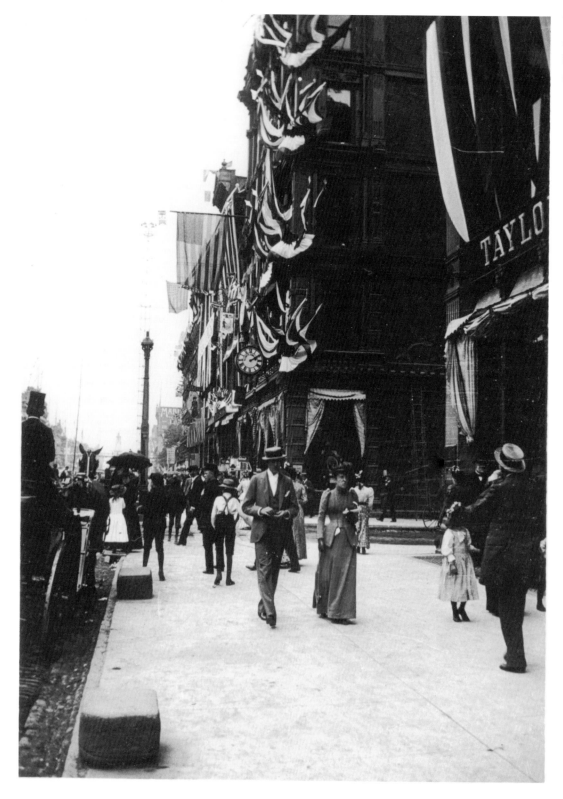

Woodward and State Street (ca. 1892). The buildings are decorated for the GAR Reunion.

Old Federal Building. This building was demolished in 1932.

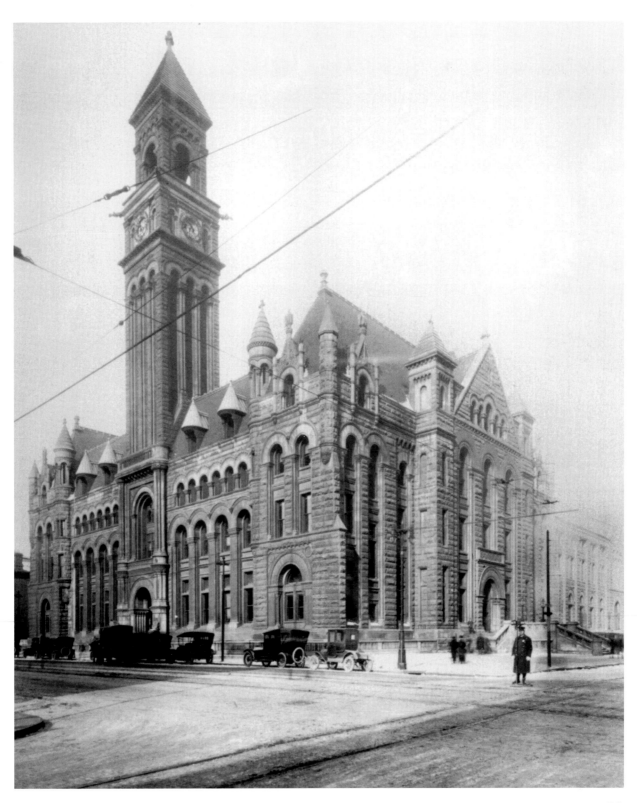

Grand Army of the Republic Reunion in 1892 at the Old City Hall. Civil
War veterans from Michigan, Wisconsin, and Illinois took part.

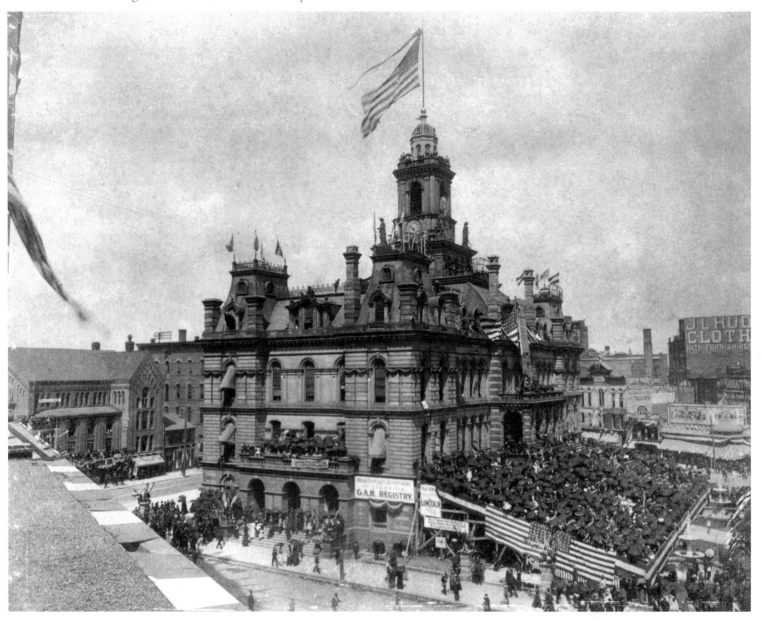

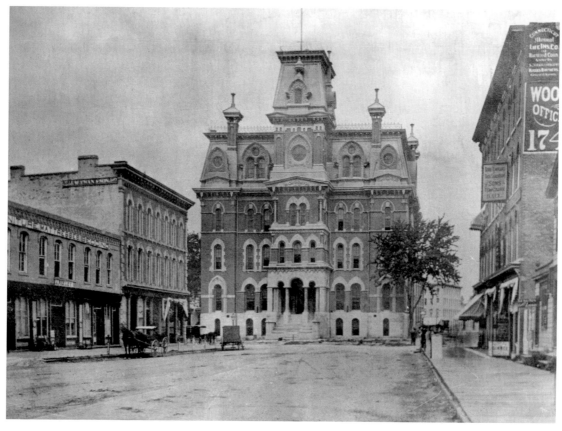

Shown here is Capitol High School on Capitol Park (the site of the old state capitol building). The school building went up in flames January 27, 1893.

The Detroit Public Works Department clears downtown
after a winter storm. (ca. 1917)

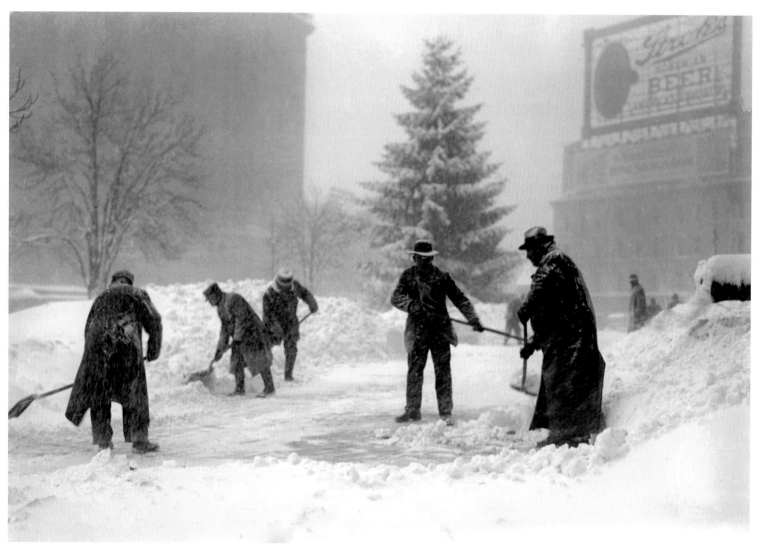

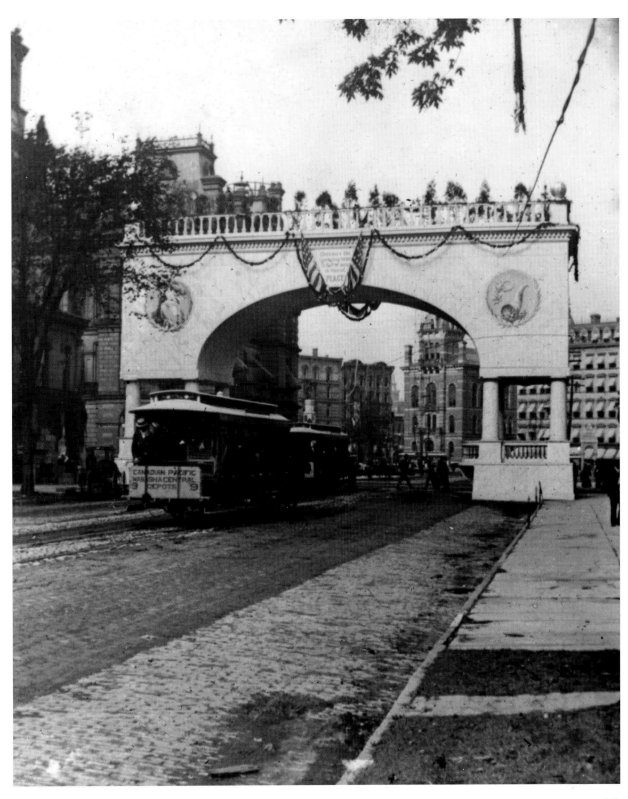

Triumphal arch put up
for the GAR Reunion
in 1892

View down Woodward of the "Piety Hill" neighborhood (ca. 1890s). This stretch of Woodward between Grand Circus Park and Warren was known for its churches. The first church on the left is Woodward Avenue Baptist, which burned in 1986. The other two, St. John's Episcopal and Central Methodist Episcopal, still stand.

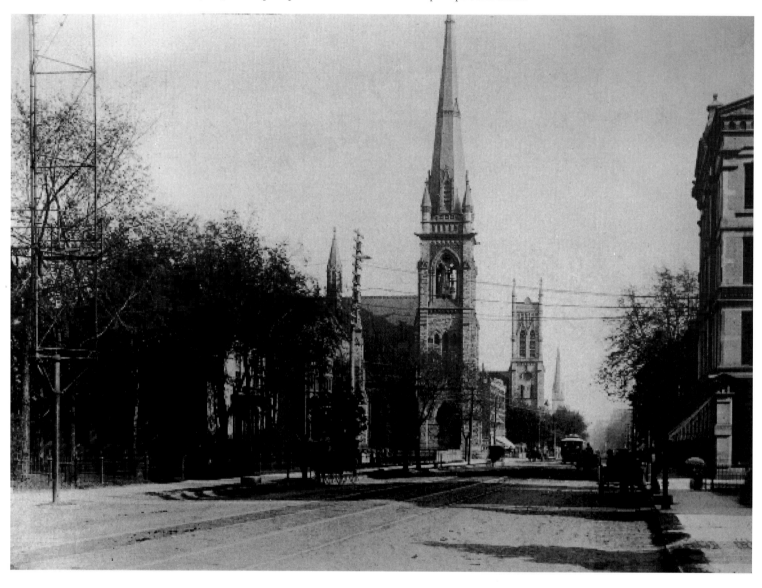

A view down Woodward (ca. 1894). Another of the light towers is visible in the background.

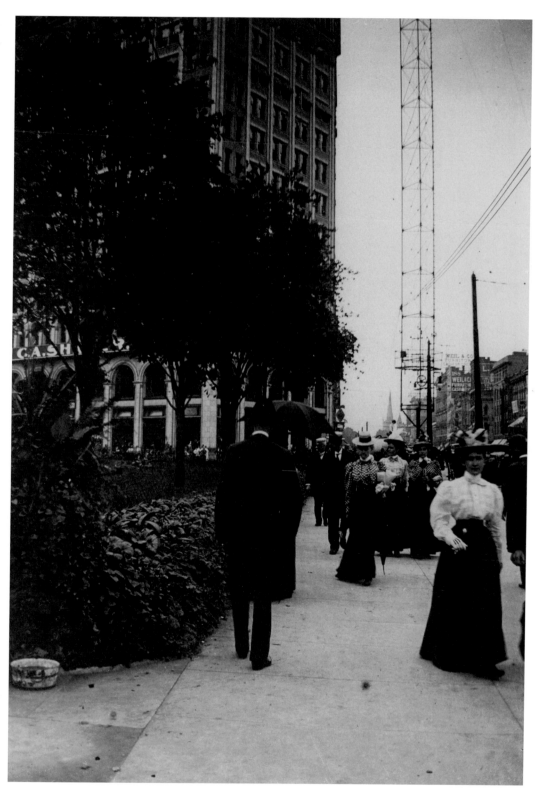

Woodward at Michigan Avenue (ca. 1895). Fred Sanders' first store was demolished to make way for the 14-story Mabley and Company Building that never went up, because of the death of C. R. Mabley. In its place, the Majestic Building was erected and opened in 1896.

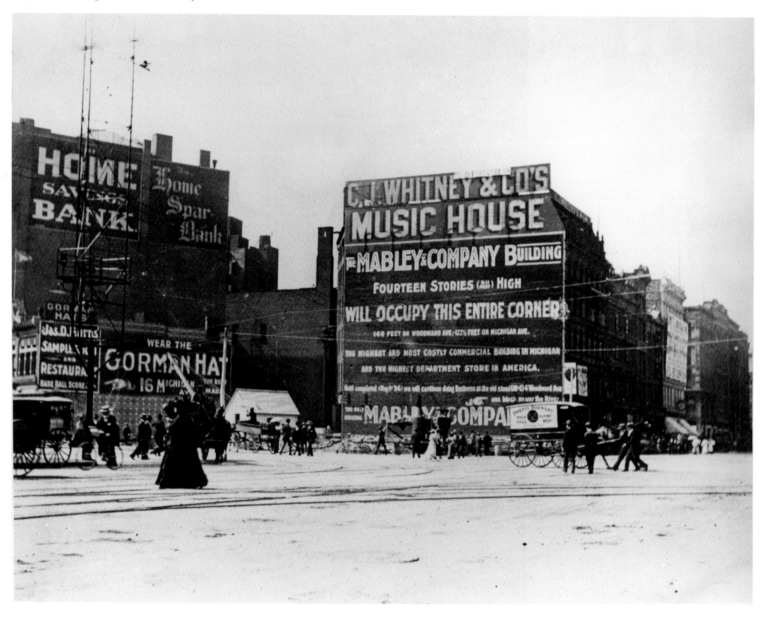

Detroit buildings
decorated for the GAR
Reunion (ca. 1892)

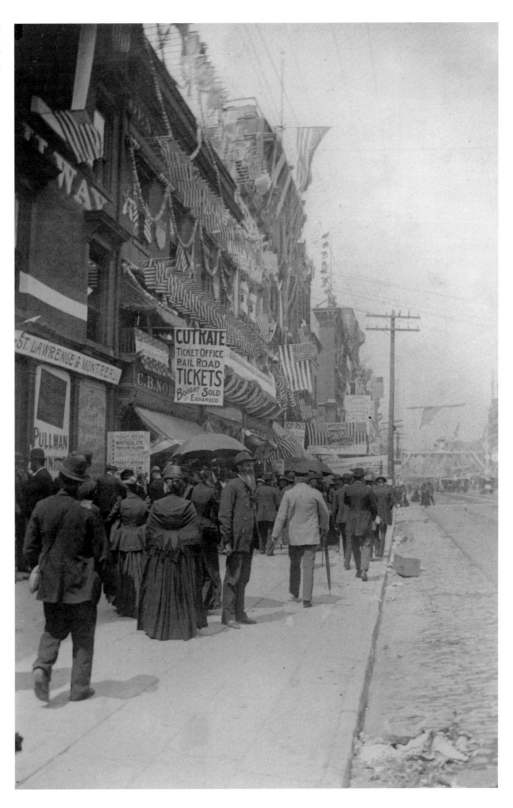

Detroiters trying to catch the trolley
on Woodward (ca. 1890s)

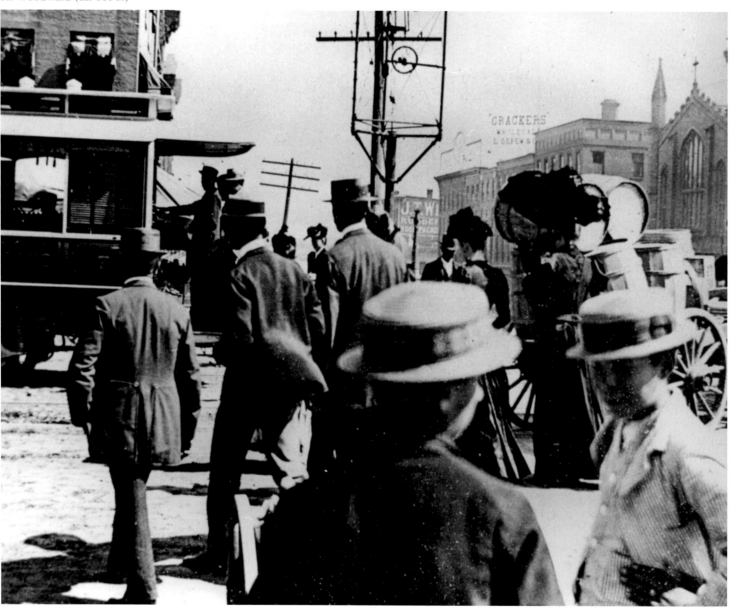

Woodward Avenue, near Campus Martius. The Detroit Opera House is visible in the middle of the image and Mabley and Company is on the right. The Russell House is between the two (ca. 1890s).

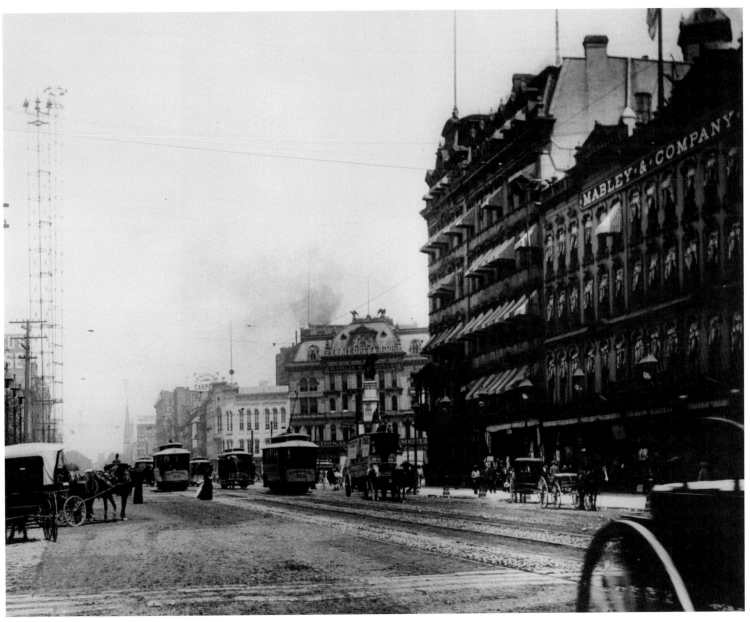

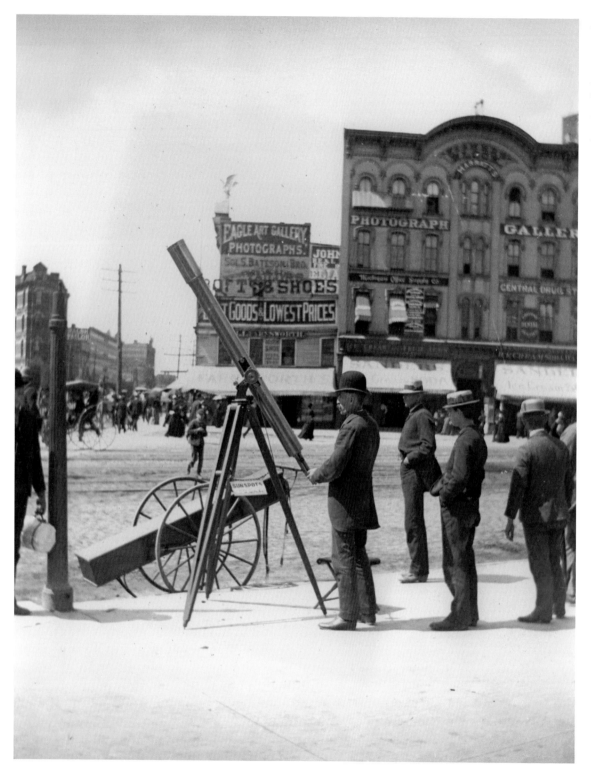

A man looks at sunspots through a telescope near the corner of Woodward and Michigan avenues (ca. 1890s). The photograph galleries in the background were there for many years.

Another triumphal arch put up to celebrate the GAR Reunion in 1892. A group of soldiers is visible under the arch in the background.

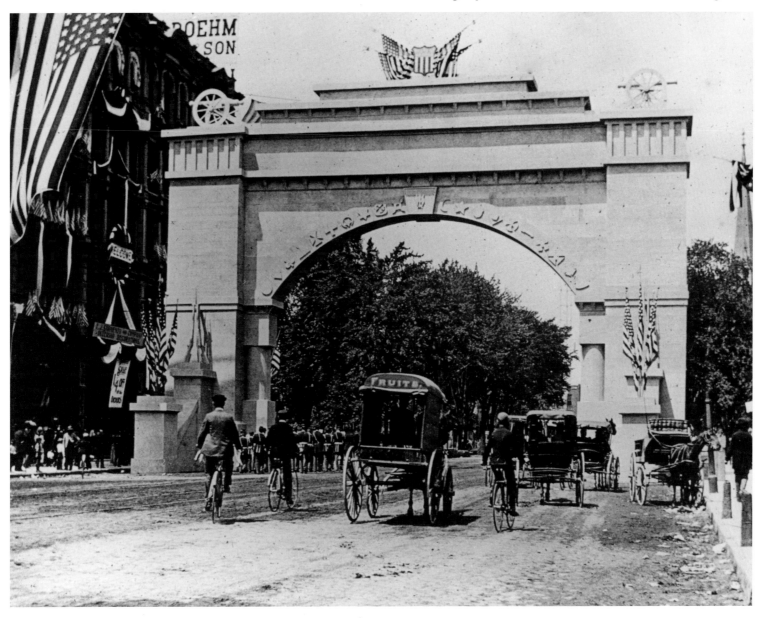

Charles B. King, a railroad mechanic, who built and drove the first automobile in the city of Detroit, 1896. It supposedly traveled at the unbelievable rate of five or six miles an hour.

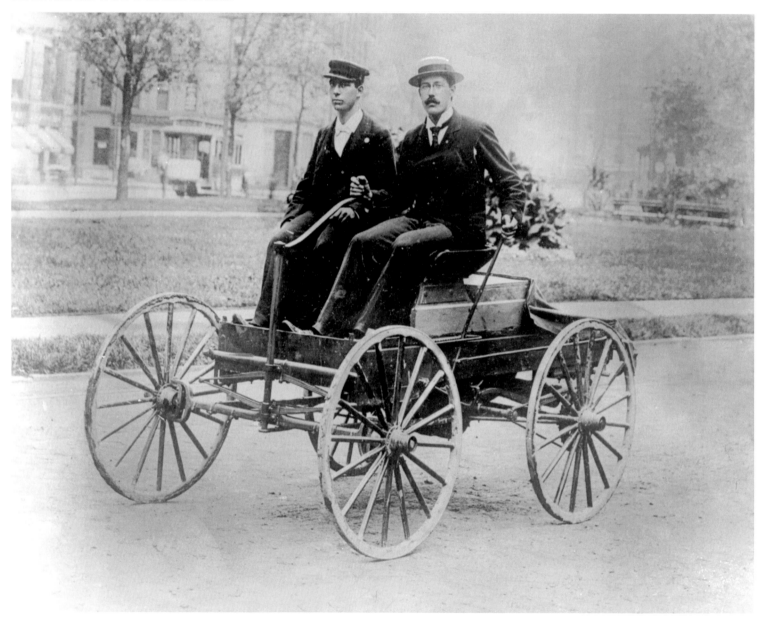

Henry Ford drives his first automobile, the quadricycle, years after its 1896 Detroit debut.

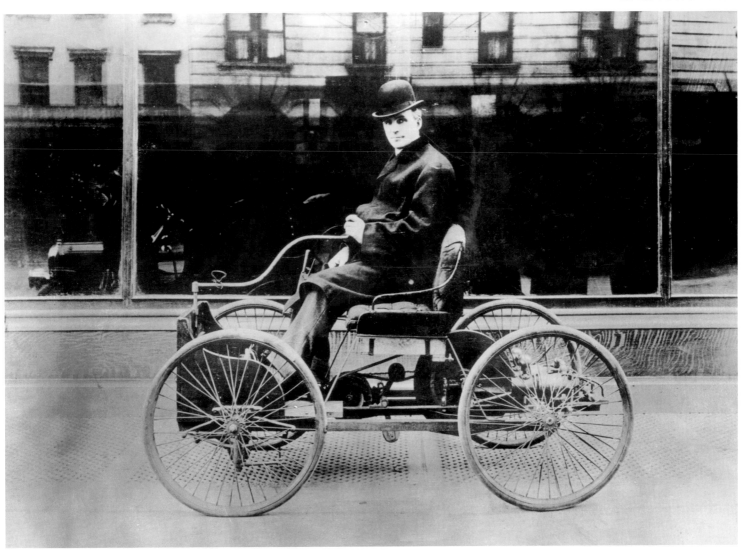

Panoramic view of Detroit in 1898. The Majestic
Building is the tall building in the middle of the image.

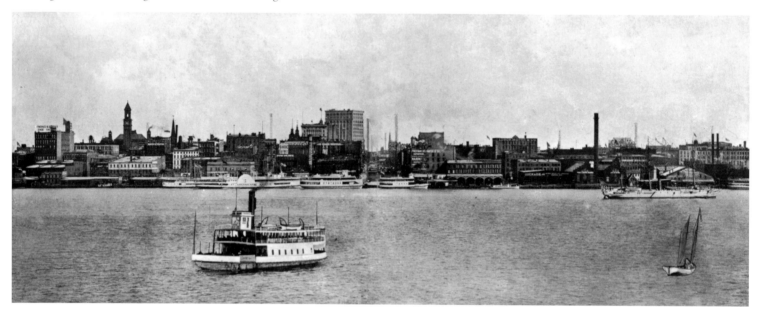

Strolling down Woodward at State Street in the 1890s. The people display several Victorian clothing accessories. The woman holds a glove in her left hand and an umbrella in her right. Gloves worn during the day were generally wrist-length to match the sleeves of daytime dresses. The glove length was longer when worn with shorter-sleeved evening dresses. Umbrellas became a fashion statement for both men and women in the late nineteenth century. Men could carry theirs tightly rolled in place of a cane. Both women and men preferred the expensive, silk-covered styles.

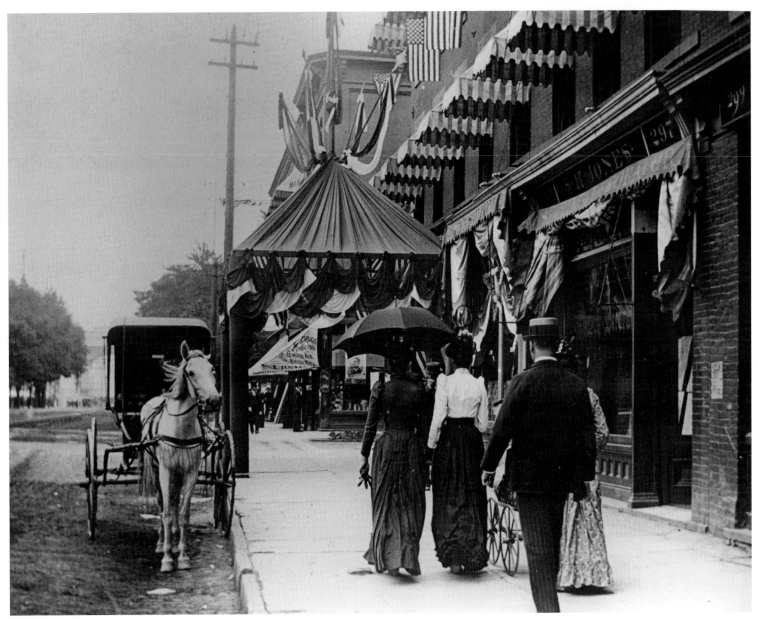

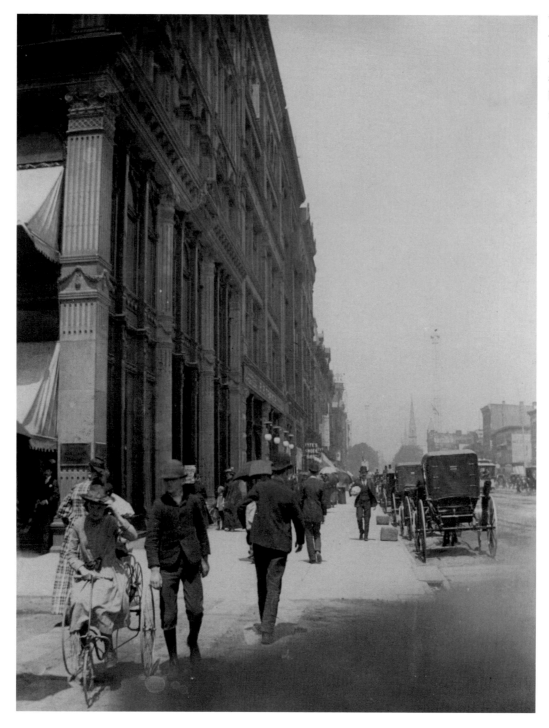

Woodward (1890s). The young lady at left is receiving attention, possibly because of the tricycle she rides.

Corner of Michigan and Woodward (ca. 1890s). The store in the middle background is Sanders Confectioner.

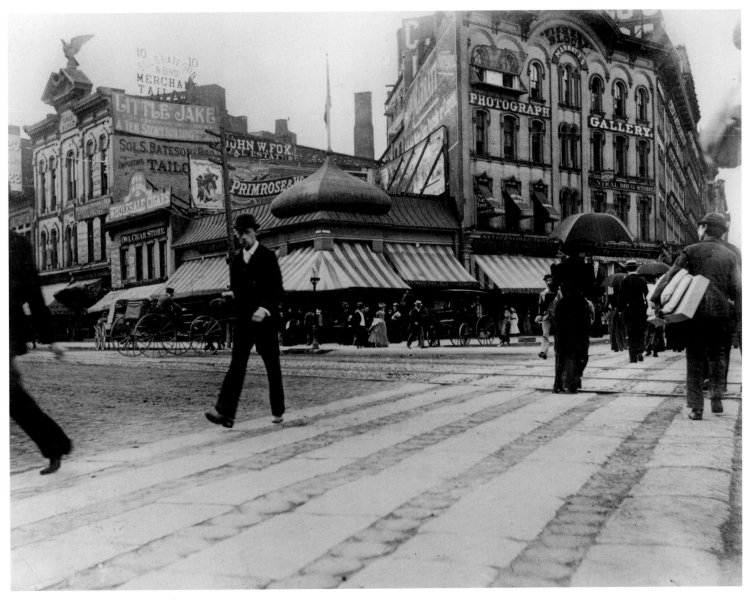

Replicas of the ships of Columbus parade down the Detroit River in 1893. The ship in front re-creates the *Santa Maria*. The other two are replicas of the *Pinta* and the *Nina*.

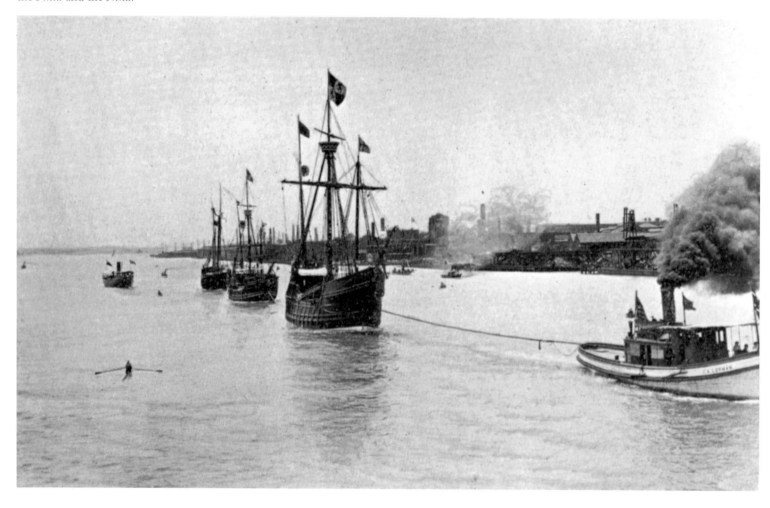

Fort Street's Union Depot at Third Street opened in 1893. The tower was an imposing one hundred feet tall, and the four clocks on each face were each ten feet in diameter. The building was demolished in 1974.

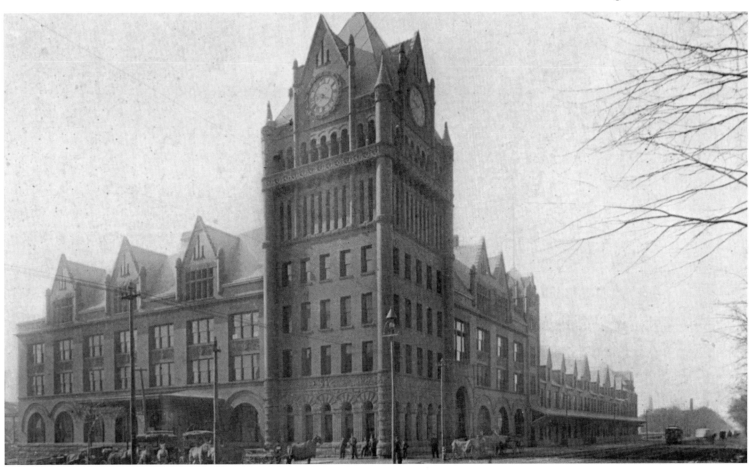

The Interurban, shown here, was an electric streetcar that ran long-distance routes in and out of the city, to and from the suburbs. More luxurious than city streetcars, they mostly catered to well-to-do riders, who could afford to live beyond the city limits.

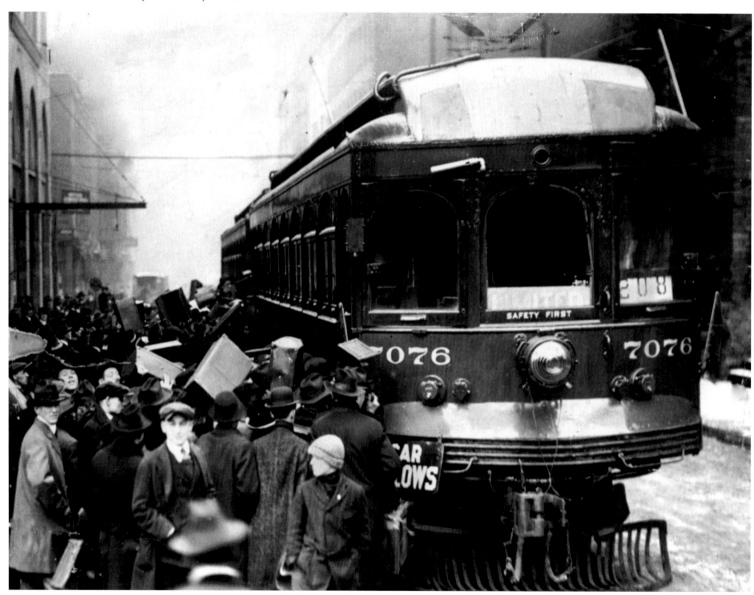

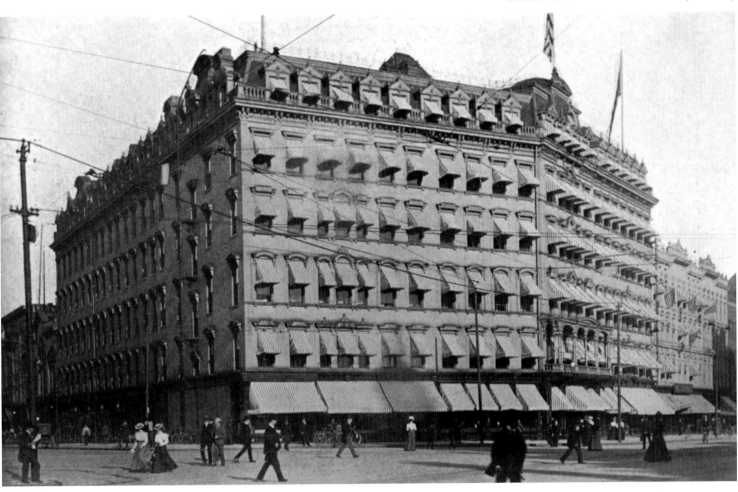

Russell House hotel on Woodward (ca. 1899)

Canal at Belle Isle. Canals were built to drain the land on the island, but served a dual purpose for these canoe riders. Belle Isle was only four feet higher than the surrounding Detroit River. (ca. 1899)

Building Industry and Community

1900–1919

In the first two decades of the twentieth century, the automobile industry and world events had a considerable impact on the city of Detroit. By 1900, Detroit's population had exceeded 285,000. Spurred on by the emergent automotive industry, in the next twenty years the population would approach one million. Along the new city roads, theaters, sporting venues, and department stores began to spring up to occupy the free time of the city's growing population.

In 1909, Woodward was paved eighteen feet wide between 6 and 7 Mile, the first section of paved road in the nation. To control the growing amount of car, horse, and pedestrian traffic on downtown streets, the city erected a raised platform on Woodward in 1917 to station a police officer responsible for directing the traffic.

The Wayne County Building opened in 1902 and the Dime Building opened on Griswold behind the City Hall in 1910. The Detroit Tigers, with outfielder Ty Cobb, began play at the new Navin Field in 1912. Theaters like the National, the Columbia, and other Vaudeville venues found homes on Monroe Avenue. In 1911, J. L. Hudson moved his store from the first floor of the Detroit Opera House to the site on Woodward where it stood for 87 years.

General Motors was organized in 1908 and led by William Durant. In 1903 Henry Ford established another player among today's Big Three, Ford Motor Company, and began producing the sturdy, dependable Model T in 1908. In 1913, Ford introduced the moving assembly line, which cut the time needed to make the vehicle, thus lowering its cost. The next year, Ford shocked the world by offering workers an eight-hour workday at $5 a day. That was more than double the current wage and a workday an hour shorter.

Many of those seeking the infamous "$5 a day" came to Detroit through the new railroad station, Michigan Central Station, which opened in 1913 at Vernor and Michigan. Michigan Central also served as a transportation hub for Detroit soldiers, nurses, and volunteers who took part in World War I. Approximately 65,000 men and women from Detroit entered the armed forces during the conflict, and of those, 1,360 never made it home.

The war affected Detroit women's employment status as local women found jobs that had been off limits. Many women worked in industrial defense plants, automobile and tire factories, and some were even streetcar conductors.

Cadillac Square looking west from the Wayne County Building (ca. 1906). The square was named for the founder of Detroit, Antoine de la Mothe Cadillac, and was originally the site of the Central Market. The building in the center of the background is City Hall, built in the 1870s and demolished in 1961. The Majestic Building is the tall one on the right.

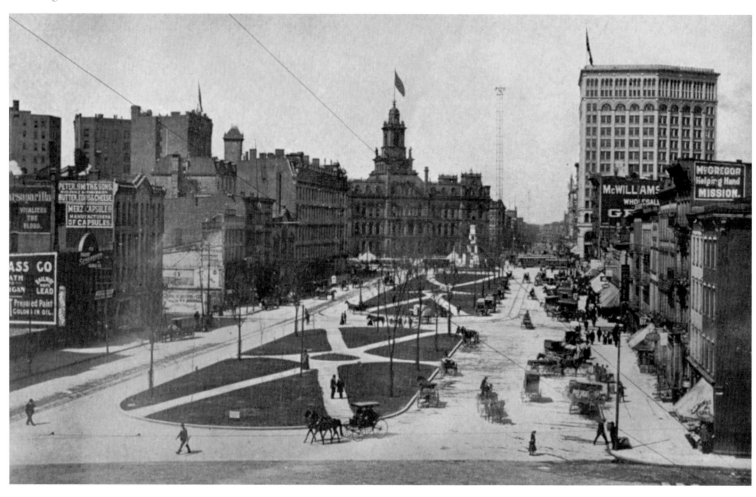

Streetcars on the corner of Woodward and Jefferson (ca. 1900).
The Majestic Building is the tall building in the background.
By this time electric streetcars had replaced the horse-drawn
vehicles of the nineteenth century.

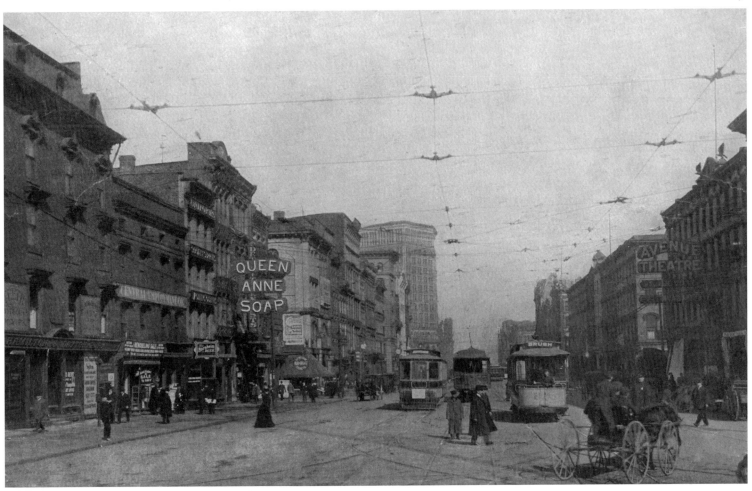

Knowing how Detroiters love parades, one can guess that these people are possibly watching one in the early 1900s.

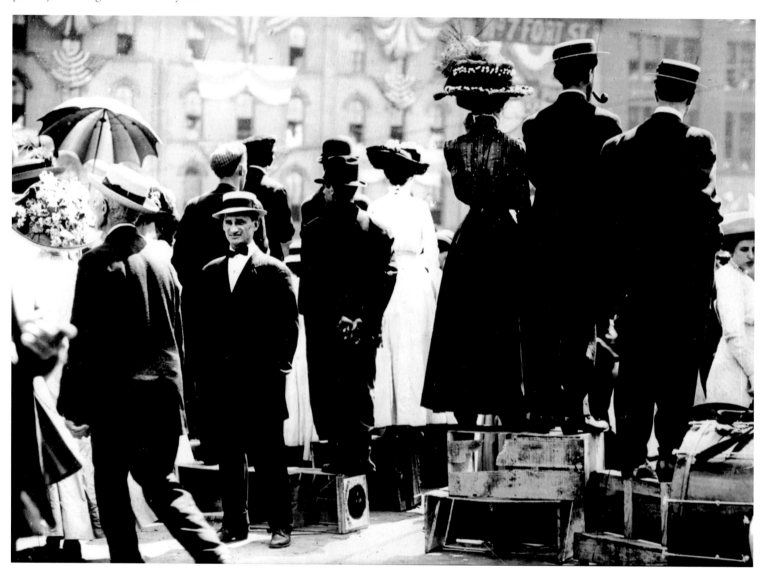

Central Avenue, Belle Isle. This was the main boulevard through the middle of the island. (ca. 1900)

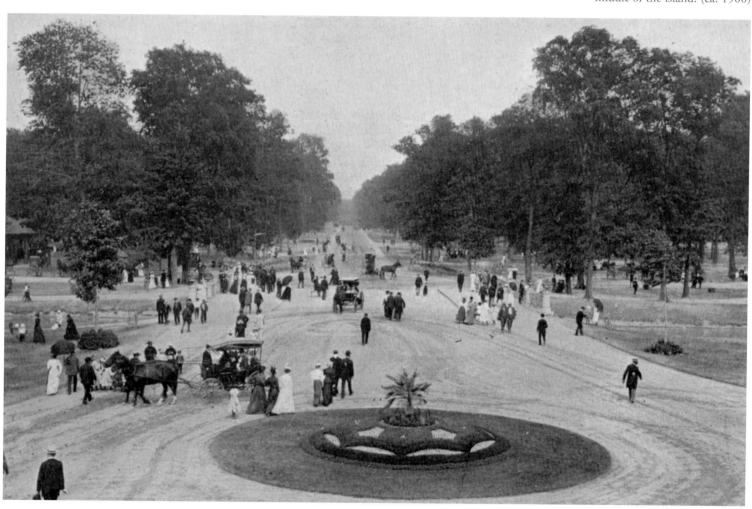

The west side of Woodward Avenue between Grand Circus Park and Clifford Street (ca. 1900). In 1908, Grinnell Brothers Music built their headquarters on this site.

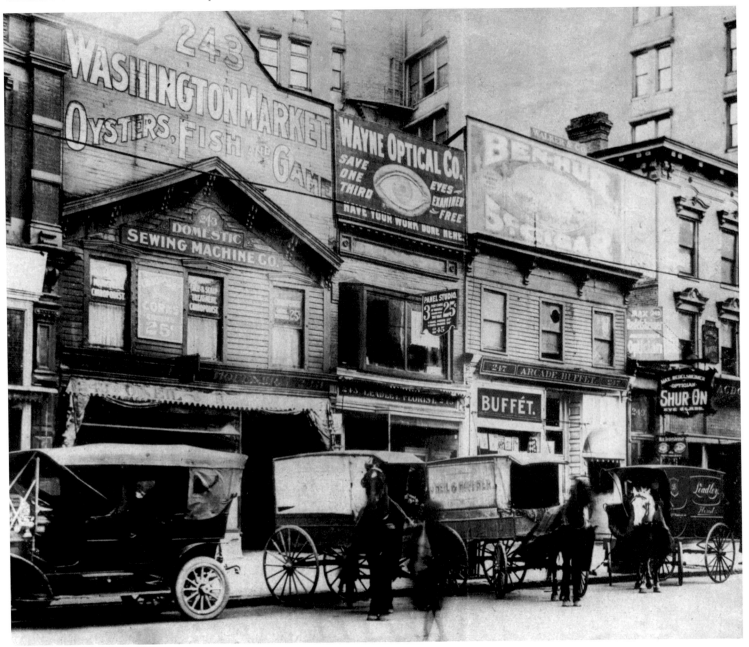

Theodore Roosevelt visits Detroit's Light Guard Armory early in the twentieth century.

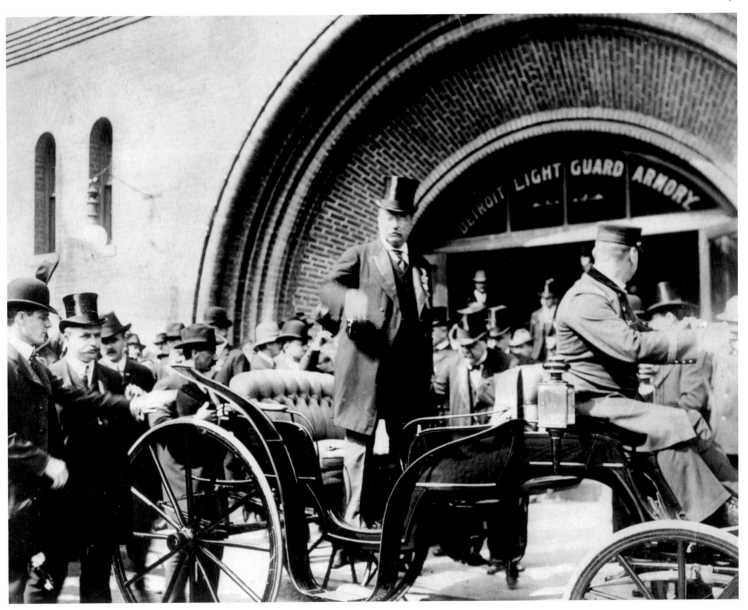

Pontchartrain Hotel at Cadillac Square. The hotel was named after Antoine de la Mothe Cadillac's friend, Count Louis Pontchartrain, who was King Louis XIV of France's chief counselor and minister of marine. In view here is the second Pontchartrain hotel, which ended operations in 1919.

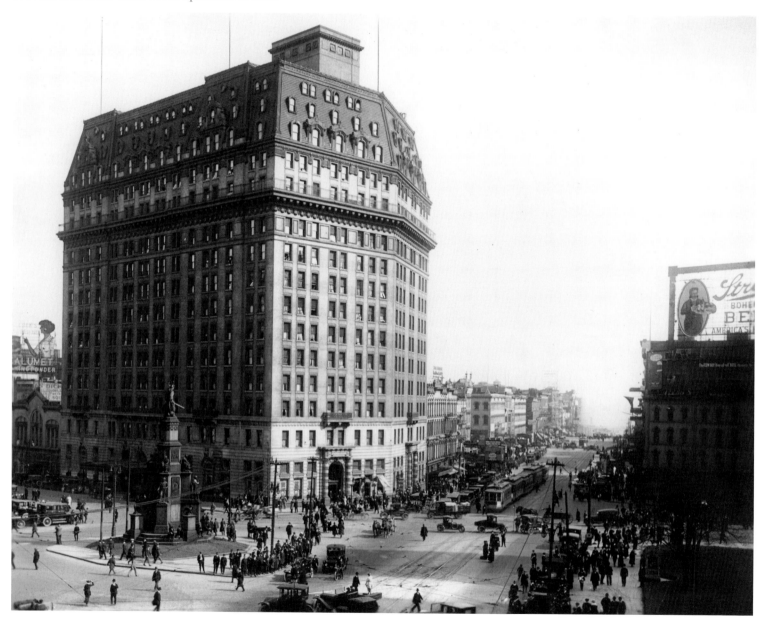

Women strolling down Detroit streets show off the Edwardian fashion of the day (ca. 1910s). Hat brims grew wider and hat crowns were ornately decorated.

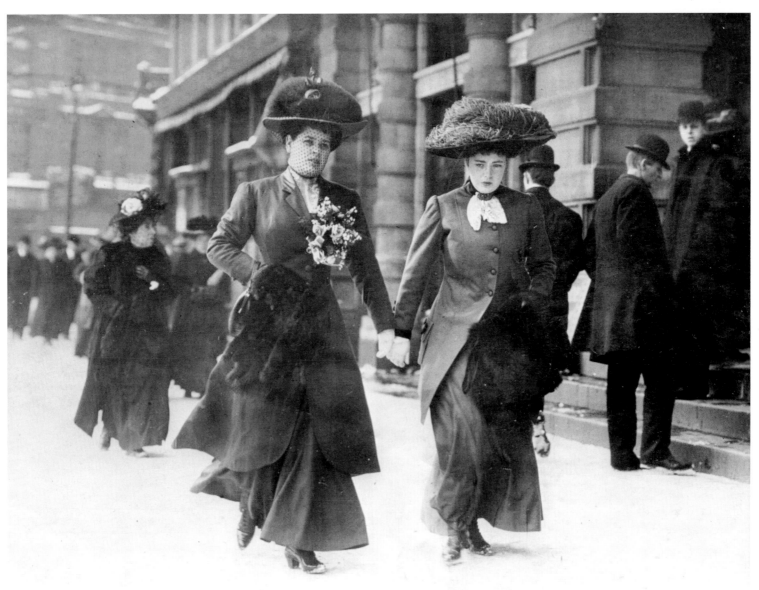

Well-dressed women walking down Detroit streets (ca. 1910s). Both women wear high-collar dresses. High collars were only for daytime use. In the evening, the dresses of society women sported low necklines so that the ladies could display their jewelry.

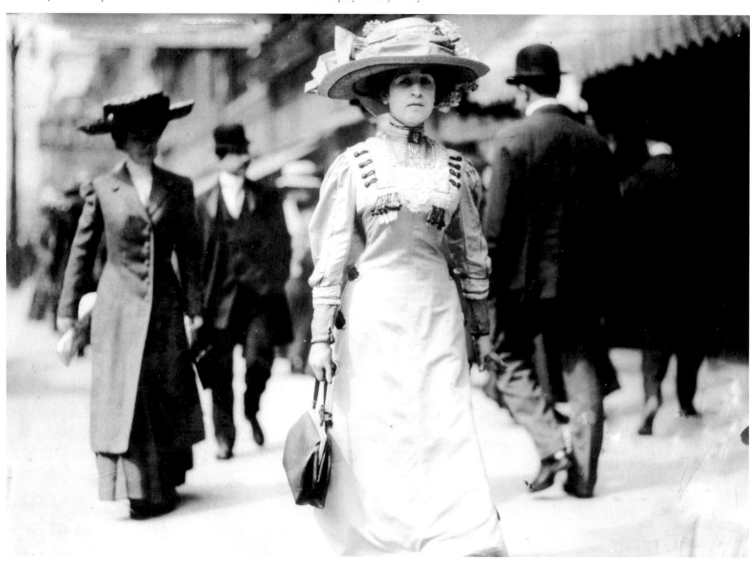

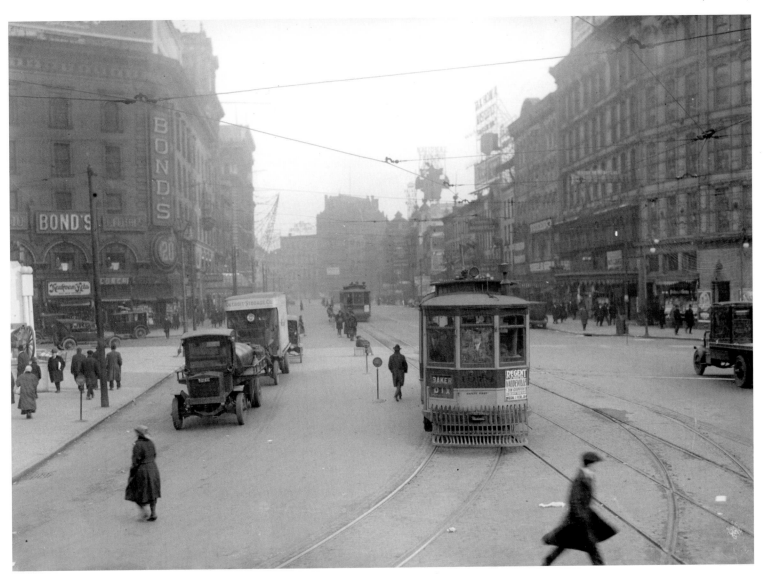

A view down Monroe Avenue (ca. 1918)

Woodward at Campus Martius (ca. 1912). The building at left is the Pontchartrain Hotel. The Soldiers and Sailors Monument is visible at far left.

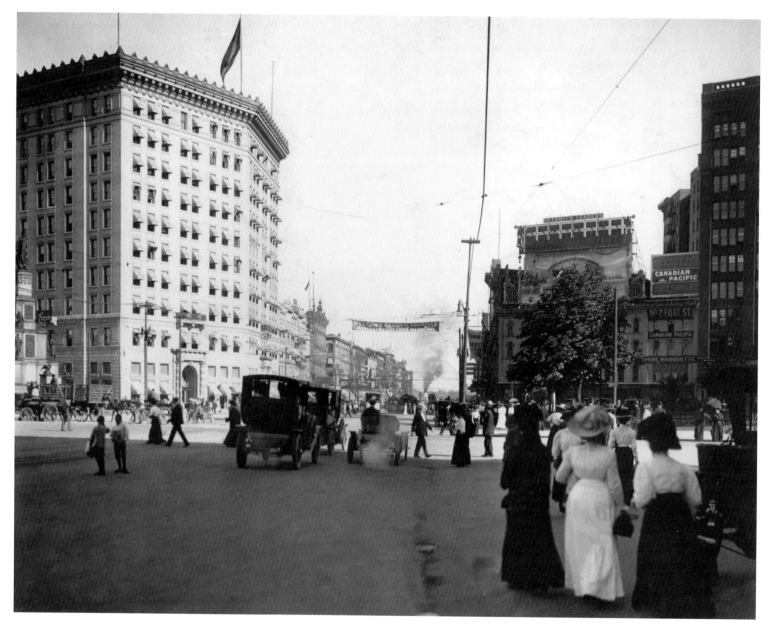

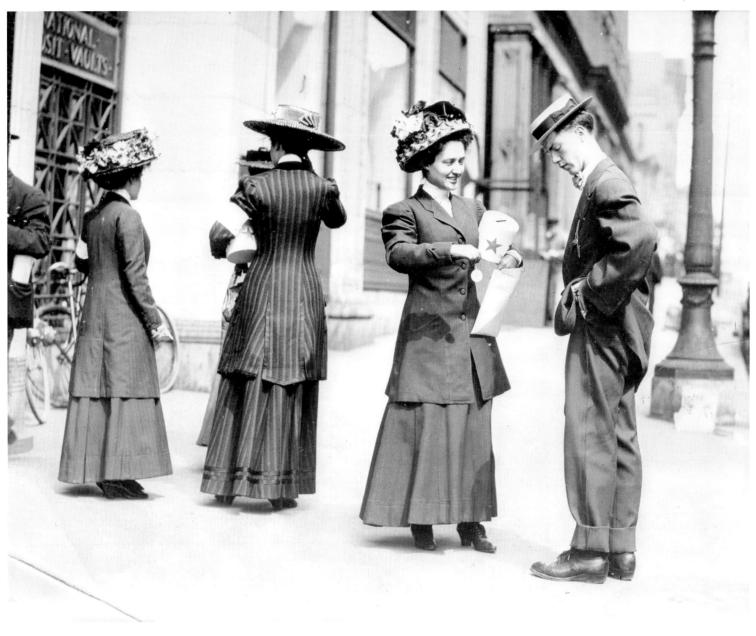

Woodward (ca. 1915). The old Pontchartrain Hotel is on the left. The Bagley Memorial Fountain, the structure with the pointed canopy, was a water fountain designed by master architect Henry Hobson Richardson and given to the city by former Governor John J. Bagley. It was eventually moved from Campus Martius to the northeast corner of Woodward and Monroe. Currently it sits in the median at the head of Cadillac Square, in front of the Wayne County Building.

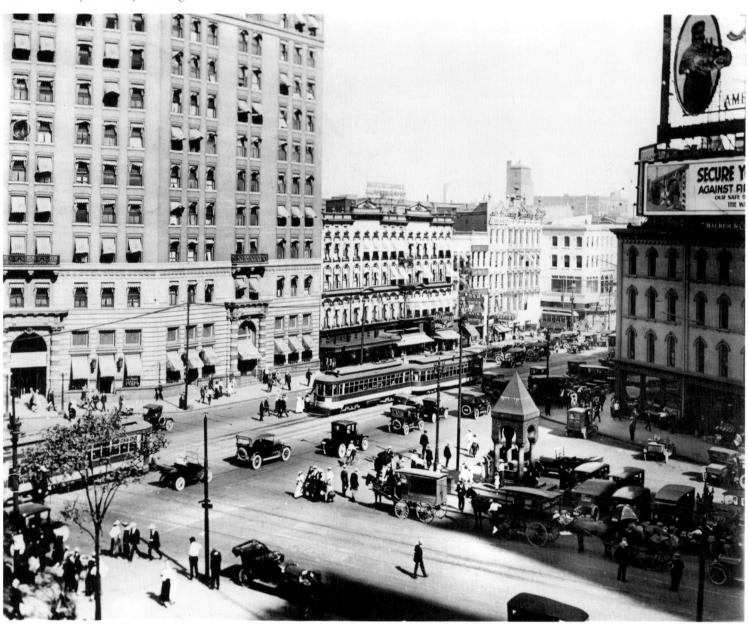

Workers spray the trees lining LaSalle Boulevard, a street northwest of downtown Detroit.

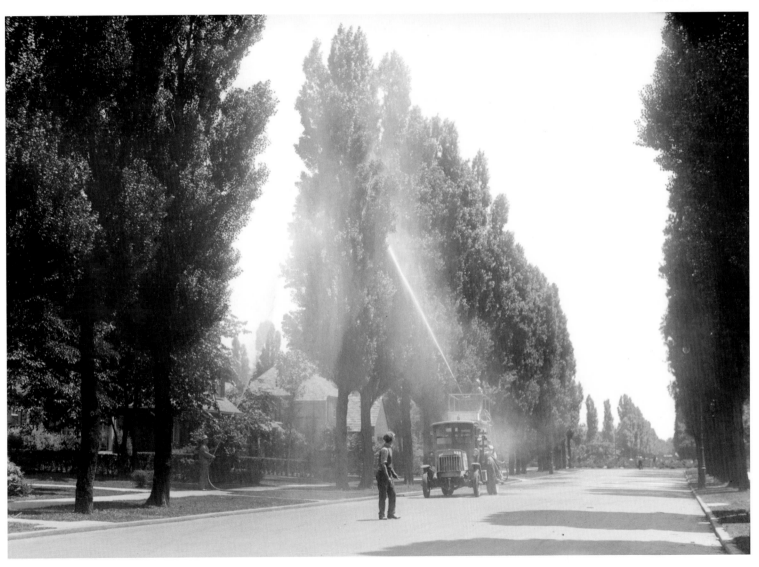

Corner of Monroe and Cadillac. Vaudeville venues and theaters like the
Columbia and the National lined the streets of Monroe in 1910. The St. Clair
Hotel, built in 1892, is in the background at left.

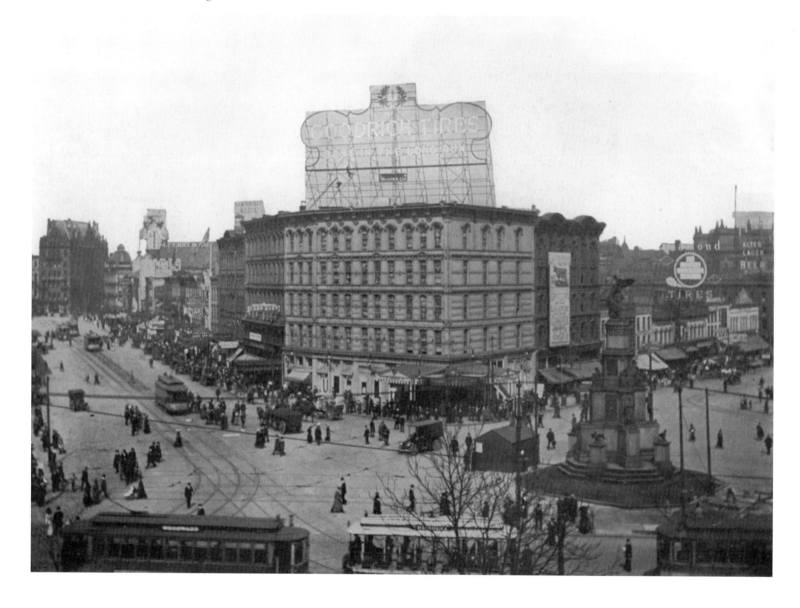

A couple rides along the city streets during a Detroit winter in a light-weight "speeding sleigh" or cutter (ca. 1905). John Breitmeyer and Sons Florist is behind them.

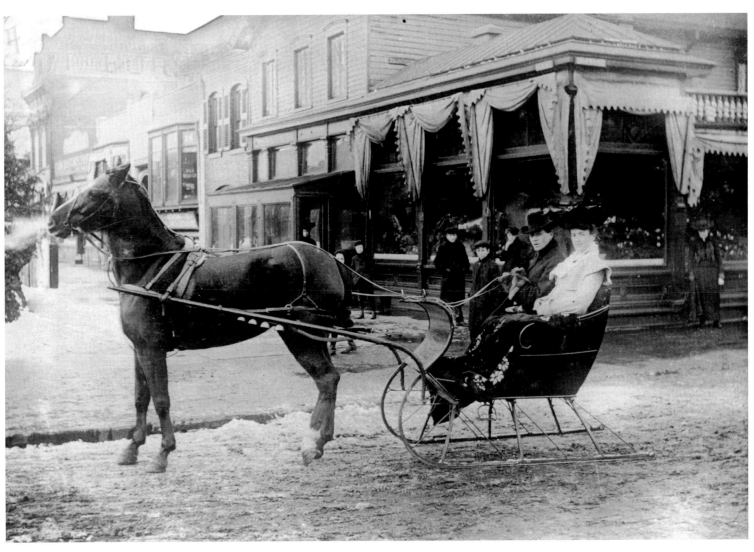

Street scene from the east side of Detroit, down
Gratiot Avenue (ca. 1910)

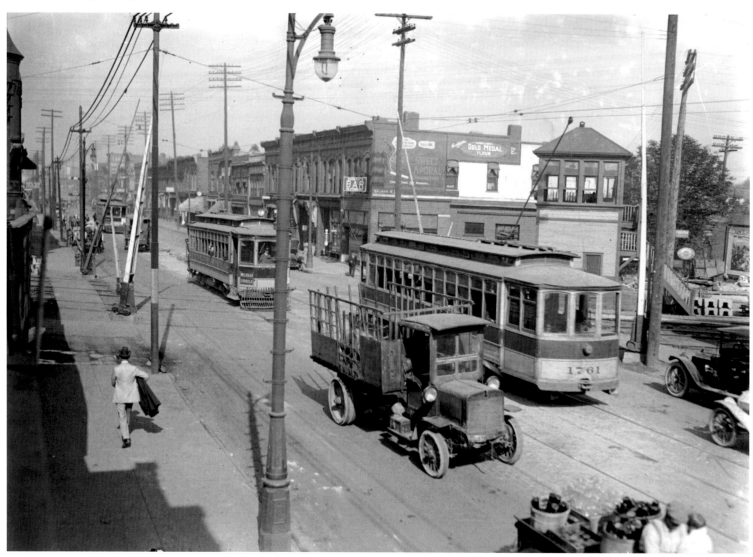

Boys playing shinny on a Detroit street (ca. 1910). Shinny was an informal type of hockey. The boys' hockey sticks are actually tree limbs.

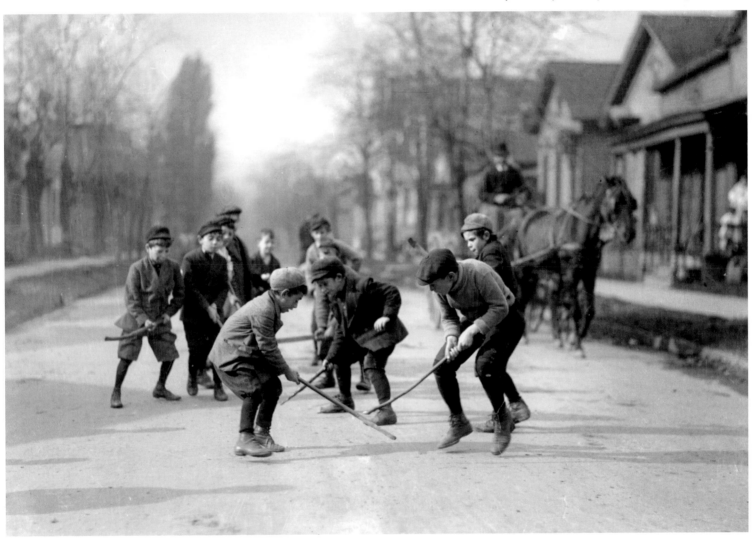

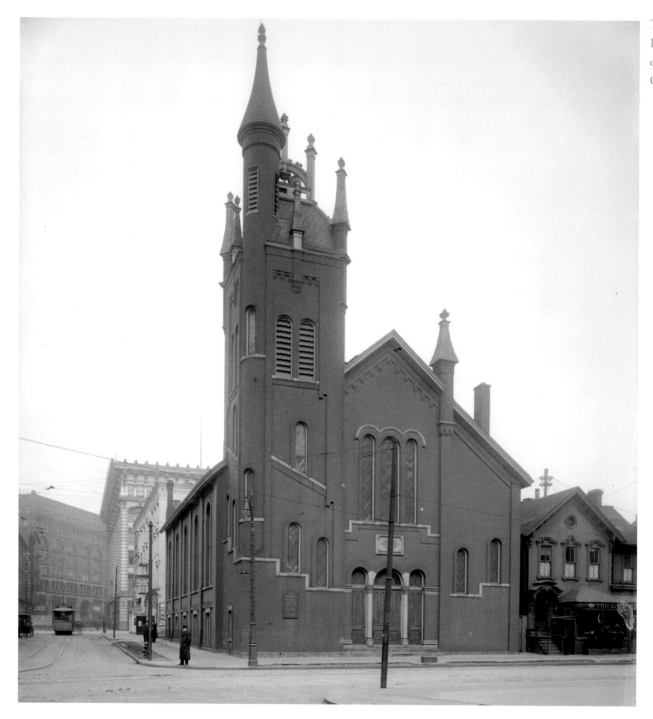

The Central
Presbyterian Church
on Bates Street near
Cadillac Square
(ca. 1910)

The Detroit Auto show in 1910, held at the old Wayne Gardens at the foot of Third Street. The first auto show in Detroit was held in 1899 at the Light Guard Armory. It was held at many venues throughout the years, including parks, lumber plants, dance halls, and the state fair grounds. In 1960 it moved to the Cobo Center, its home ever since.

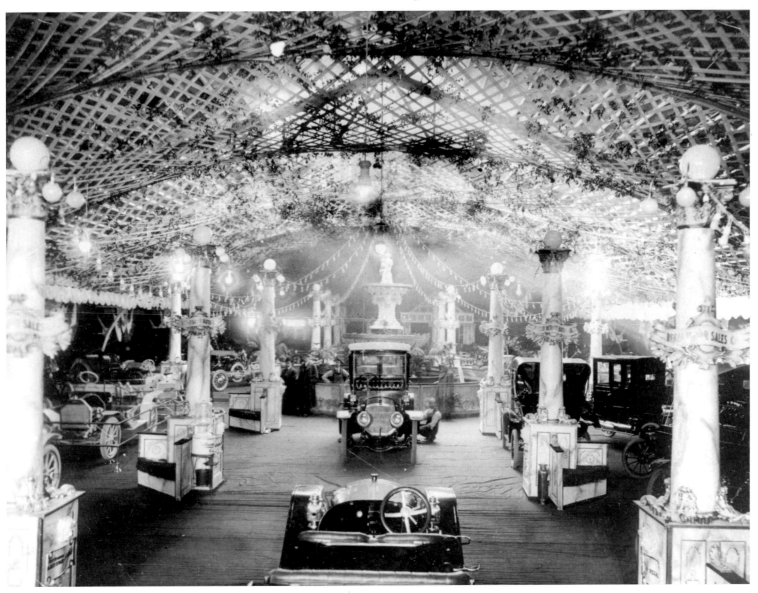

An employee of the Detroit Public Works
Department cleans Frederick Street in 1911.

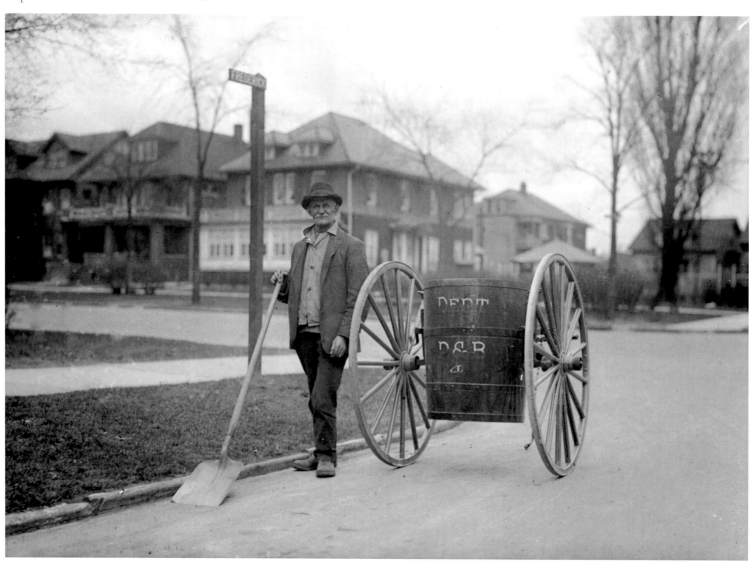

The Detroit Public Works Department removes snow from city streets using the Barber-Green Snowloader (ca. 1920). The Snowloader originated in Chicago in 1920, and many cities including Detroit quickly purchased one.

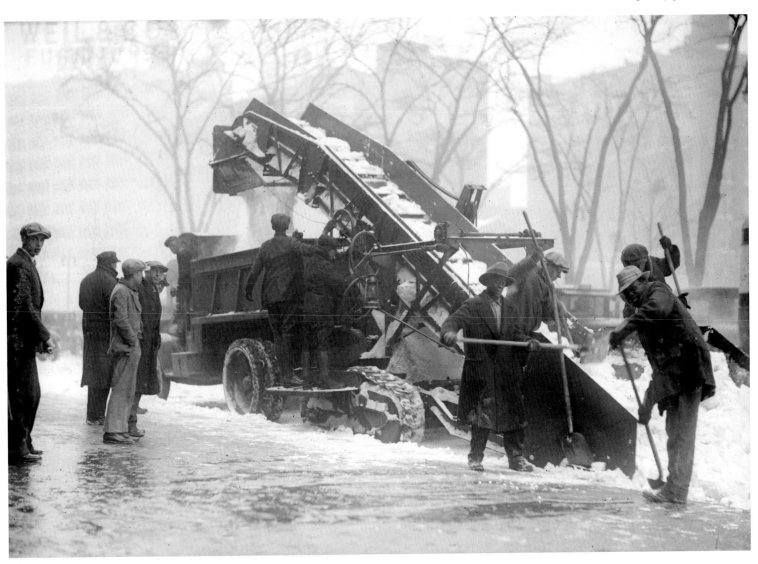

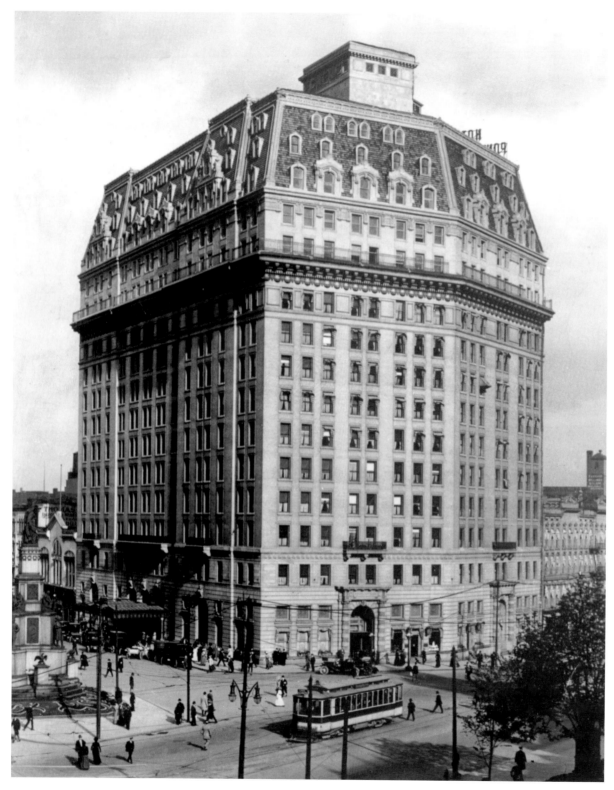

The Pontchartrain Hotel with the five-floor addition of a mansard roof (ca. 1917). The five extra floors were added in 1916.

The upper class strolling down Detroit streets. As hats got bigger and more ornately decorated, women's hair had to get bigger to support them. Big, back-weighed hair was the style in the early 1910s, as illustrated by the woman on the left whose hair is spilling out from behind her very large hat.

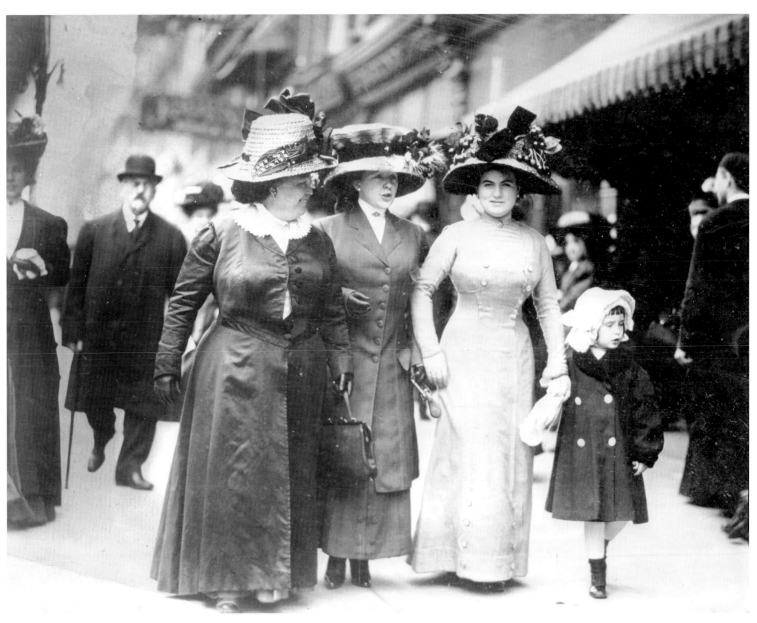

Henry Ford meets Helen Keller in 1916. Anne Sullivan is behind them. The man at left is E. G. Pipp, the *Detroit News* managing editor at the time. The other man is not identified.

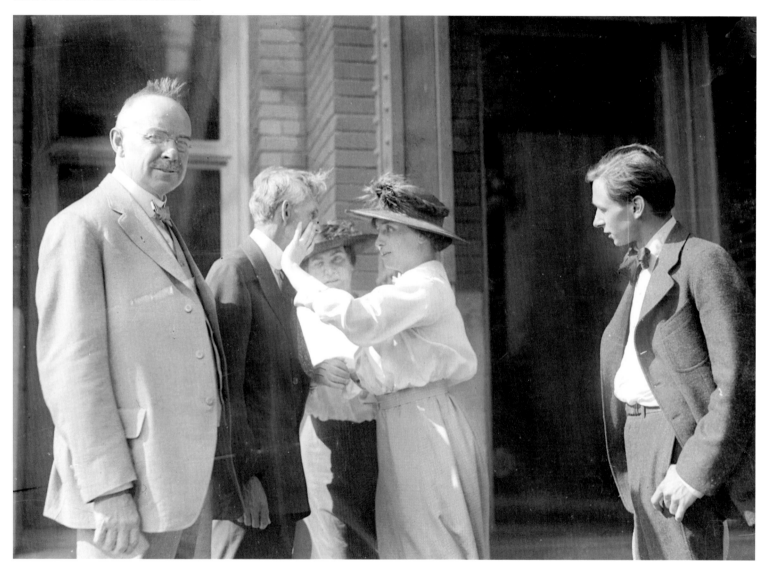

A view down Woodward. On the right is part of Wright and Kay
Jewelers and on the left is the Majestic Building (ca. 1905).

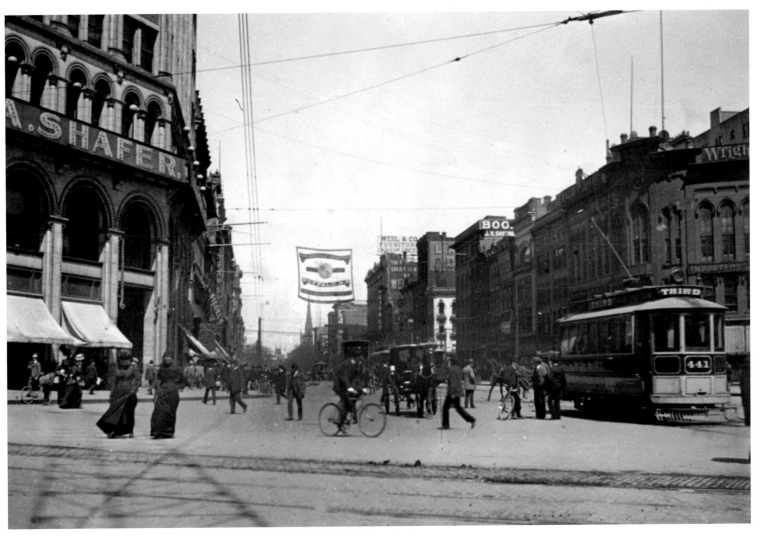

Automobile race at the Michigan State Fair Grounds (ca. 1915). The Michigan State Agricultural Society purchased the state fair grounds for one dollar on April 18, 1905, from department store owner Joseph L. Hudson.

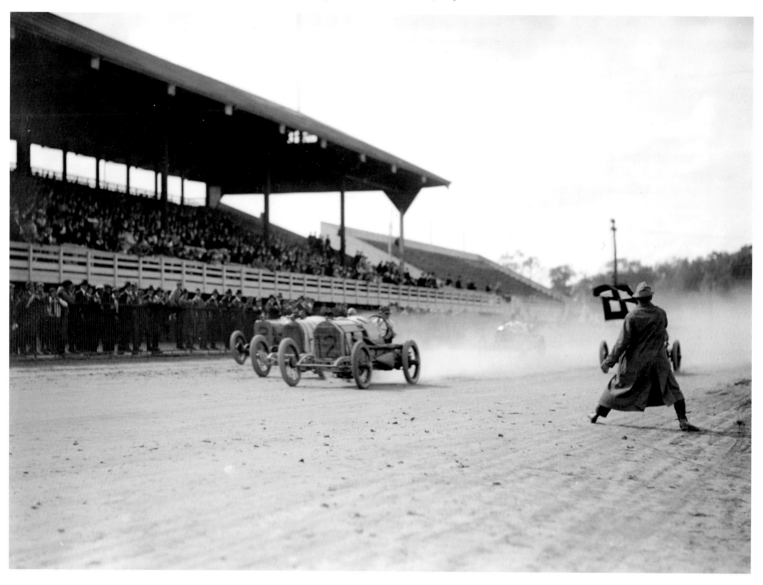

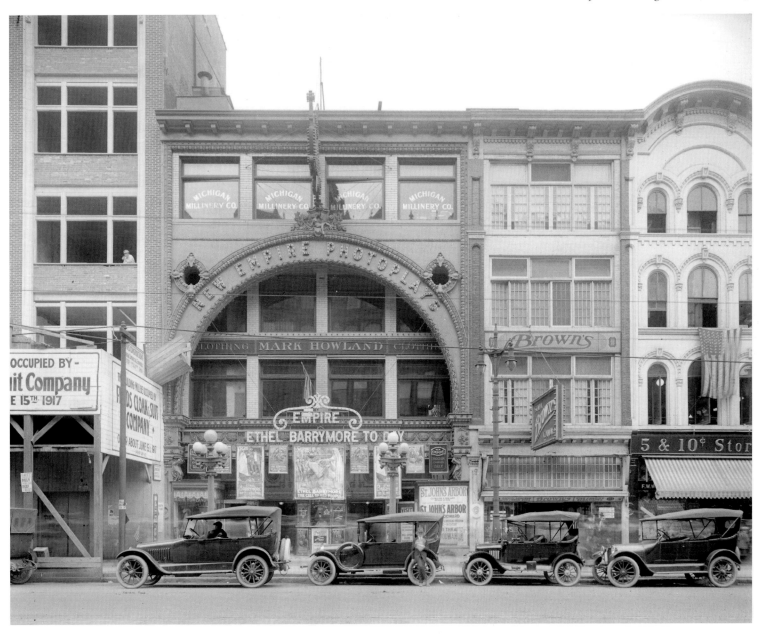

The Empire Theatre where Ethel Barrymore's film "The Call of Her People" was being shown (ca. 1917).

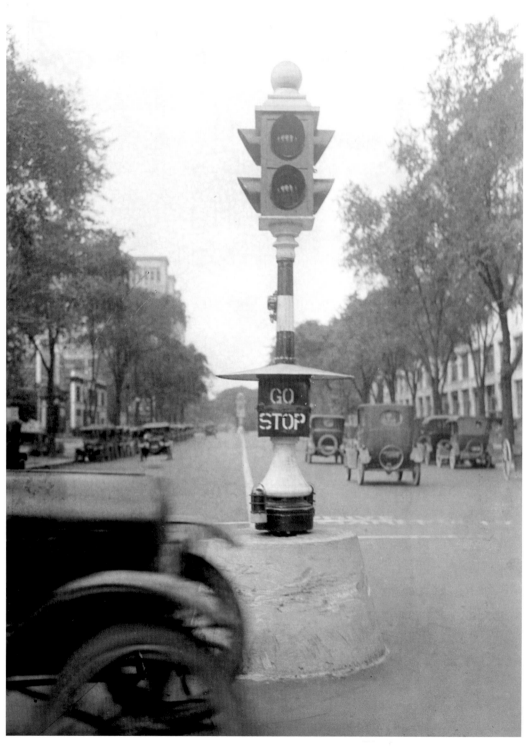

Traffic light at the intersection of Woodward and Grand Boulevard (ca. 1925). The General Motors building, designed by famous Detroit architect Albert Kahn and completed in 1922, is faintly visible in the background at left.

A woman walks down Woodward Avenue with her umbrella shading her from the summer sun (ca. 1910). Her dress is the epitome of Edwardian summer fashion with its light fabric, lace and embroidery, higher waistline, and narrow skirt.

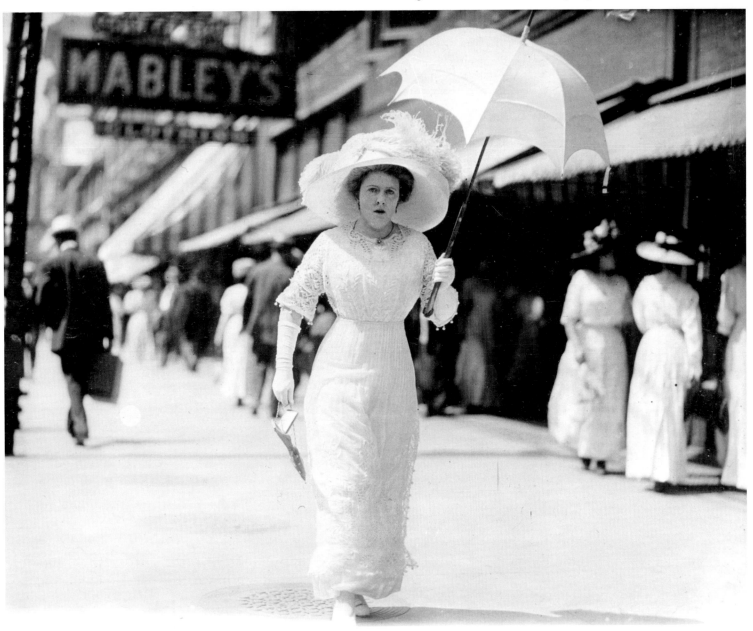

Former president Theodore Roosevelt takes part in a parade down
Woodward on a visit to Detroit (ca. 1910s).

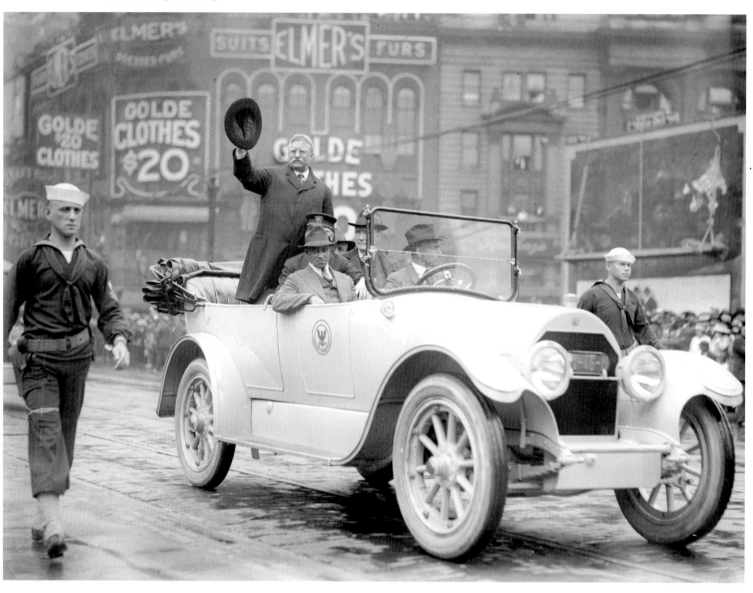

FROM SOARING SKYSCRAPERS TO STOCK MARKET CRASH

1920–1941

In the 1920s, Detroit was the place to be. It was the fourth most populous city in the nation. There were dance halls, theaters, museums, sports arenas, and, for an illegal drink, an estimated 25,000 speakeasies operating within the city by 1930.

Automobiles were king in Detroit, as the city produced most of the automobiles sold throughout the country. Walter Percy Chrysler formed the final member of the Big Three, Chrysler, in 1925.

New skyscrapers went up throughout the decade of the 1920s. The Penobscot Building opened in 1928; the Buhl Building opened in 1925; the Union Trust (Guardian) and the Fisher buildings both opened in 1929. Cultural institutions were getting new homes too. The Main Branch of the Detroit Public Library was completed in 1921 and the Detroit Institute of Arts opened its doors in 1927.

Detroit's hockey team, the Cougars (they became the Red Wings in 1932), started playing at the Windsor Border Cities Arena for the 1926-27 season. When Olympia Stadium was finished, the Cougars moved there for the 1927-28 season. The Detroit radio station WWJ began operating in 1920, and famous sports announcer Ty Tyson broadcast baseball for the first time over the airwaves in 1927.

Two important bridges were built in the 1920s. Enjoying Belle Isle got much easier when the Belle Isle Bridge was completed in 1923. Detroit boasted the longest suspension bridge in the world when the Ambassador Bridge, connecting Detroit to Windsor, Canada, opened on November 11, 1929.

The Stock Market crash of 1929 and the ensuing Great Depression had a devastating effect on Detroit and its citizens. When banks closed, many lost their savings. Jobs were lost when auto production fell. Evictions and bread lines were a common sight throughout the city in the 1930s. Some Detroiters benefited from federal relief programs like the W.P.A., finding jobs sewing, making bandages, or even digging up old street rails for scrap metal drives.

By the spring of 1936, Detroit gained the title "City of Champions" after the 1935 Tigers won the World Series, the 1935 Lions won the National Championship, and the 1935-36 Red Wings won the Stanley Cup.

Deteriorating employment conditions for those who were working opened the door for the labor unions. In 1937, the Detroit-based United Auto Workers (UAW) found success and gained contracts with Chrysler and General Motors. It would be 1941 before Ford recognized the UAW.

The intersection of Woodward and
State Street (ca. 1920s)

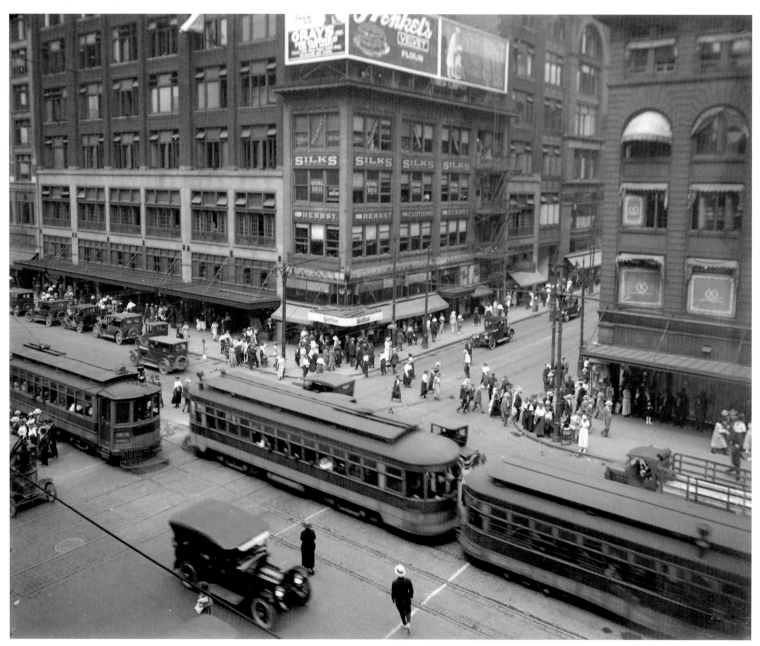

Elephants wearing baseball get-ups put on a show for the crowd of spectators who have gathered at Campus Martius in front of the Majestic Building (ca. 1920s).

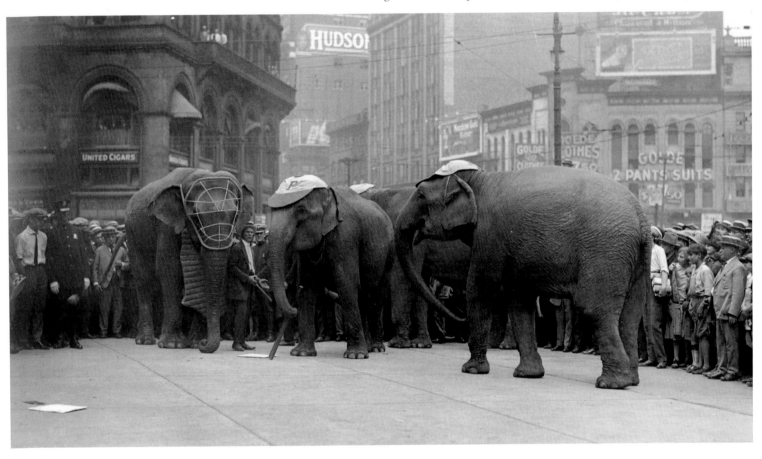

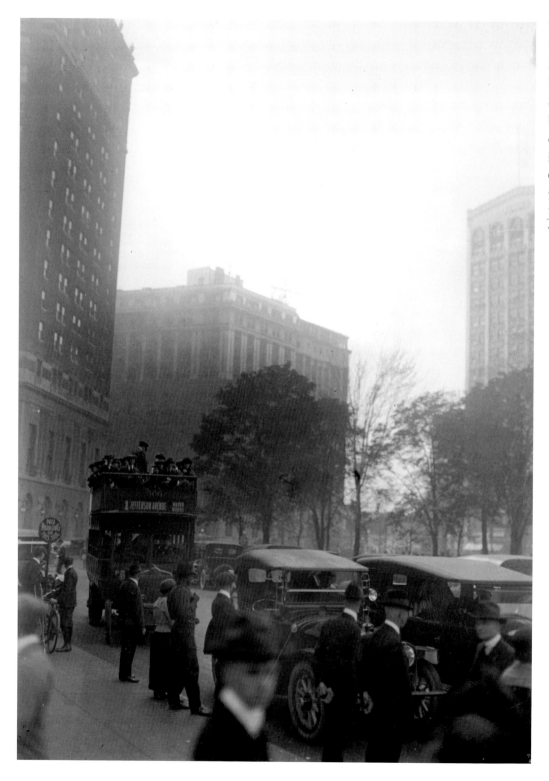

Traffic at Grand Circus Park (ca. the late 1920s). The building at left is the Statler-Hilton Hotel built in 1914. The double-decker bus is Detroit Motorbus Company number 506, headed down Jefferson Avenue for Water Works Park.

The 119th Field Artillery unit from World
War I parades down Woodward (ca. 1918).

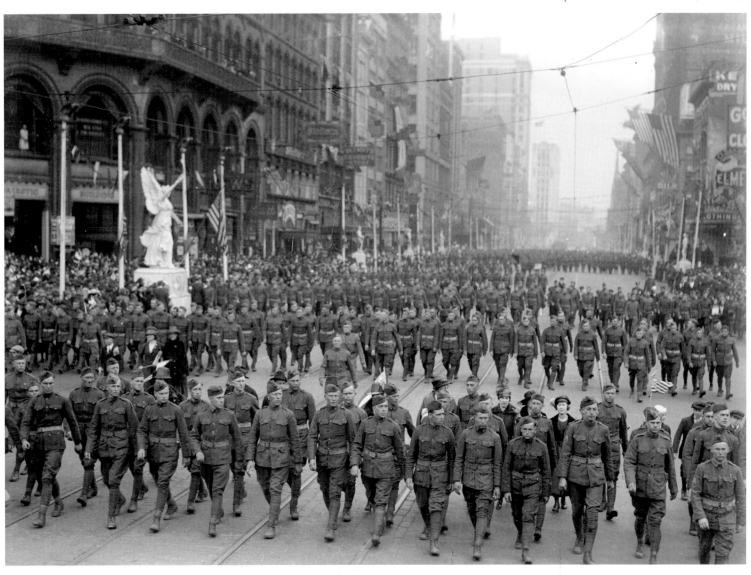

Detroiters show their patriotism in an
Armistice Day parade, November 11, 1918.

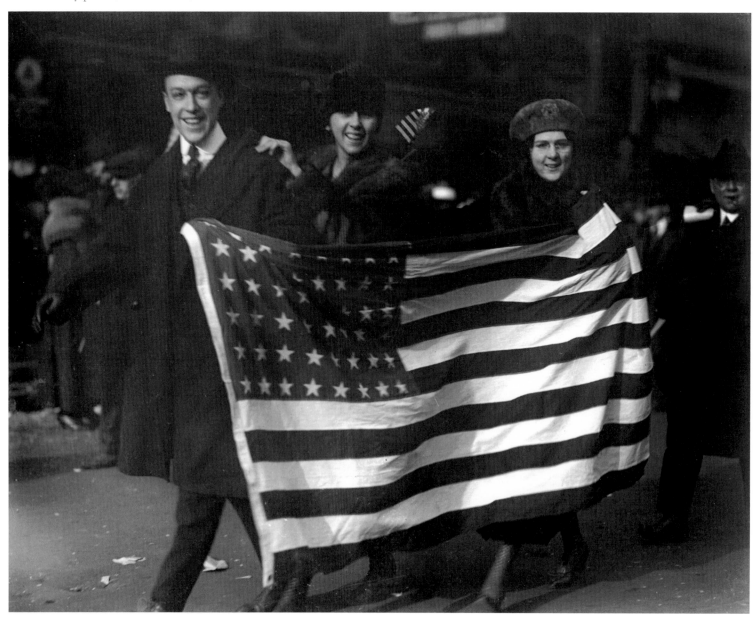

Woodward was not the only busy thoroughfare in Detroit. This photo shows
the crowded intersection of Michigan and Cass avenues. (ca. 1920s)

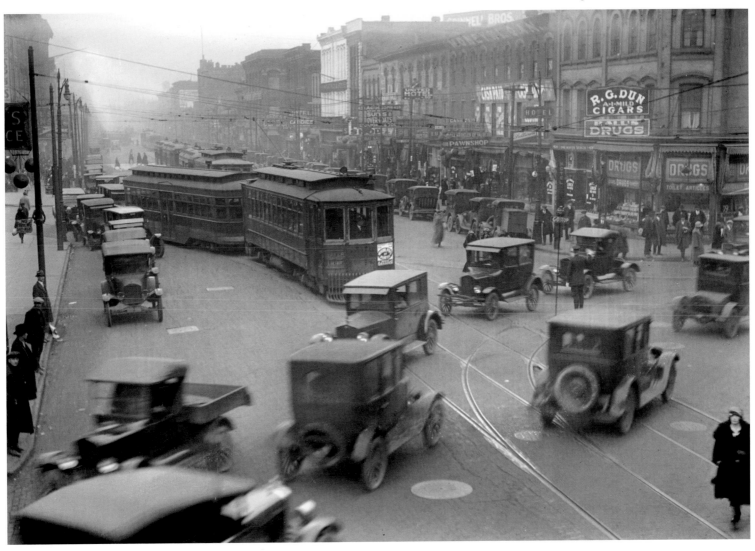

A rare wintertime photograph of Campus Martius. The Dime Building,
built in 1910, is in the far background behind City Hall.

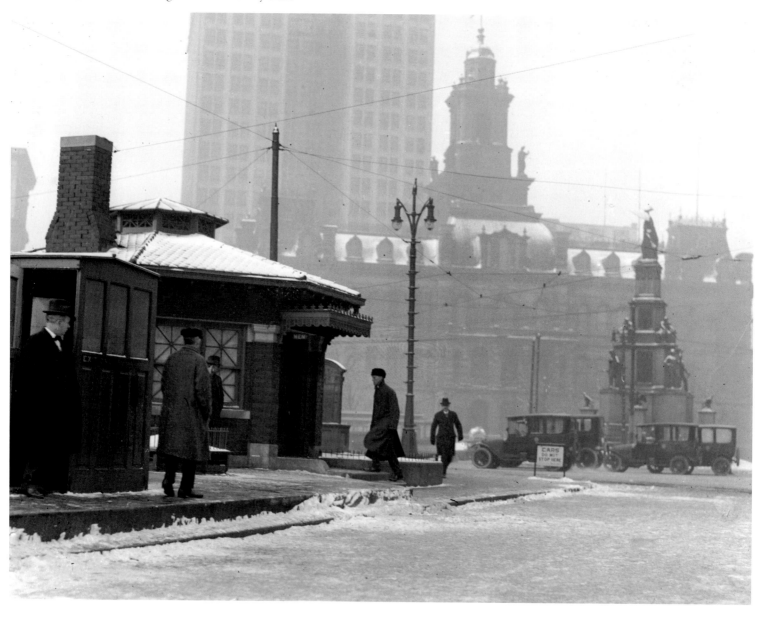

Randolph Street at Gratiot (ca. 1920s). At upper-right is a "crows nest" traffic-signal tower, manned by a Detroit police officer.

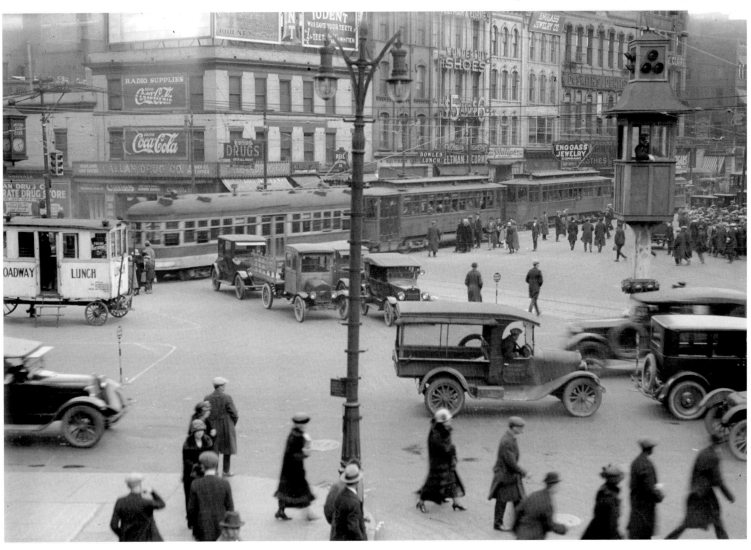

Michigan Avenue at Woodward
(ca. 1920s). Another "crows nest"
traffic-signal tower is visible in the
background.

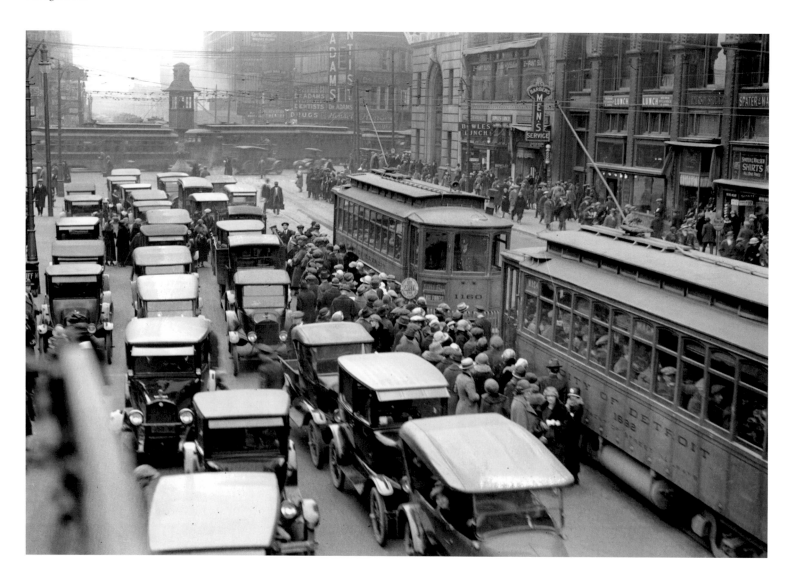

Griswold at Fort Street at night (ca. 1920s). The Dime Building, built in 1910, is the tall building in the background.

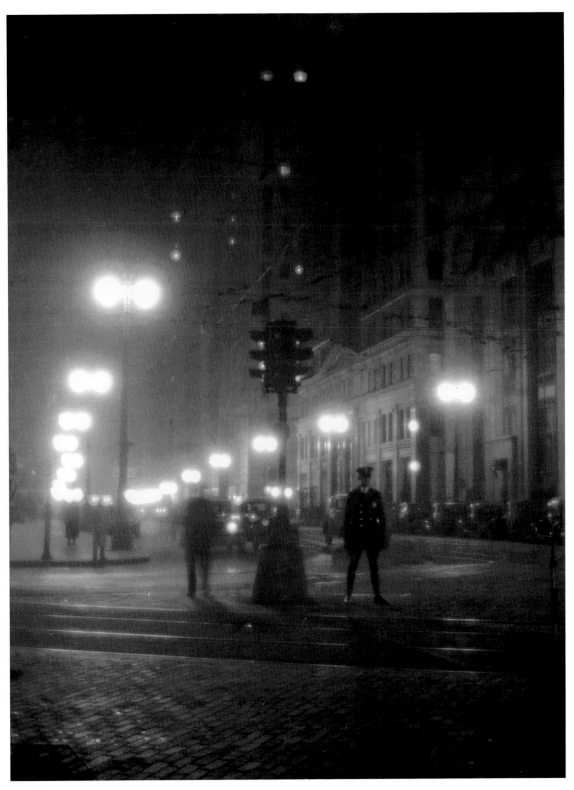

Woodward Avenue (ca. 1920s). The tall buildings in the background are all a part of
the First National Building, built in 1922. The shorter one in front of the cluster is the
Vinton Building, which was built in 1917. DSR streetcar 3043 and the Detroit Motorbus
Company's double-deck bus are headed south to Jefferson Avenue. (ca. 1928)

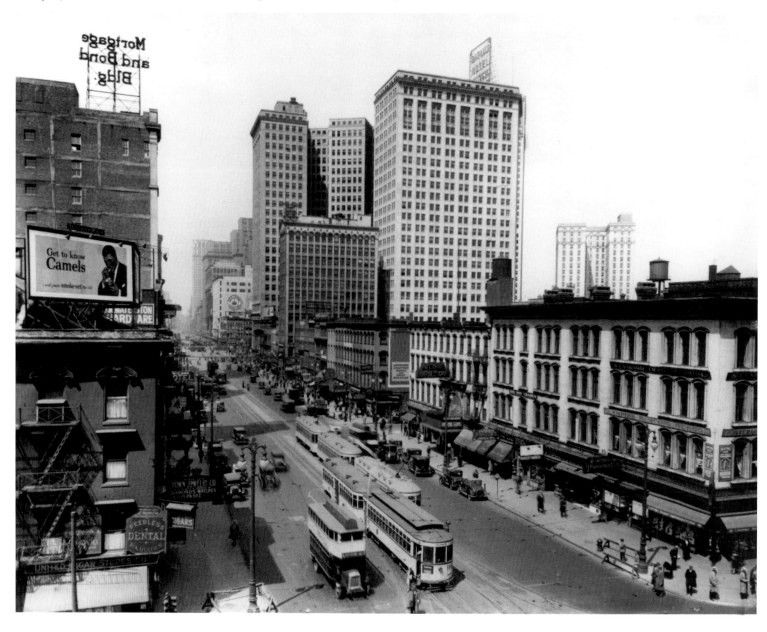

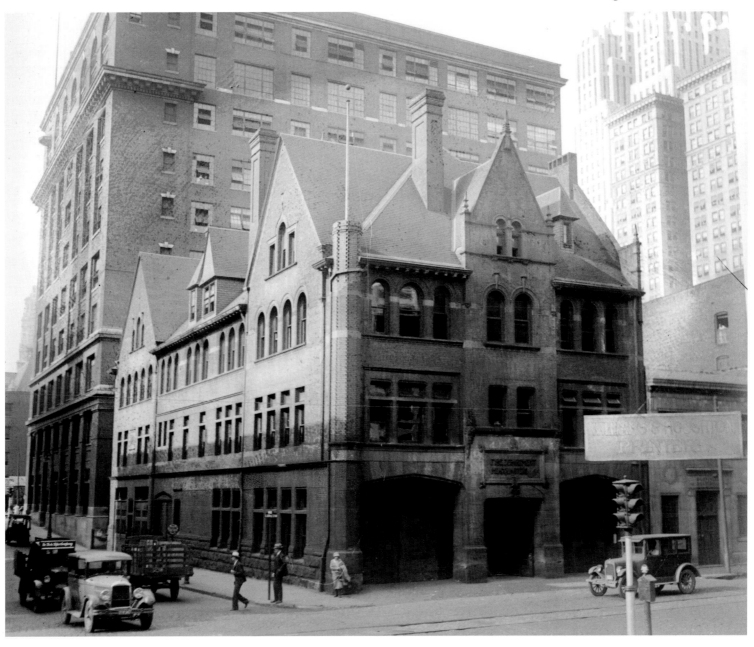

Fire Department Building on Lafayette (ca. 1928). Williams and Houghton Printers is next door.

A snowstorm sideswipes downtown, January 1927.

"Crows nest" traffic light at the corner of Grand Boulevard and
Woodward (ca. 1925). It doesn't look like the traffic light is doing its job
of organizing traffic.

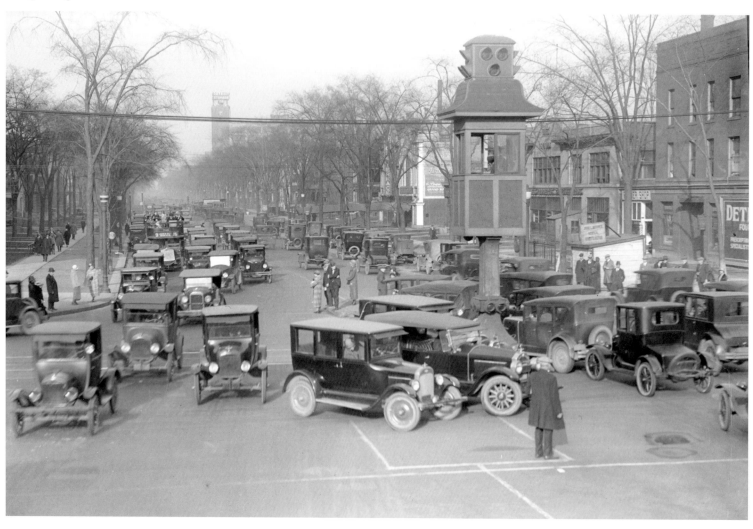

An October rainfall flooded city streets in 1925.

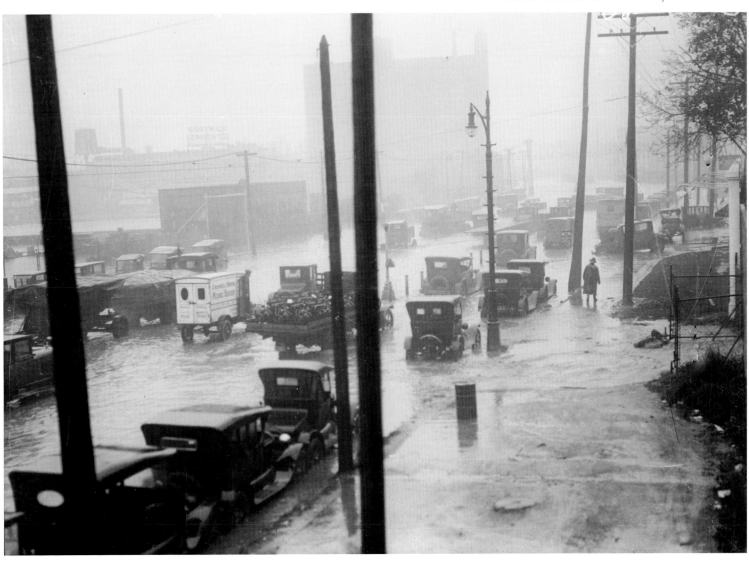

Detroit children wade through a flooded Jefferson Avenue during heavy
rainfall (ca. October 1925).

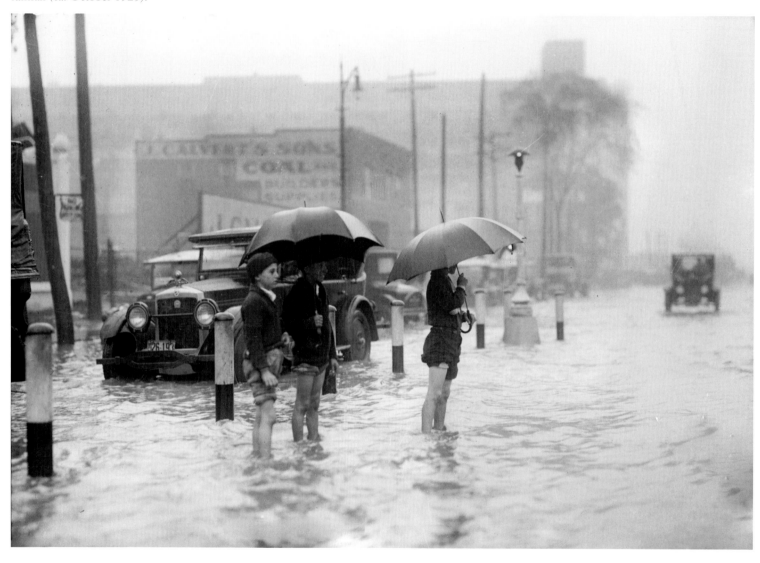

Boys hitch a ride to get down a flooded Grand Boulevard near Hamtramck.

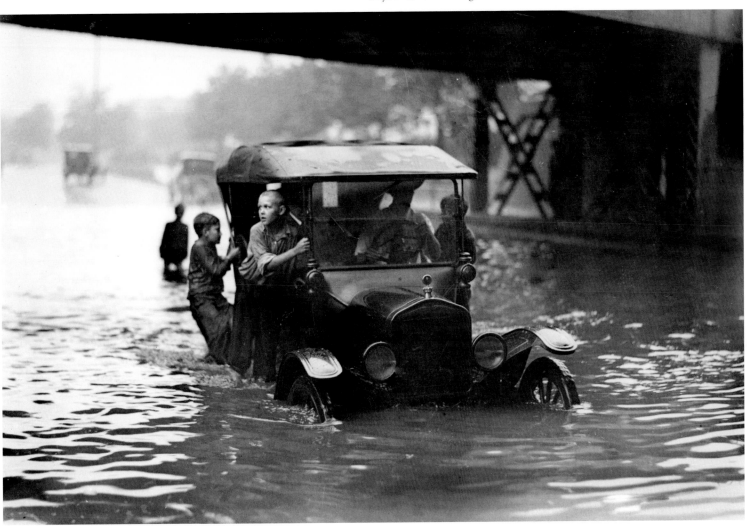

This old police headquarters building fit snugly on the triangular plot of land between Randolph, Bates, and Farmer streets (ca. 1920s). In the background is the D. M. Ferry and Company, Dexter Mason Ferry's seed-producing business that achieved world dominance in seed production in the late nineteenth and early twentieth centuries.

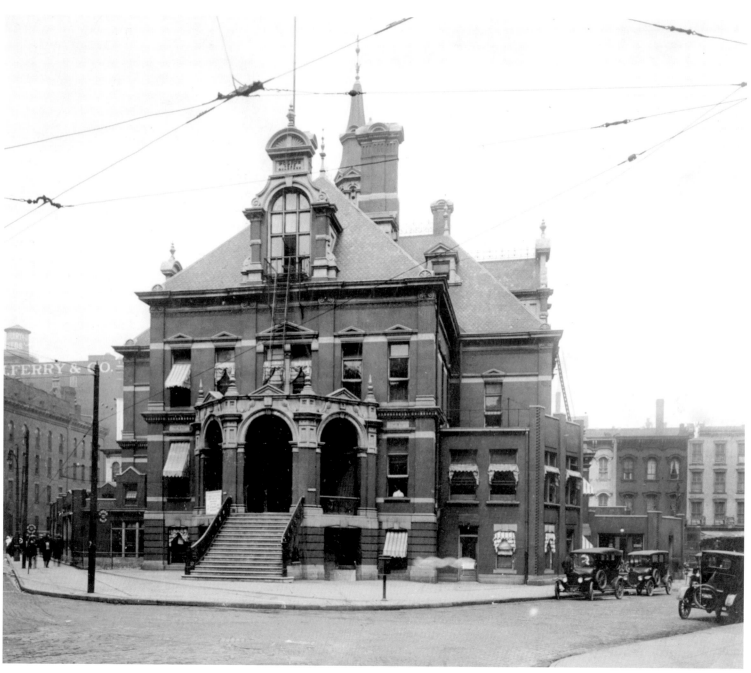

Dr. McArthur's dentistry sign on his building at the corner of Woodward Avenue and Clifford Street is quite toothsome. (ca. 1920s)

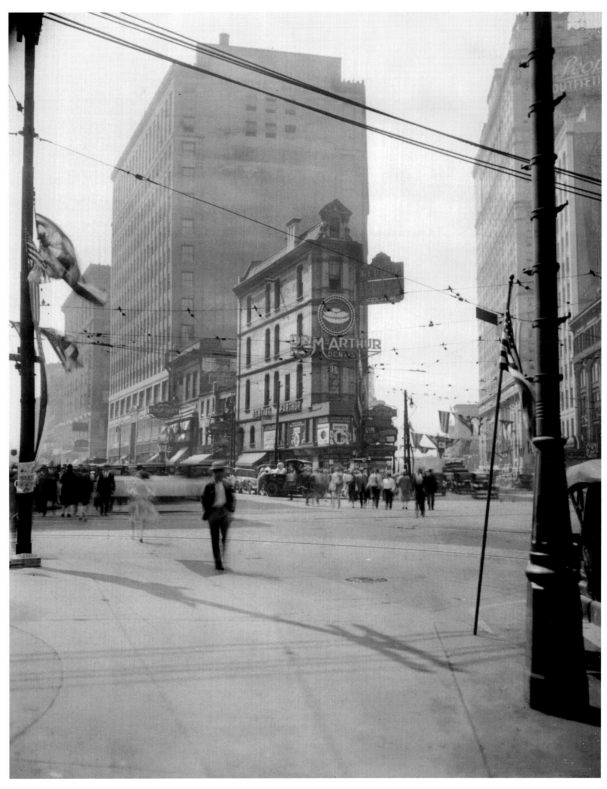

In 1927, Henry Ford and his son Edsel sit in the fifteen-millionth Model
T produced. That year also marked the end of Ford Motor Company's
production of the Model T.

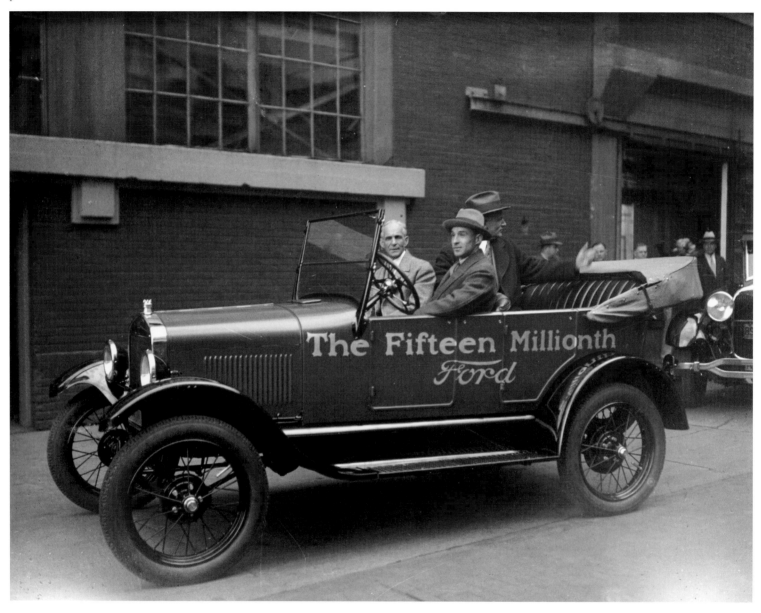

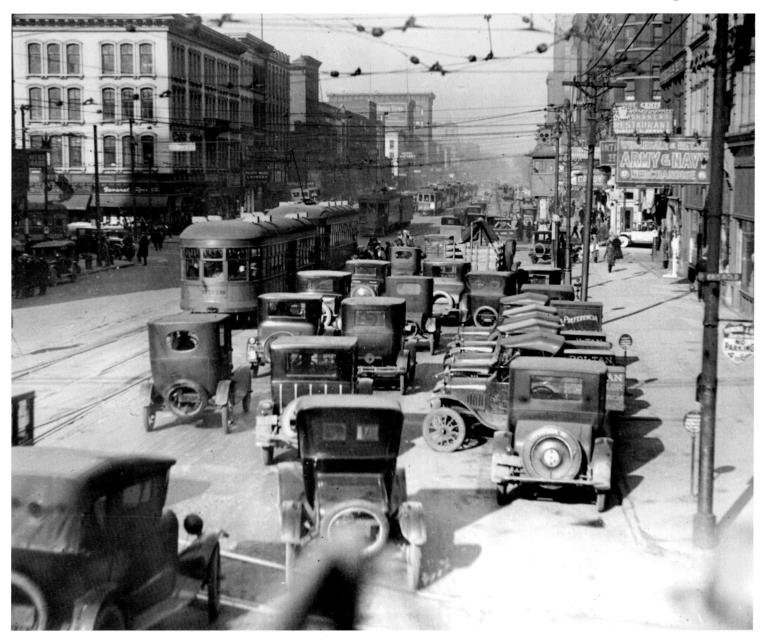

Jefferson Avenue at Woodward,
looking east (ca. 1924)

In August of 1927, Charles Lindbergh returned to his birthplace, Detroit, to join a parade in his honor commemorating his solo flight from New York to Paris in May of that year. His mother, a Detroit schoolteacher, rode in the car with Lindbergh, who was the nation's most eligible bachelor at the time.

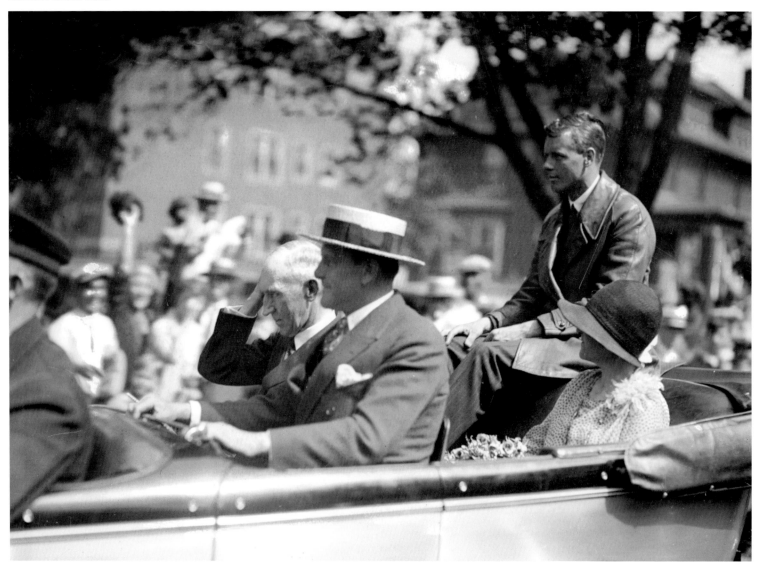

The General Motors Building on Grand Boulevard (ca. 1930). It was originally named the Durant Building after the founder of General Motors. When it was finished in 1922, it was the second largest office building in the world.

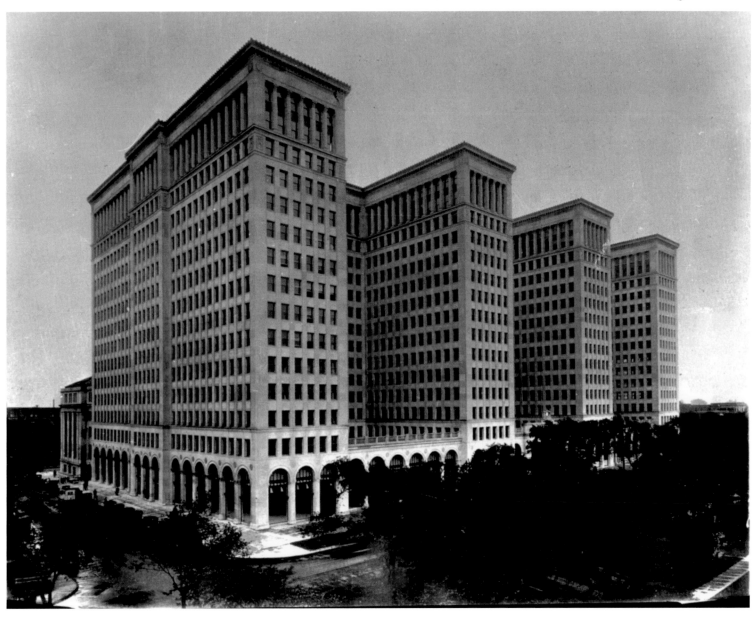

These last-minute downtown Christmas shoppers show off the fashions of the day in 1928. They are wearing cloche hats with fur-trimmed or fur coats. Hems have crept up to the knee and beyond. The woman in the middle is wearing trendy T-bar shoes.

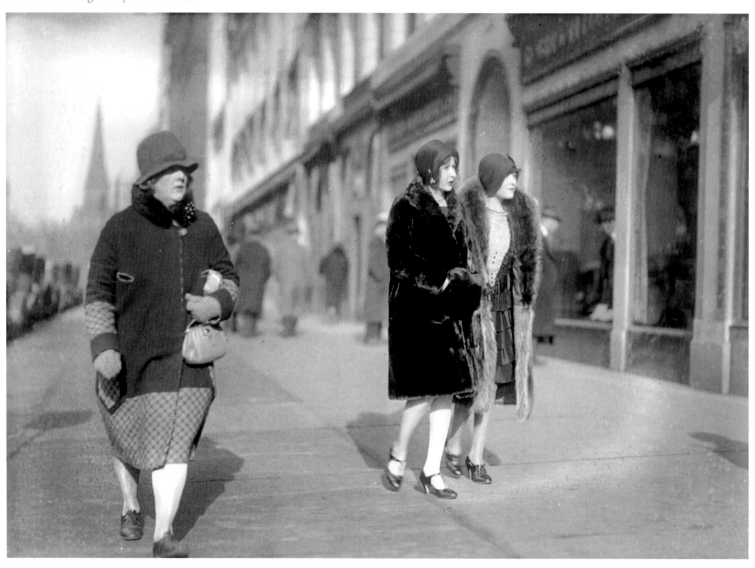

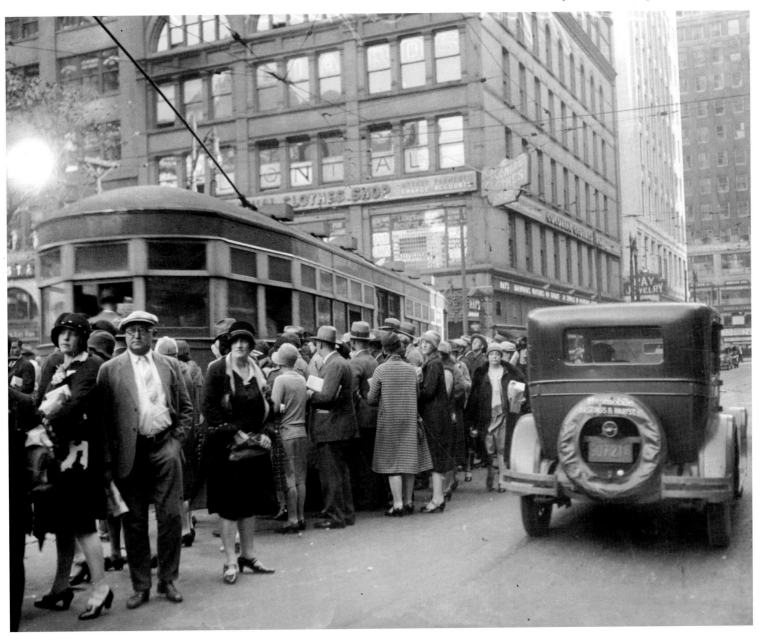

Crowds wait for the streetcar at the
Capitol Park loading station. (ca. 1920s)

A November snow makes walking difficult, so this woman and her
child decide to use one of the new Dodge Graham–built Detroit buses.
(November 28, 1928)

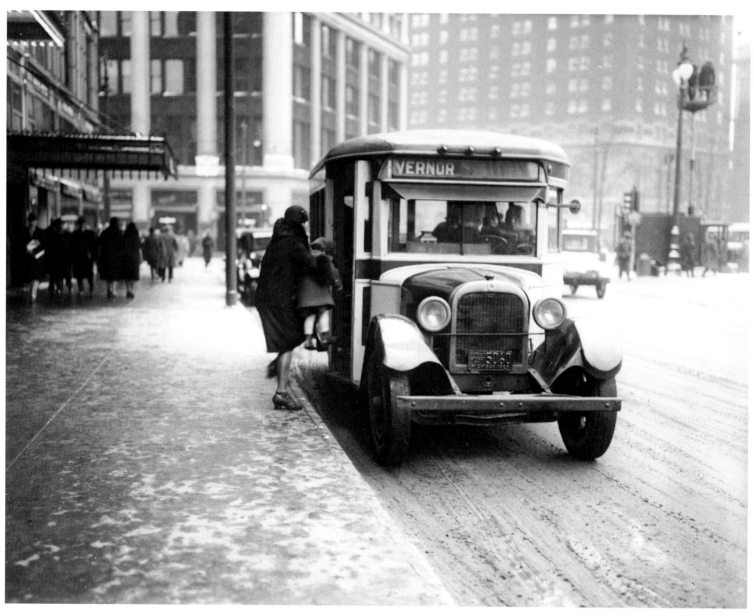

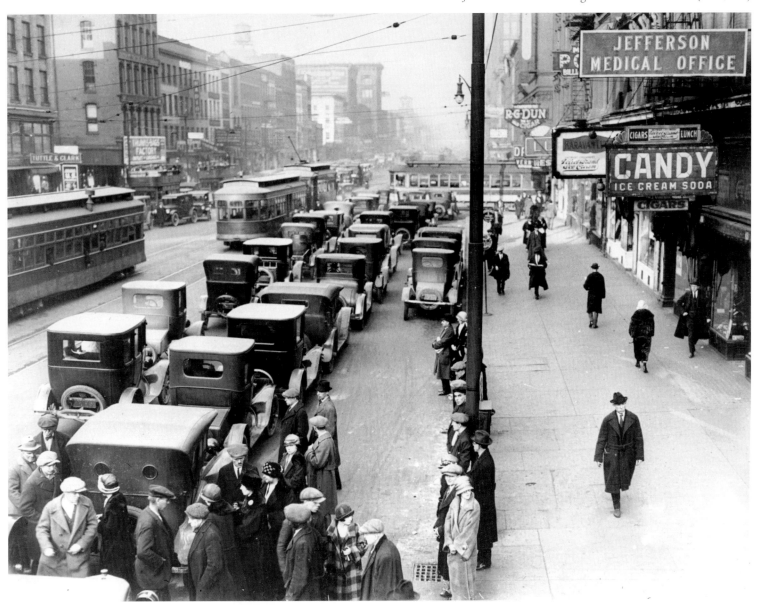

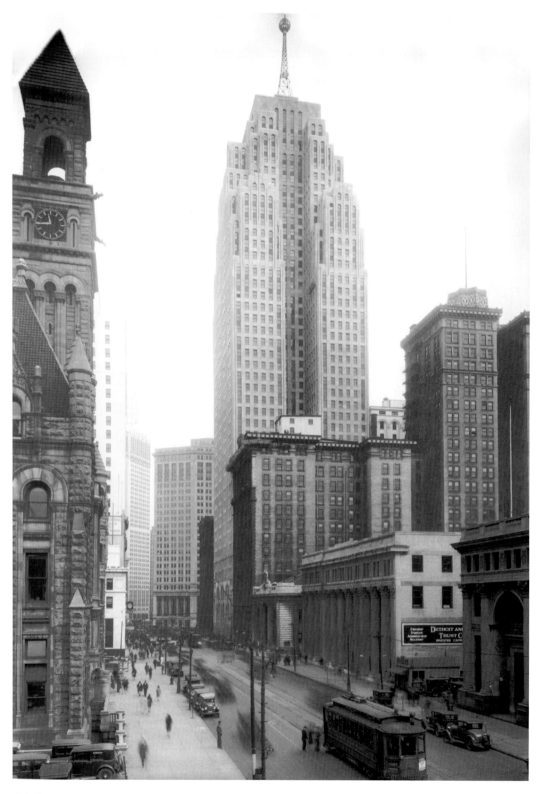

Looking down Griswold Street at the Penobscot Building, October 22, 1928. At left is the old Federal Building, demolished in 1934.

Ice fountain at Washington Boulevard and Michigan, February 1927. The water was allowed to run all winter creating the enormous heap of ice. The statue at right is that of General Alexander Macomb, a War of 1812 hero who eventually became commanding general of the Army of the United States. He was also a member of the wealthy family that owned Grosse Ile and most of the land that is now Macomb County.

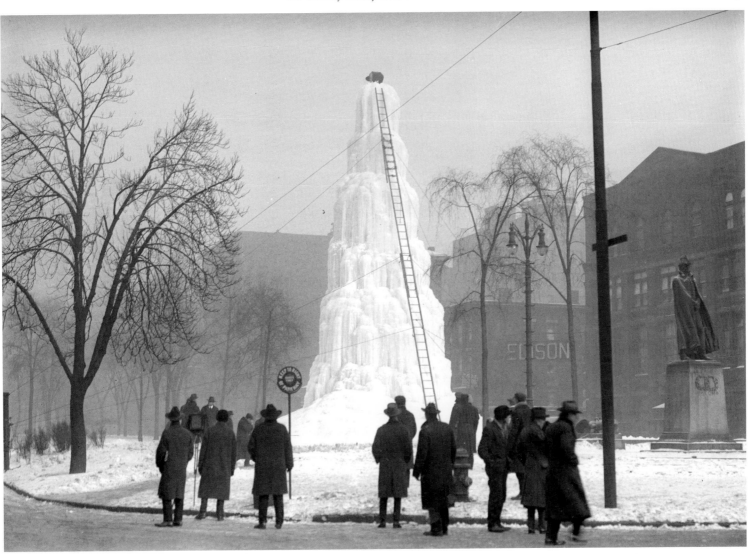

Men building the Penobscot Building (ca. 1927). Faintly visible in the background at right is the 36-story Book Tower, completed in 1926.

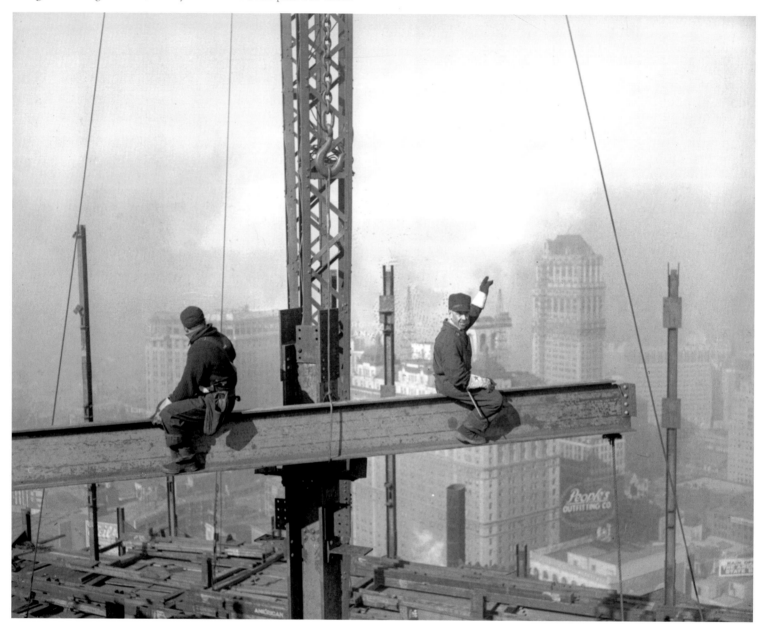

Spanish American War veterans take part in a parade down
Woodward in August 1927.

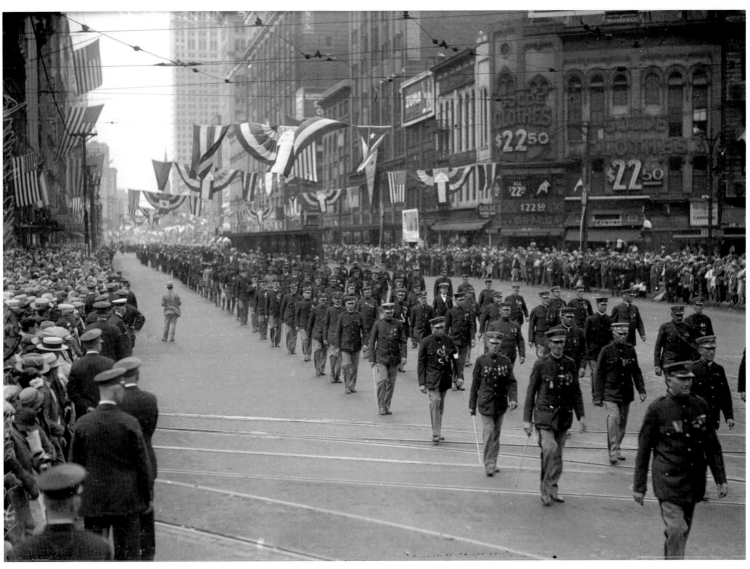

Race cars come around the corner, heading for the straightaway, at the state fair grounds racetrack in June 1929. Race fans could get very close to the action, with greater risk to life and limb.

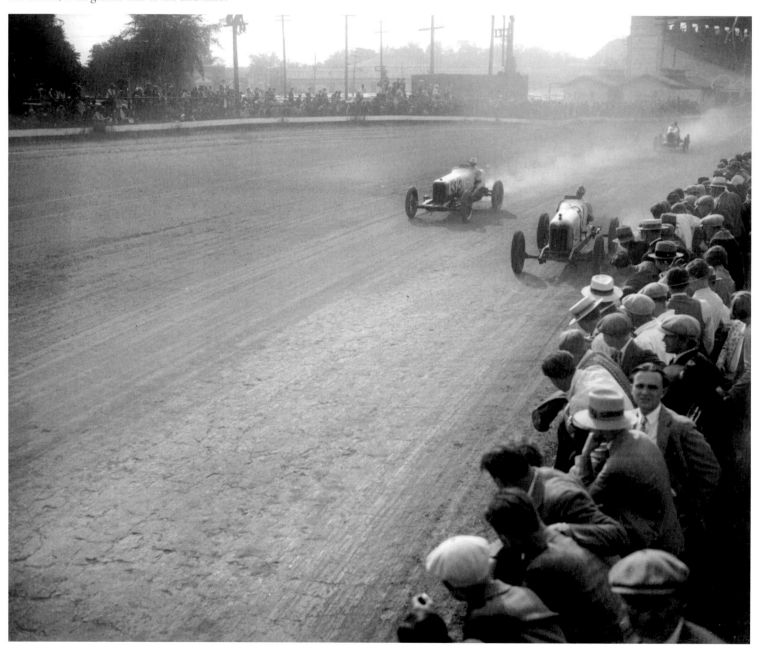

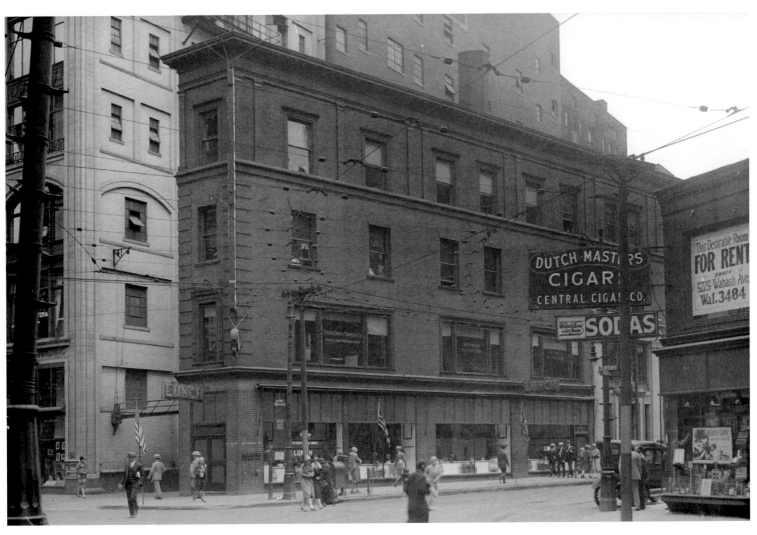

Crowds gather for the opening of the Ambassador Bridge (November 11, 1929). Connecting Detroit to Windsor, Canada, the bridge at that time was the longest suspension bridge in the world.

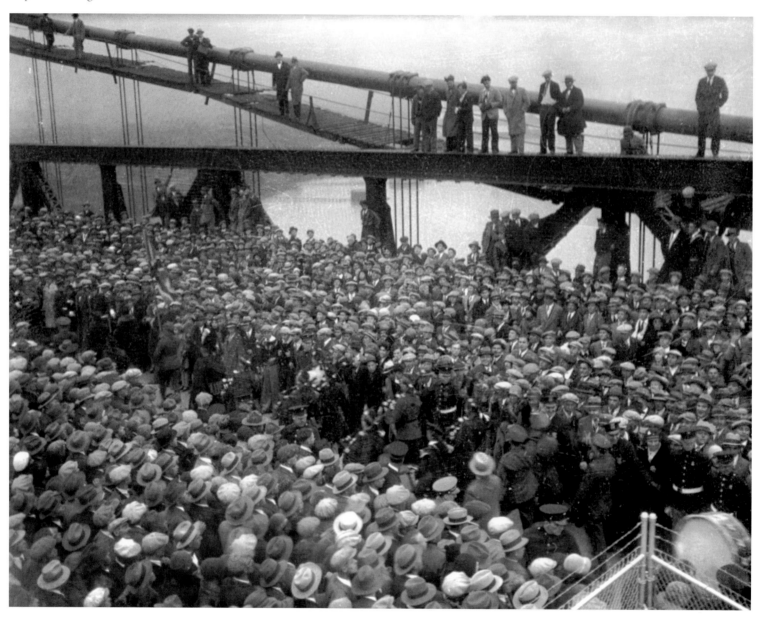

Detroiters wait in long lines to take a drive across the Ambassador Bridge on its first day open, November 1929.

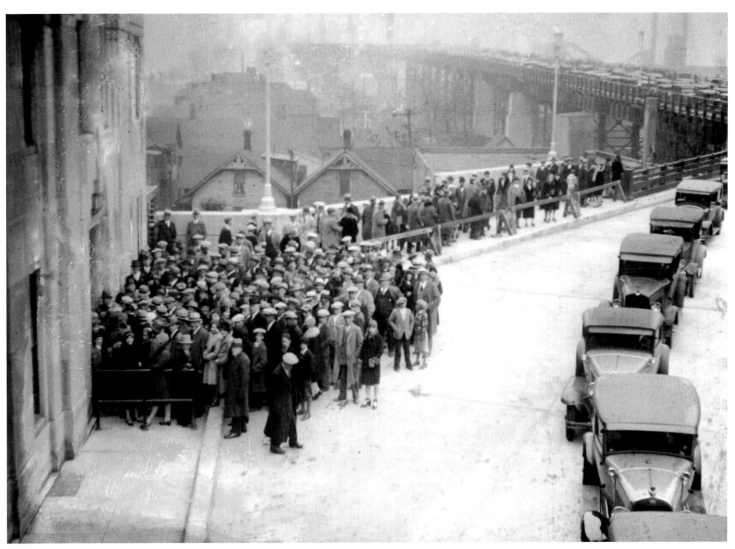

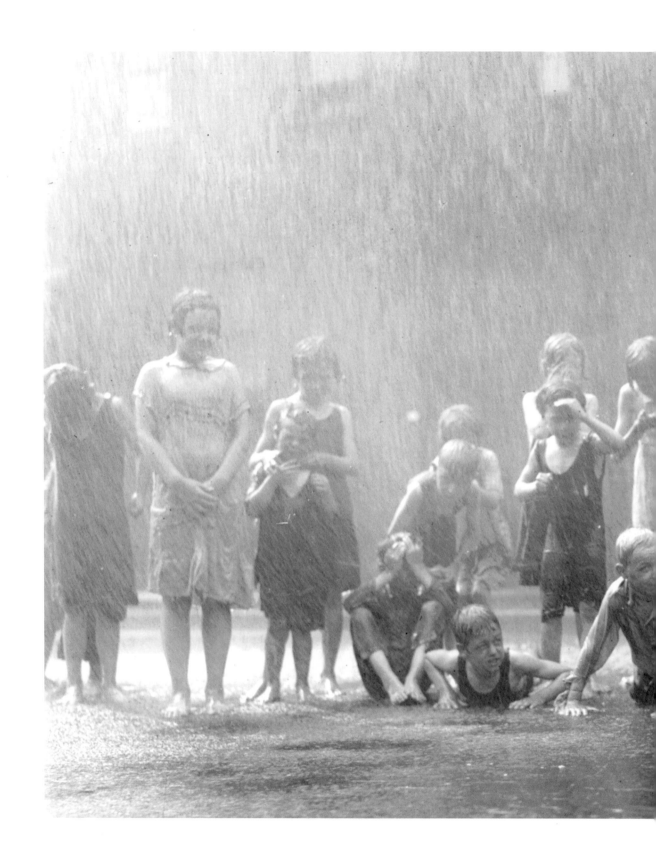

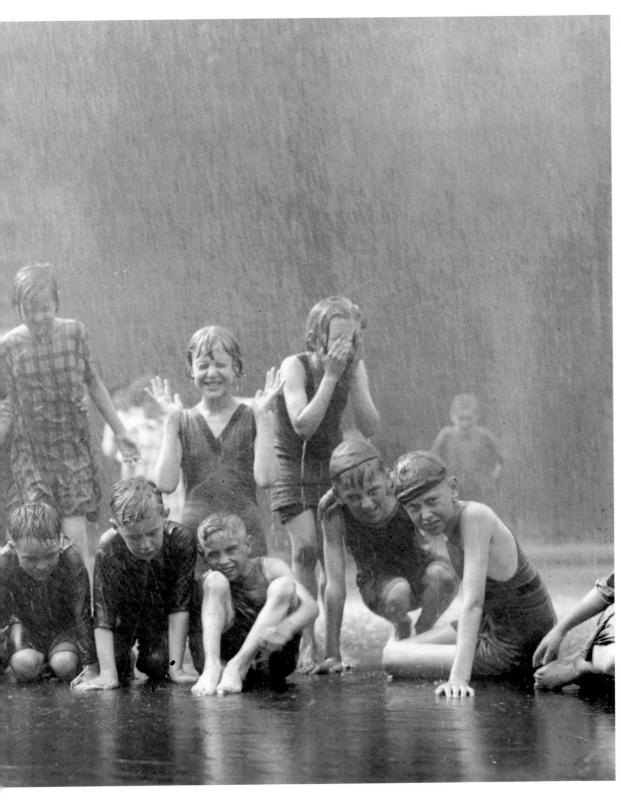

Children cool off in a Detroit street, perhaps by way of an opened fire hydrant, while posing for the camera.

President Herbert Hoover visits Detroit ca. 1920s. He is using the
Magnavox Loudspeaker, invented in 1915, to speak to the crowd gathered
downtown.

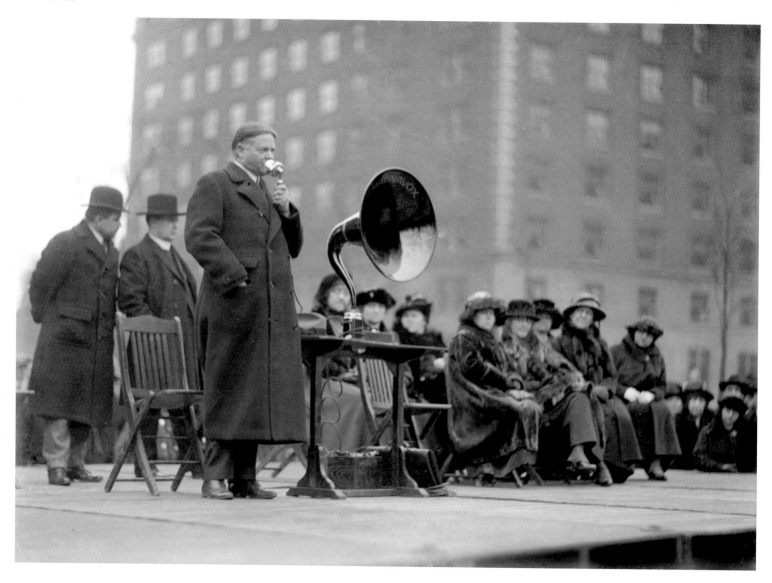

An aerial photograph of the Ford Highland Park Plant in 1929. Home of the Model T, Highland Park was where Henry Ford first began to build his cars using an assembly line.

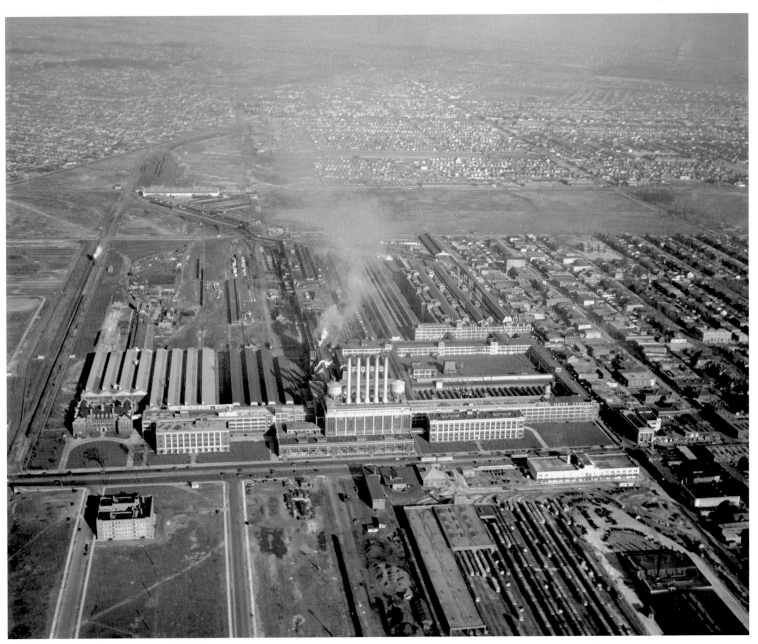

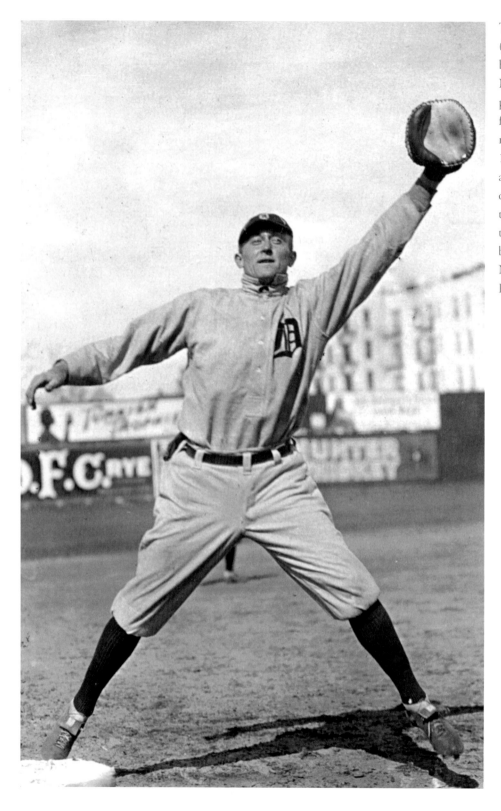

Tiger outfielder Tyrus (Ty) Cobb reaches for a ball during practice at Navin Field. Ty Cobb played for the Tigers from 1905 to 1926 and managed them from 1921 to 1926. He had a career batting average of 367, won 12 batting titles, and was one of the first five players to be nominated to the National Baseball Hall of Fame in 1936.

Eager Detroiters step into a new Detroit Street Railway (DSR) bus on its way to Chicago, ca. 1925.

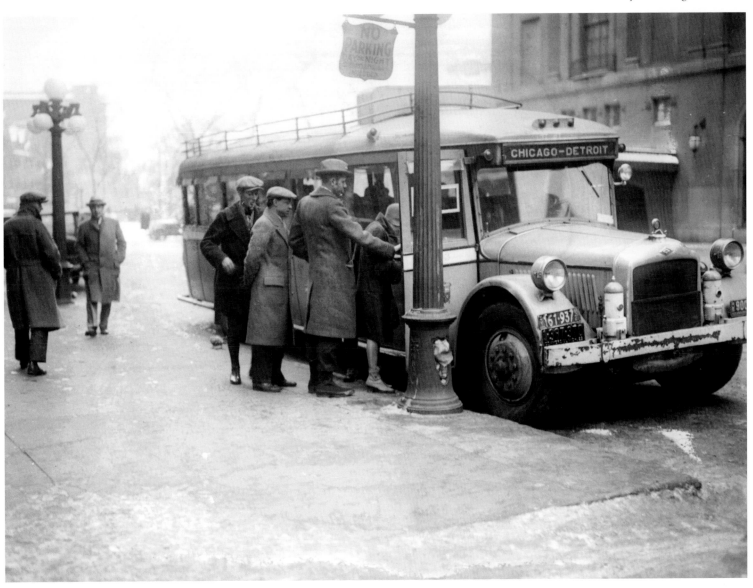

Men in immigrant neighborhoods form a line in the street for
vaccinations. (ca. 1920s)

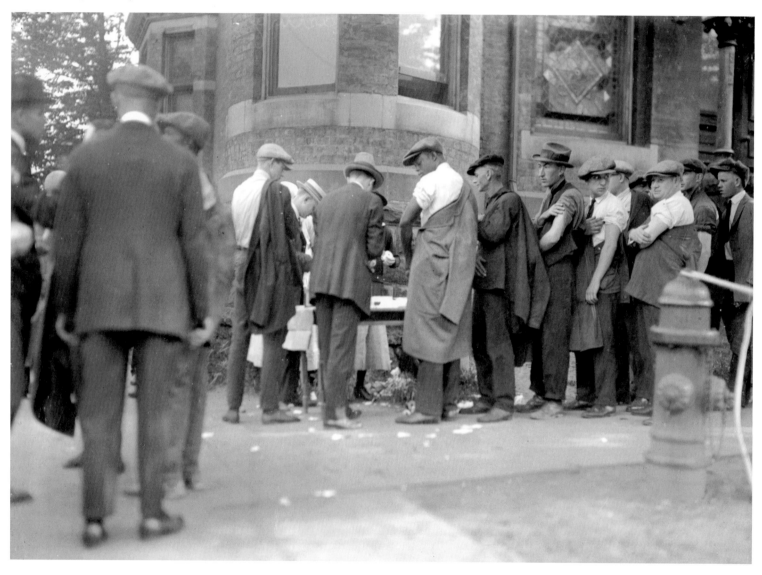

A DSR conductor shakes the hand of local politician John C. Nagel on the opening day of the Michigan Avenue–Dearborn extension line. (October 1929)

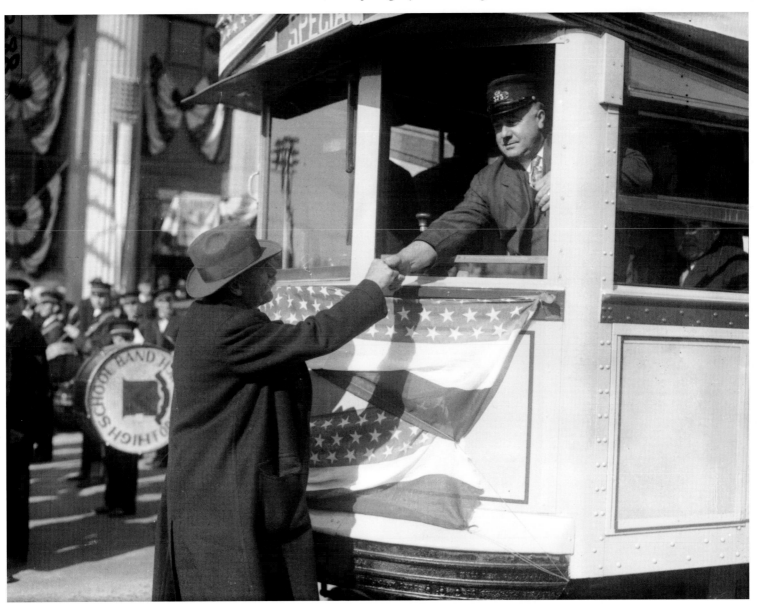

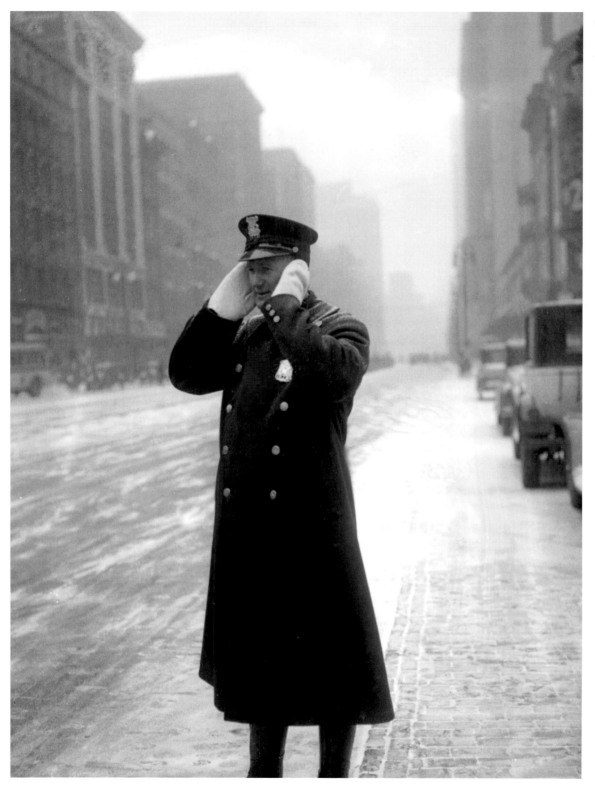

A Detroit police officer tries to warm up his ears while on duty downtown, January 1929.

A view down Congress Street with the Wayne County and Home Savings Bank on the right and a binding and printing company on the left (ca. 1920s).

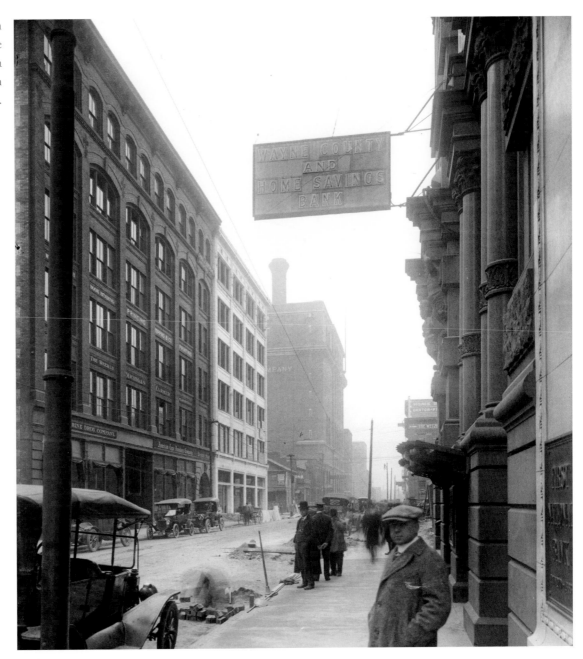

The 1930 Auto Show that took place in the Convention Hall near Woodward and Warren, a building financed by the wealthy Grindley family and completed in 1924.

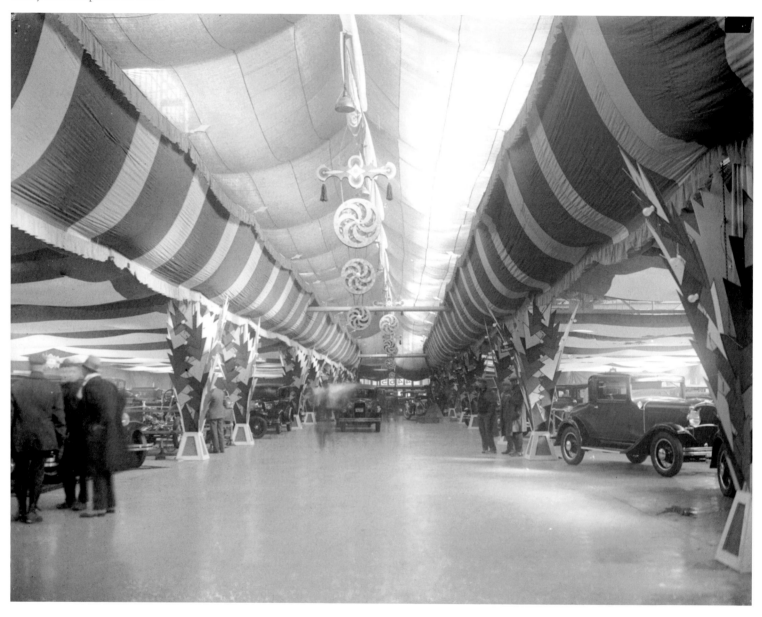

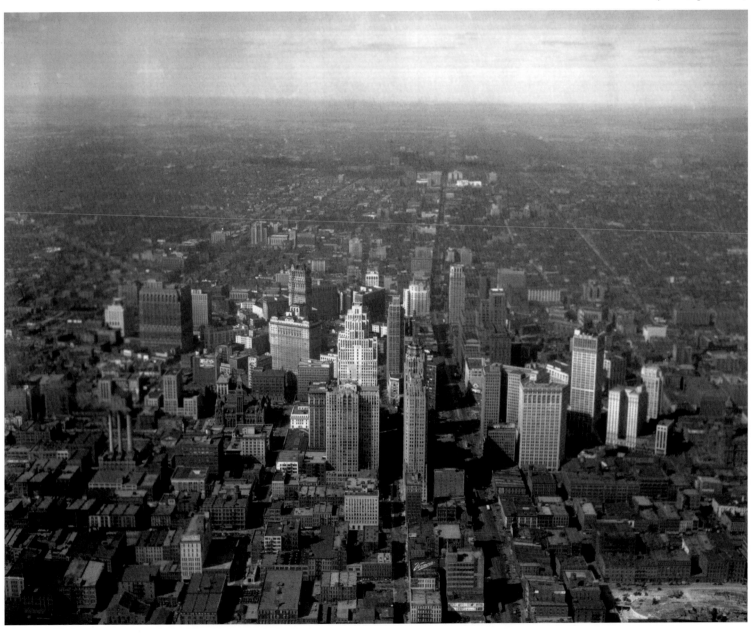

Aerial photograph of Detroit's exciting
new skyline (April 1930)

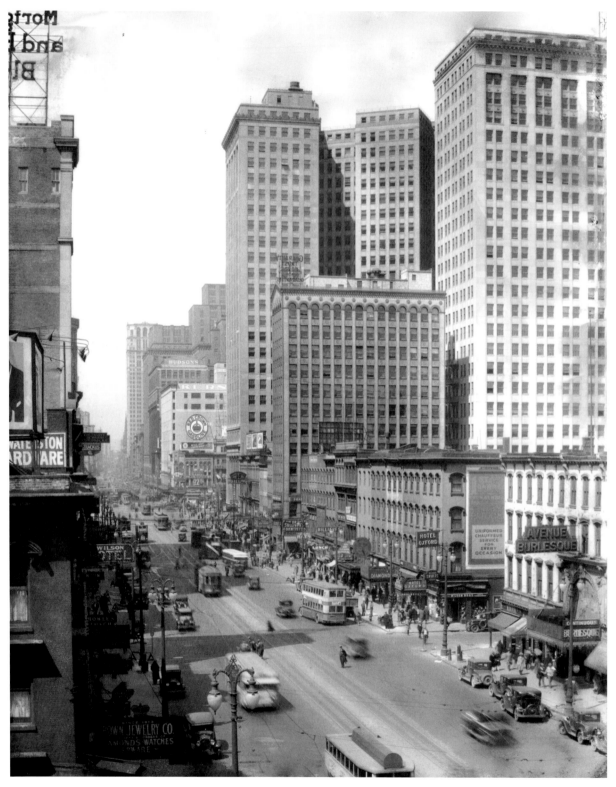

Woodward Avenue looking north from Jefferson Avenue. In the middle is Albert Kahn's 12-story Vinton Building, built in 1917, and the taller one behind it is Kahn's First National Building, built in 1922.

The Depression hit Detroit hard with close to 20 percent of Detroit's work force out of a job. In this image, the unemployed demonstrate at Campus Martius, near Monroe Street, to show their frustration (March 1930).

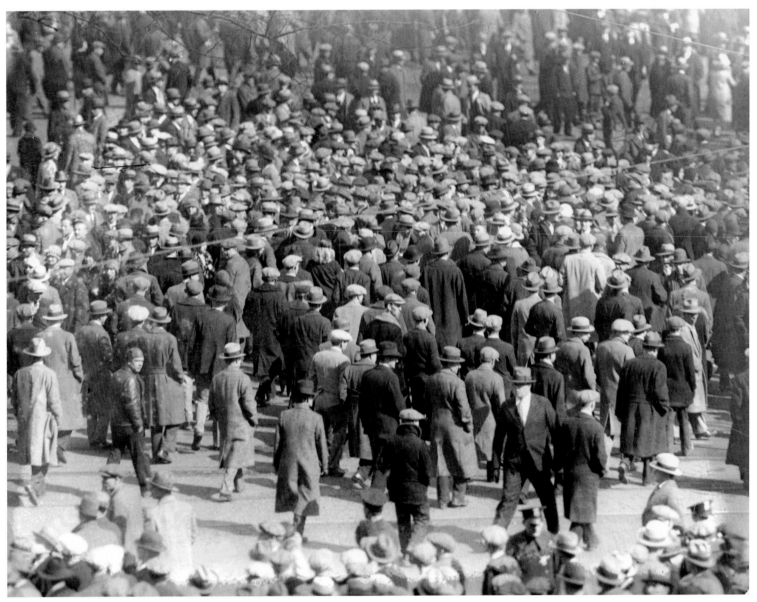

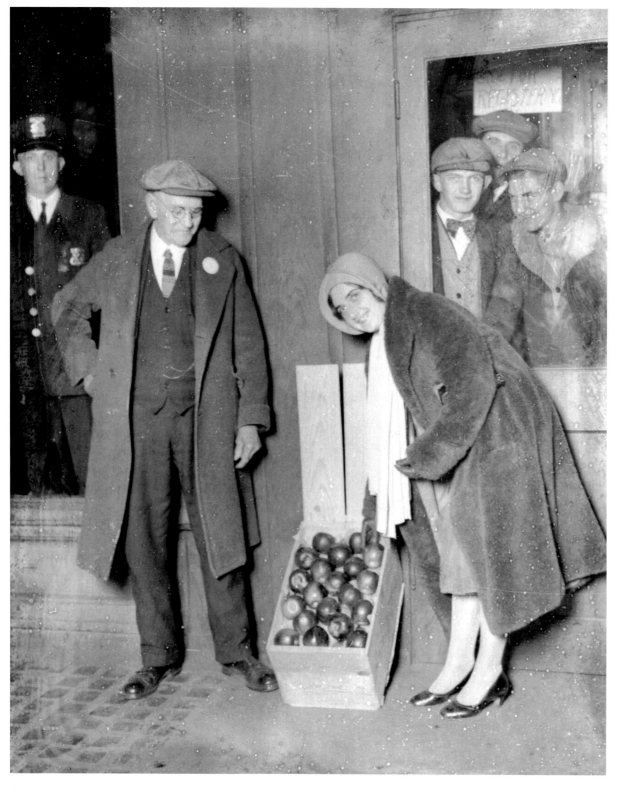

A woman in a mink coat and her companion buy an apple from one of the many apple vendors selling their goods (for about 5 cents each) to earn a living during the Depression (ca. 1930).

Crowds of unemployed men begin to demonstrate in front of the Wayne County Building to show their frustration at the lack of jobs (March 1930).

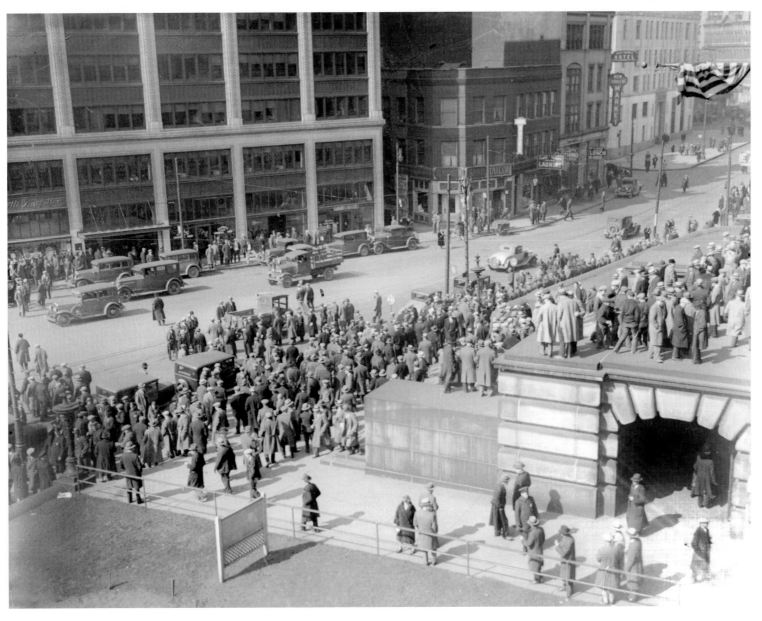

Washington Boulevard north of Michigan Avenue. The Boulevard is decorated for Christmas 1930. Completed that year was St. Aloysius Parish Church, the white building on the right side of the street sandwiched between two taller ones.

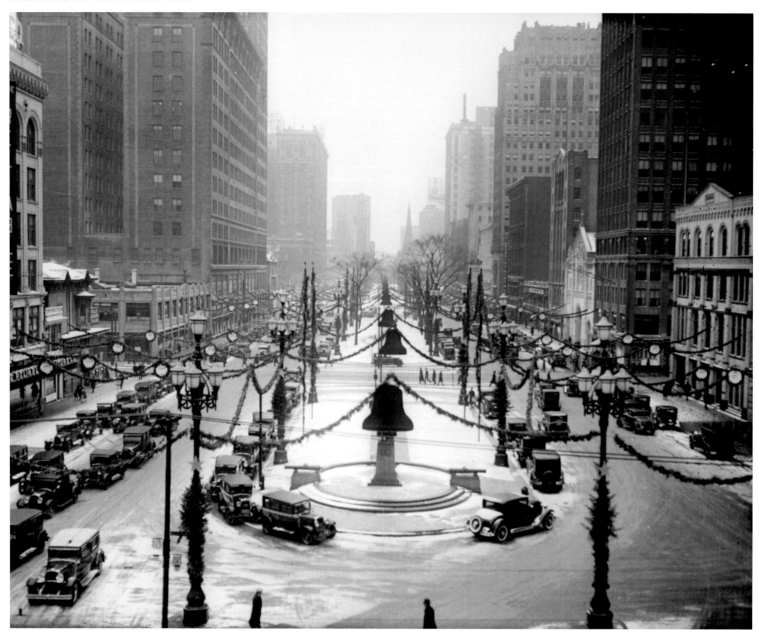

The Fort Street entrance of the old Federal Building, December 1930. A new Federal Building was built on Lafayette and dedicated in June 1934. This one was demolished in 1932.

A very busy Woodward Avenue at
Clifford Street in the fall of 1930.

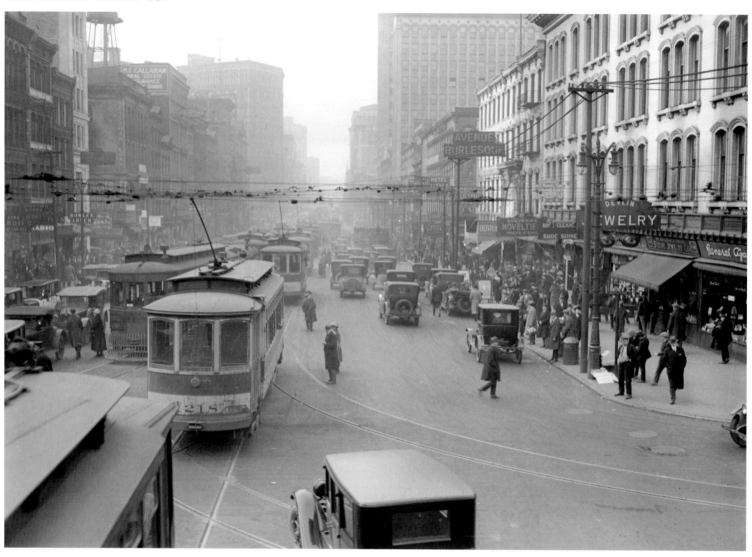

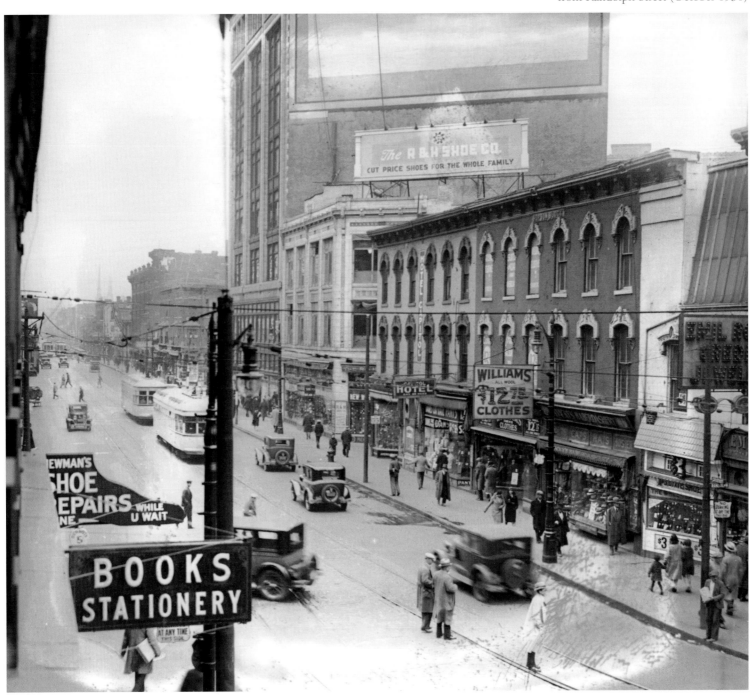

Gratiot, before it was widened, looking east
from Randolph Street (October 1930)

Gratiot on the east side of Detroit,
looking west toward downtown from
Chene Street (October 1930)

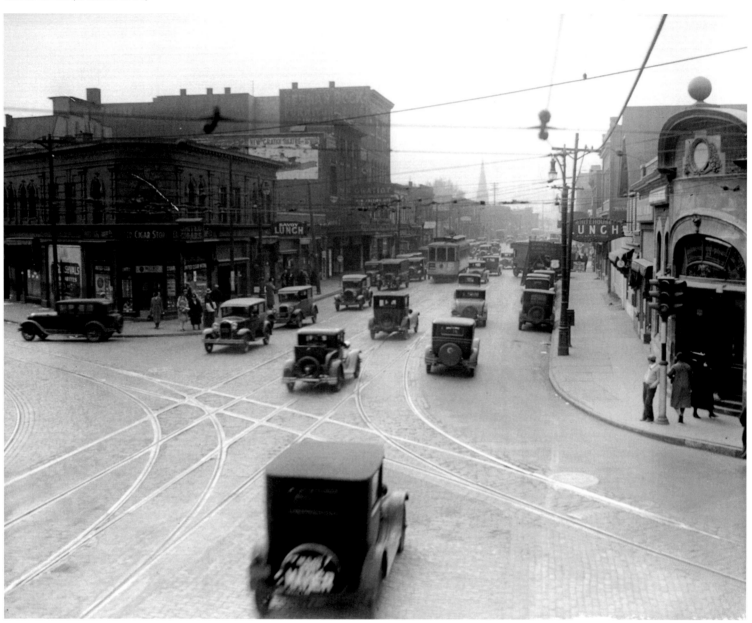

Electric and horse-drawn streetcars take part in the DSR Trolley Pageant down Woodward Avenue (January 1931). The parade started from Elizabeth and ended at Jefferson.

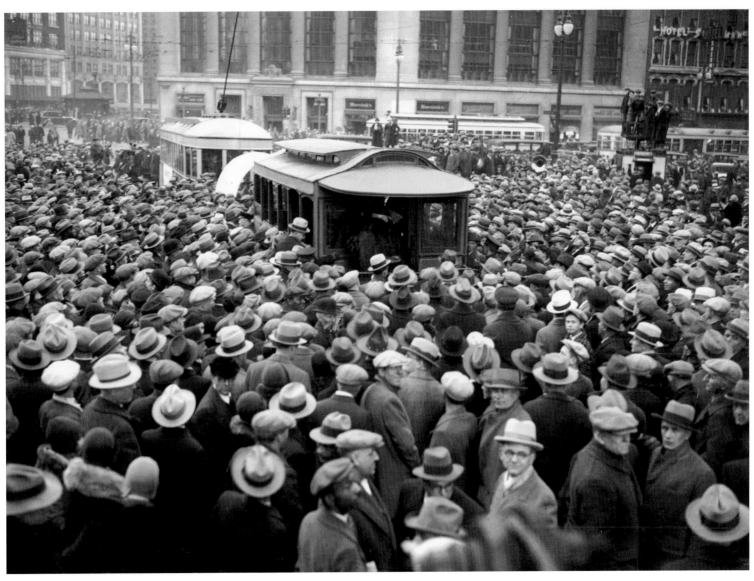

Cars race at the rural track at Eight Mile and Schoenherr (September 1932).

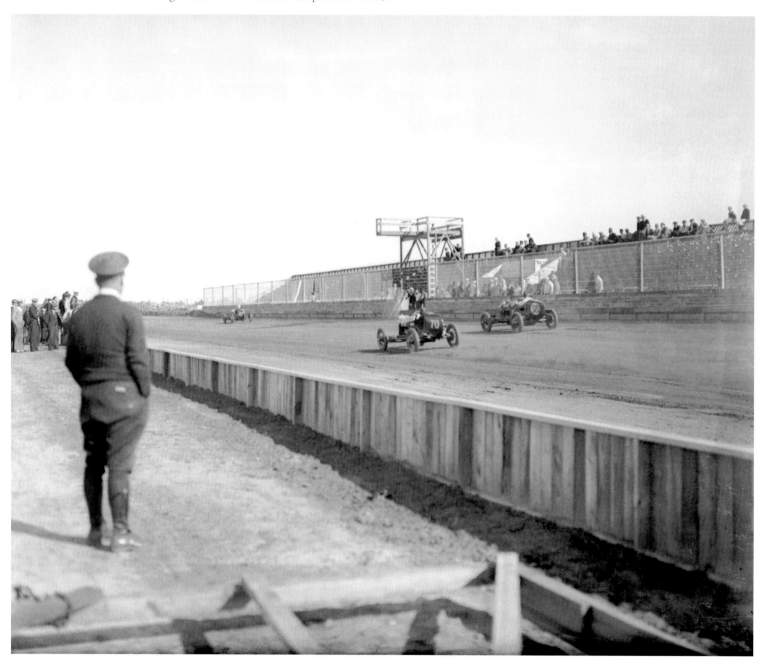

Unemployed auto workers cross the Rouge River drawbridge on their way to protest hunger and joblessness at the gates of the Ford Rouge Plant. The demonstration became violent as Dearborn police threw tear gas and fired upon the protesters, killing five and wounding nineteen (March 1932).

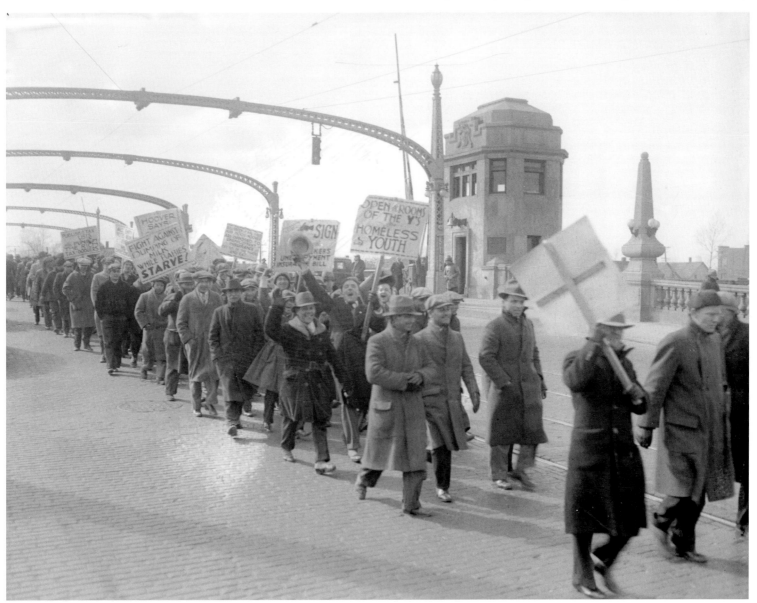

First Lady, Eleanor Roosevelt, commemorates the opening of a slum clearance project on Benton Street, northeast of downtown, near what is now the Detroit Medical Center (ca. 1935).

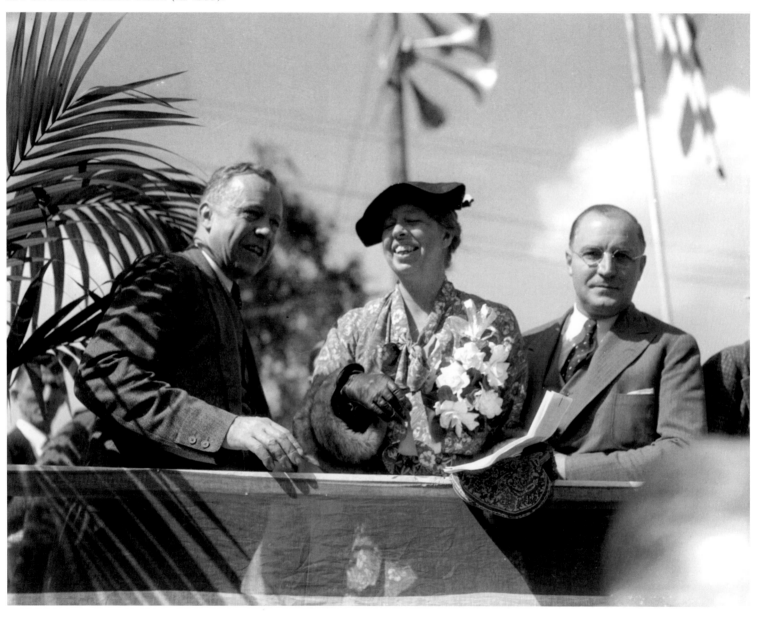

Woodward near Vernor Highway (ca. 1935). On the left of the street is a Sanders Confectioners store. Sanders was a Detroit favorite, known for their candy, ice cream, sundaes, and especially the ice cream soda. Credit for invention of the soda is extended to Sanders, although others lay claim to that honor.

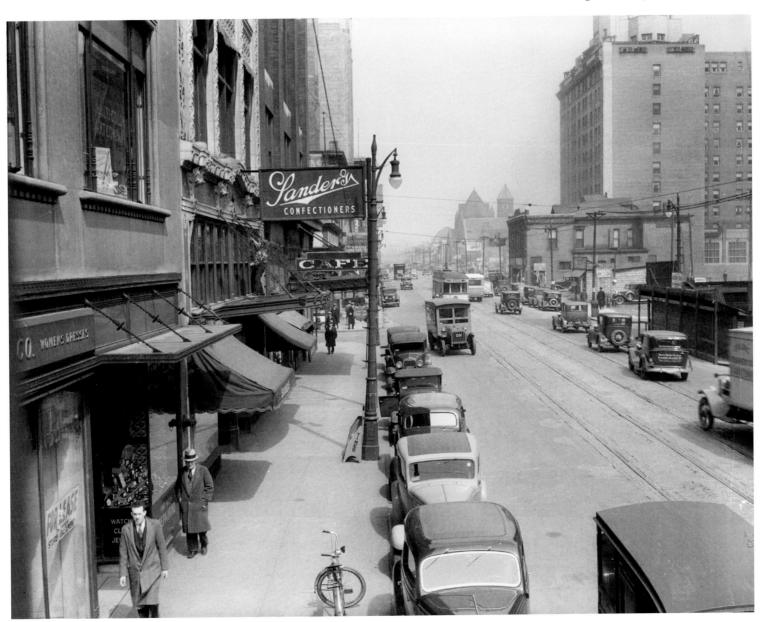

House at the corner of Bagley and 20th Street owned by Henry Ford. It is not far from his home on 58 Bagley, where he built his first automobile, the quadricycle.

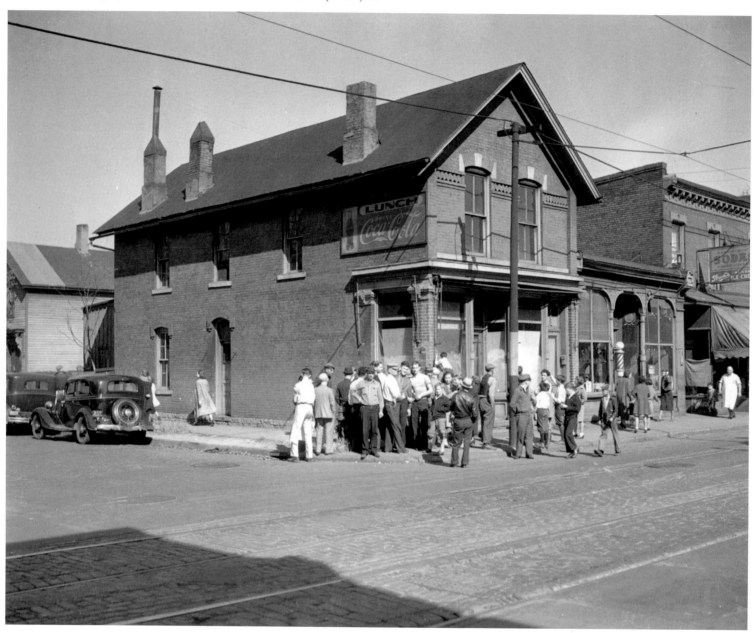

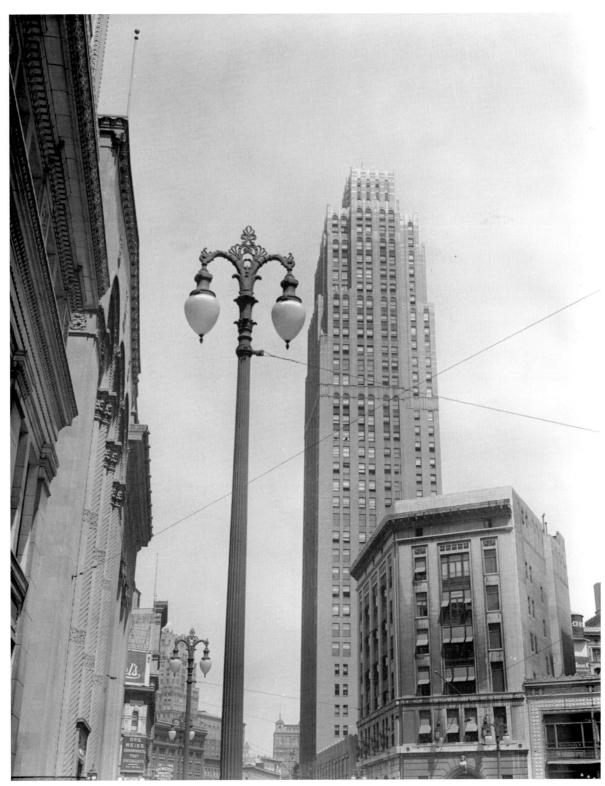

On a windy February day (ca. 1936), two women struggle to walk down a street just west of downtown. The winter of 1936 was one of the coldest in U.S. history.

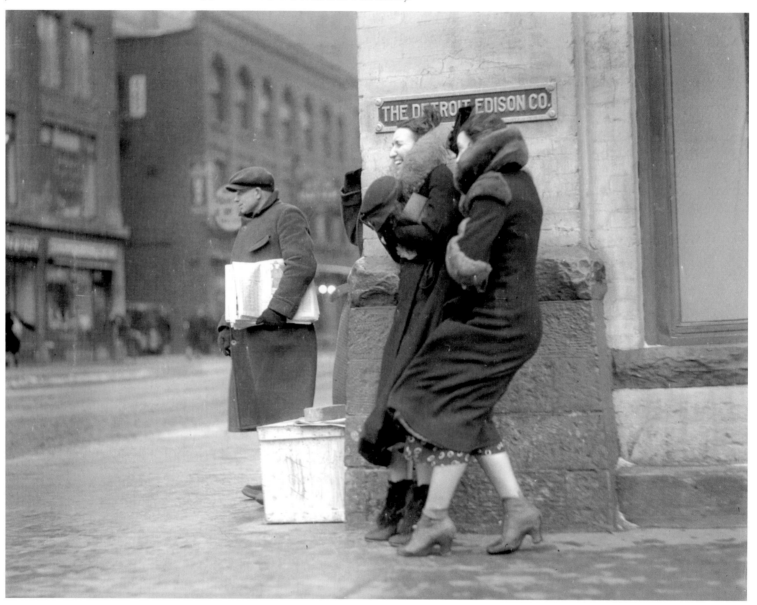

The wind made the icy streets and sidewalks even more treacherous, as evidenced by the woman being helped back to her feet by a Detroit police officer. (February 1936)

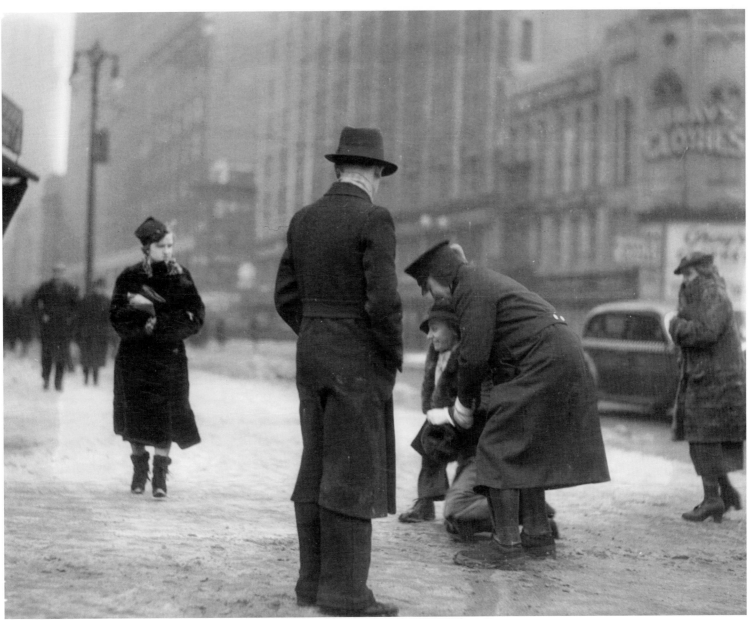

Woodward Avenue decorated to celebrate Detroit Day. A sign advertises
Major Bowes Amateur Hour's national radio inauguration of Detroit Day
on September 17, 1936.

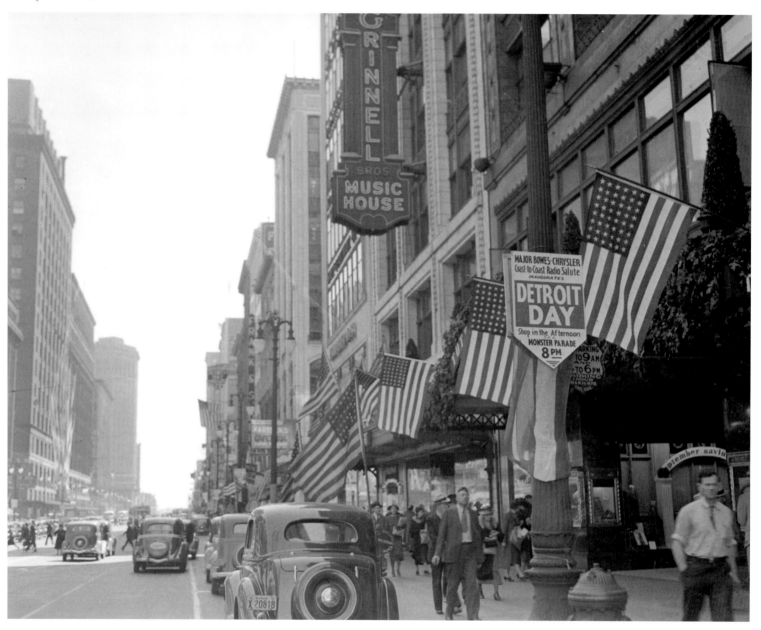

Detroit city officials and transportation officials Fran Weir, Lt. Millard Brown, and Harold Zumstein attend the opening of a widened Woodward Avenue from Adams to Vernor (November 5, 1936).

Like so many other historic Detroit buildings, the Yale Cleaners and
Tailors at the corner of State Street and Washington Boulevard will be
demolished. Preparations are under way in this image.

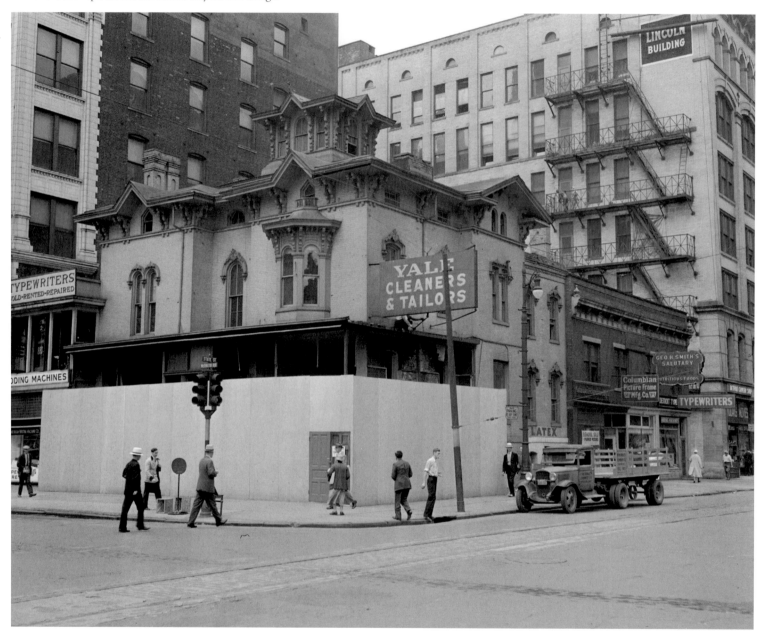

Birds-eye view down Griswold Street in the 1930s. At bottom-right is City Hall and then the Majestic Building. The tall building on the right is the David Stott Building. On the left are the Penobscot and then the Dime buildings. The tall building in the background at left is the Book Tower.

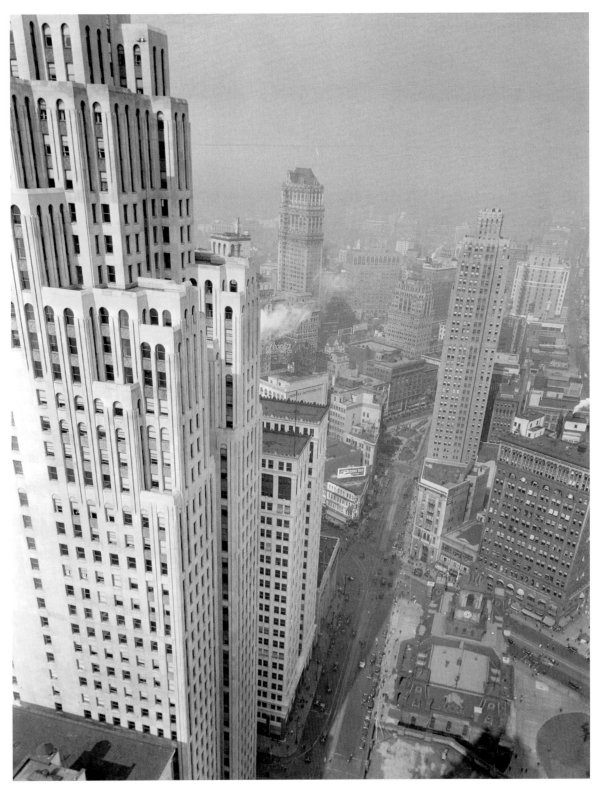

The children of the Franklin Street
Settlement House put on a circus
parade on May 7, 1938.

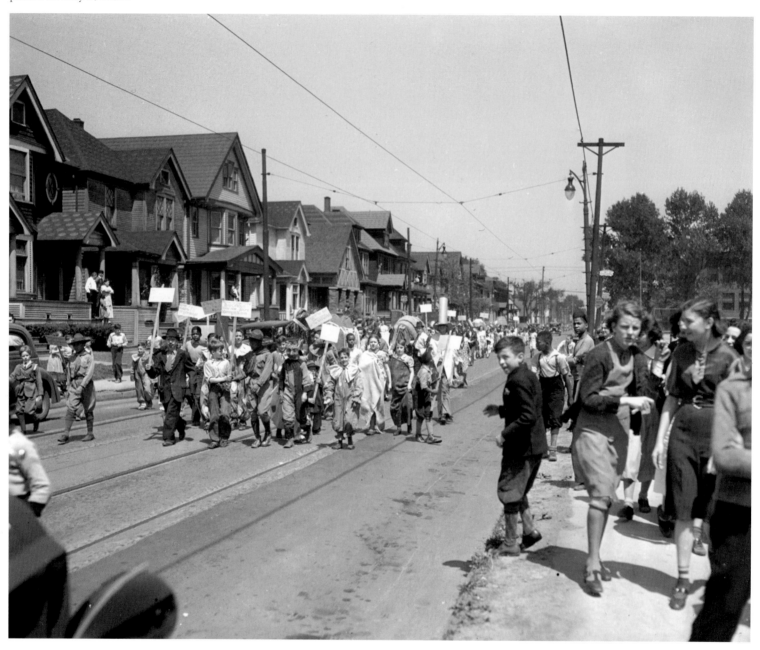

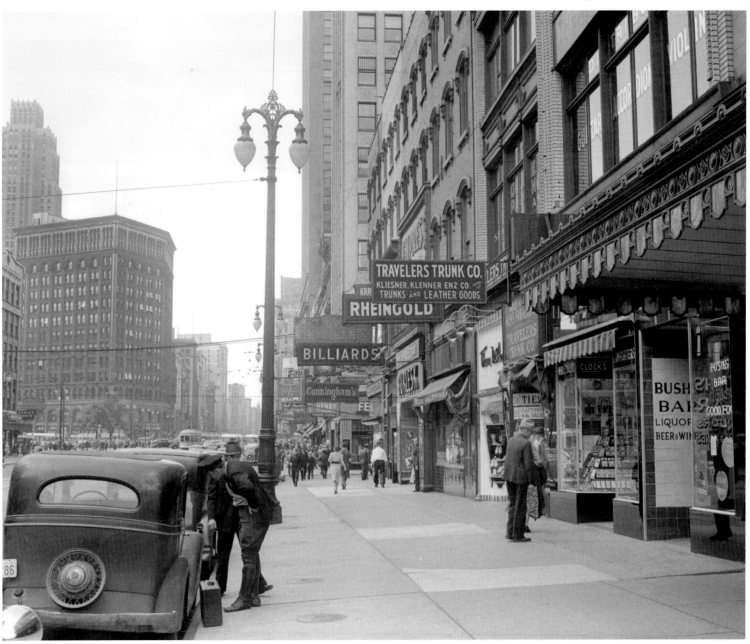

Woodward north of Congress Street
(June 1938). The Majestic and the Stott
buildings are visible in the background.

Detroit Street Railway workers leave St. Andrews Hall after voting to end the 32-hour wildcat strike in April 1938. The strike cost the workers an estimated $30,000 in lost pay and the DSR $36,000 in lost revenue.

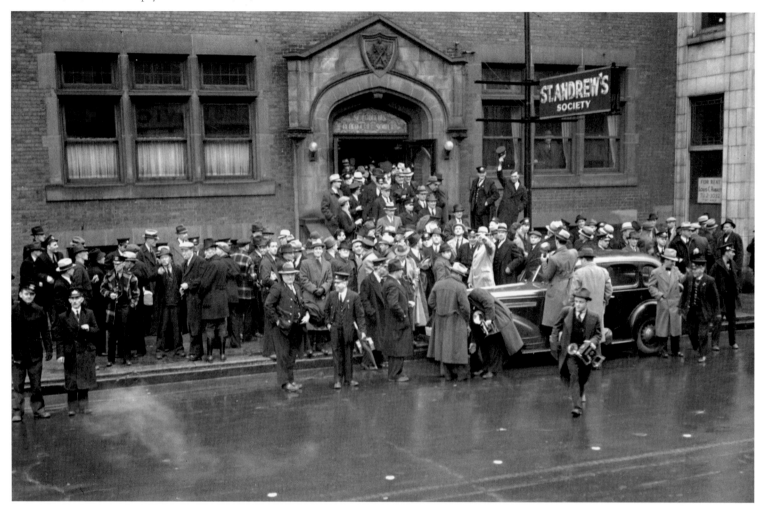

A view down Cadillac Square. The Michigan Soldiers and Sailors Monument is at center. The building on the right is the First National Building, designed by Albert Kahn and built in 1922. The 40-story building on the left is Cadillac Tower, built in 1927. This view shows the awkward, windowless side of the building, which is even barer with the razing of the shorter building next door. In recent years that side has been painted with murals of local athletes.

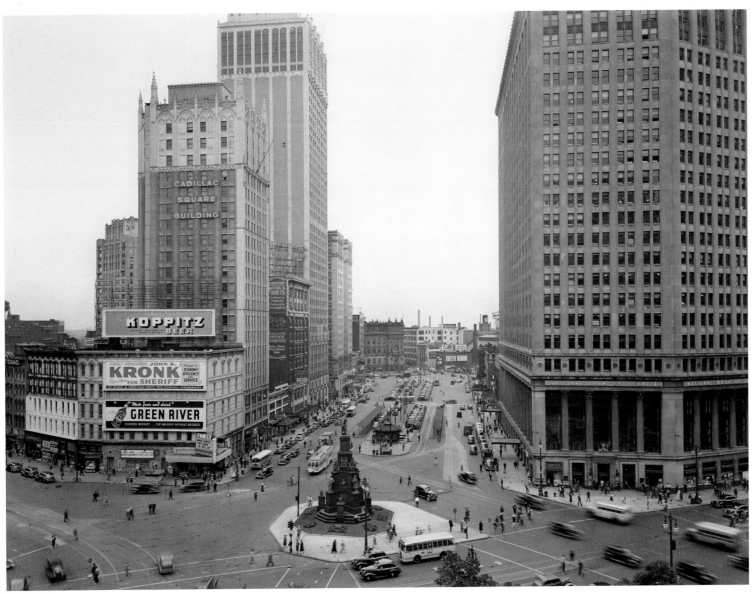

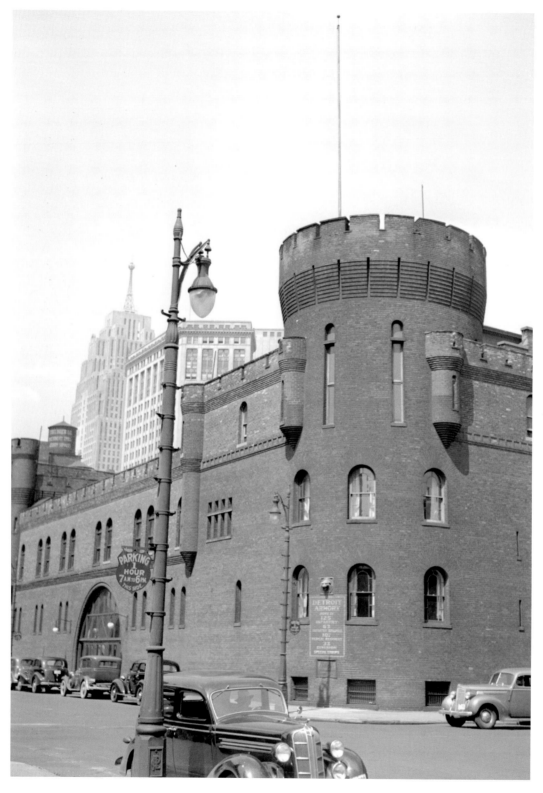

The Detroit Light Guard Armory building at the corner on Congress. The building was razed in 1945 and a new armory built on East 8 Mile Road. The Light Guard was established when a number of young men, including some former members of the Detroit City Guard (from the Black Hawk War), formed an independent, volunteer company in Detroit on April 2, 1836. In 1855, the unit became the Detroit Light Guard. This unit has had a continuous existence to the present day and is now Company A, 1st Battalion, 125th Infantry, stationed at the Detroit Light Guard Armory.

With parking becoming a problem in a city designed before the automobile was invented, this photo shows the new parking system instituted in 1939.

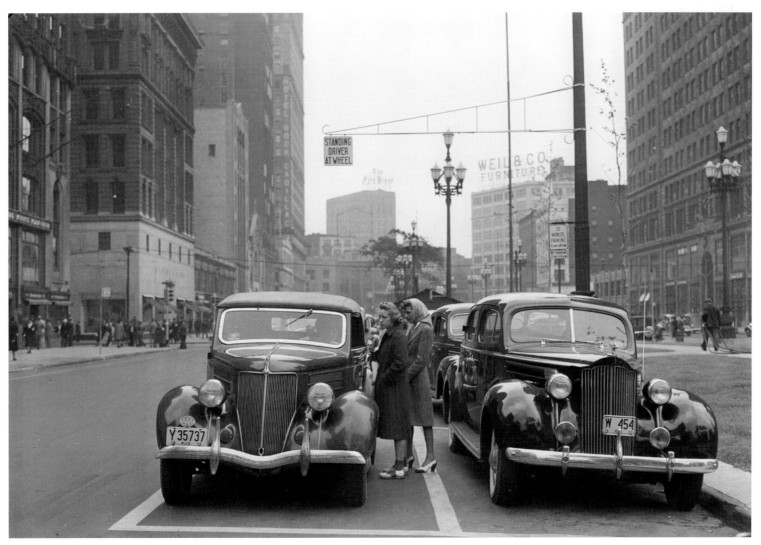

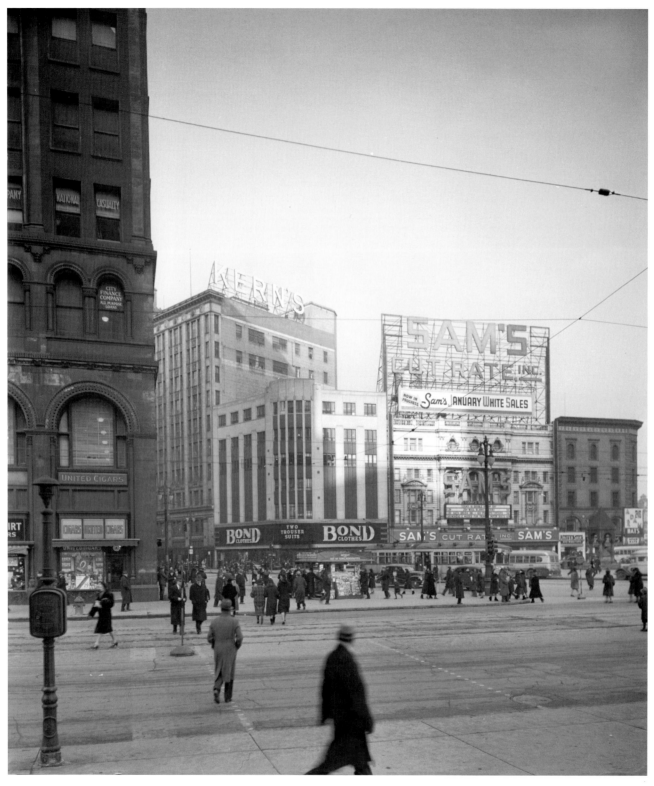

Seen here from the vantage point of City Hall are the two retail giants in the city, Sam's Cut Rate and Kern's Department Store. (January 1940)

Marchers pass Campus Martius while taking part in Detroit's Labor Day Parade (September 1940). Sam's Cut Rate is visible in the background on the right. Detroit's first Labor Day celebration took place in 1884 at Recreation Park.

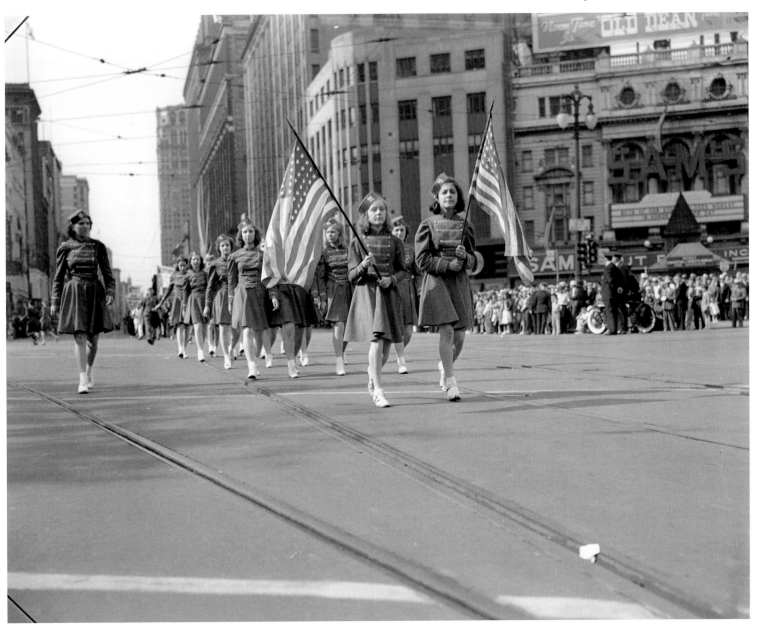

Workers from the Detroit and Cleveland Navigation Company, a company that owned and ran a fleet of passenger lake steamers, walk the picket line at the D and C building on Third Street. "Locked out" denotes that the employer, anticipating a strike, had barred employees from coming to work.

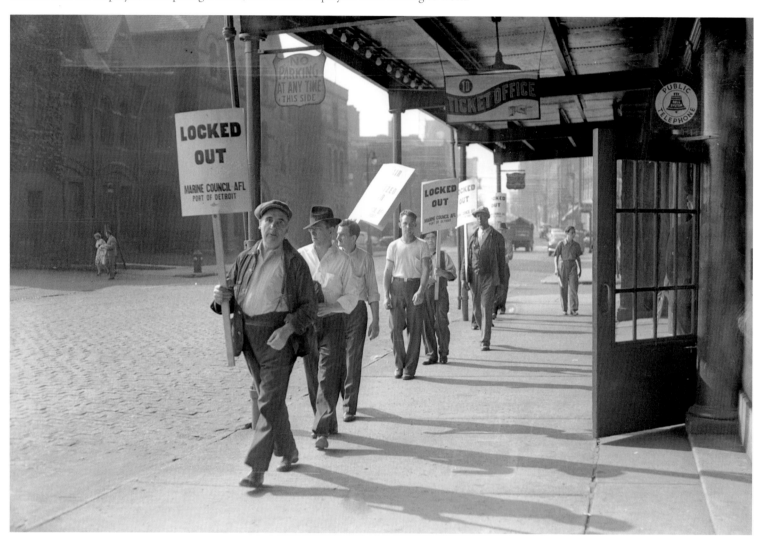

HOPING FOR RENEWAL IN MOTOR CITY

1942–1969

From 1942 to 1969, Detroit experienced great triumphs and frightening tragedies. After Japan's attack on Pearl Harbor and the entry of the United States into World War II, the city experienced one of its greatest triumphs: the switch from automotive to defense production. Detroit became known as the Arsenal of Democracy as factories turned into defense plants. Thousands were put to work when Ford built the Willow Run Plant and produced more than 8,000 B-24 Liberator Bombers.

When the war ended and the soldiers returned, Detroit's economy flourished. Detroit factories went back to making cars and Americans fell in love with the automobile once again. Enterprises that centered on the car experienced popularity as never before. Local drive-in movie theaters like the Bel-Air gained popularity, as well as drive-up fast-food businesses, like the Ross Deli Dainty.

The G.I. Bill enabled World War II veterans to go to college and made home mortgages easily accessible. Detroit-area colleges, like Wayne University, needed to expand to ease overcrowding. In the never-ending quest for bigger houses, bigger garages, and bigger yards, Detroiters began to look for homes in the sprawling suburbs. As a result, the cities around Detroit experienced a housing boom. Suburban living became even easier when freeways like the Edsel Ford and the John C. Lodge opened and made traveling into and out of the city much faster.

Commerce followed housing to suburbia. In 1954, J. L. Hudson's opened Northland Mall in the Detroit suburb of Southfield. It was the first suburban mall in the entire nation. The popularity of Northland and later suburban malls eventually led to the closing of Hudson's famous store downtown.

Within the city, new structures like the City-County Building (1955) and Michigan Consolidated Gas Company (1963) went up on Jefferson Avenue, while historic structures like the Majestic Building and the old City Hall fell victim to the wrecking ball in 1961. As the freeways made getting into Detroit easier, it became harder to get around within the city. In 1956, the Detroit Street Railway ended service, leaving the bus as the only form of mass transit.

In 1957, the Fort Wayne Pistons moved to Detroit and became the city's professional basketball team. They played

at the University of Detroit and then Cobo Hall and eventually moved out to stadiums in the north suburbs.

In the decades after the war, the dazzling musical talent of Detroiters was showcased through the home-grown label Motown Records. In 1959, Detroiter Berry Gordy, Jr., started Motown in a house on West Grand Boulevard. The company went on to produce such talent as Smokey Robinson and the Miracles, Diana Ross and the Supremes, the Temptations, Stevie Wonder, Martha and the Vandellas, the Four Tops, and Marvin Gaye, to name a few. When Motown records moved its headquarters to Los Angeles in 1972, it was the largest African American–owned business in the country.

In June 1963, thousands in the city joined Martin Luther King, Jr., in a march down Woodward to celebrate the civil rights movement. Other local dignitaries joined King as they led the march from Adelaide Street to Cobo Hall. That same year, the city mourned together as news of President John F. Kennedy's assassination came to light. Government offices were closed, Detroit theaters shut their doors, and local sports events were canceled.

The greatest tragedy to strike Detroit in the decades following World War II started in the early hours of a summer morning in 1967 on the city's northwest side. A police raid got out of hand and violence ensued. Vandalism, looting, and fire spread throughout the neighborhoods as latent racial tensions and frustrations came spilling out onto city streets. The National Guard and then the U.S. Army were called upon to help police regain control. The riot was quelled five days later, but not before the violence had caused 43 deaths, hundreds of injuries, and damage to thousands of buildings. The tragedy made national headlines and even the cover of *Time* magazine.

Detroit was back in the national media the next year when the Detroit Tigers won the World Series. The way Detroiters came together to cheer on their team led some to believe that the Tiger victory was a step toward healing the wounds of a city so divided the year before.

Hordes of Christmas shoppers wait for a streetcar at the Capitol Park loading station in December 1942.

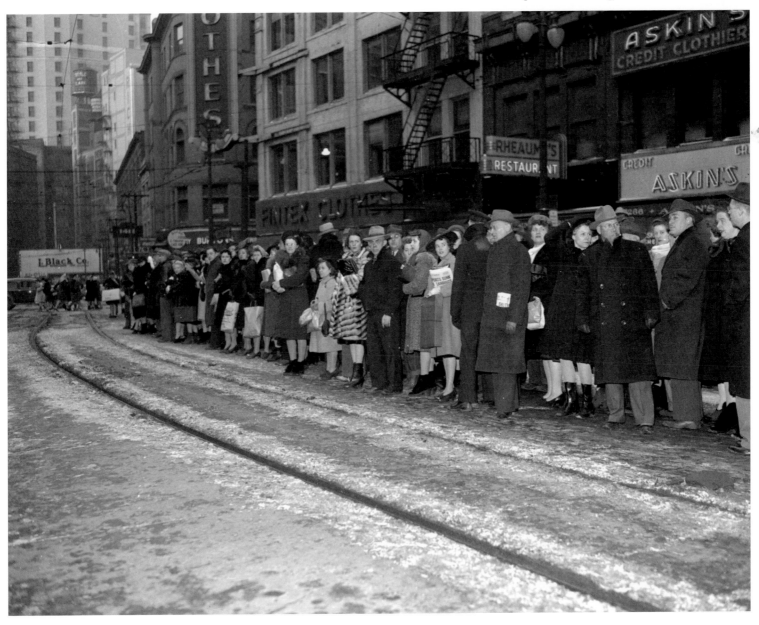

After a day of shopping, Detroiters wait to board the Grand
River trolley (December 1942).

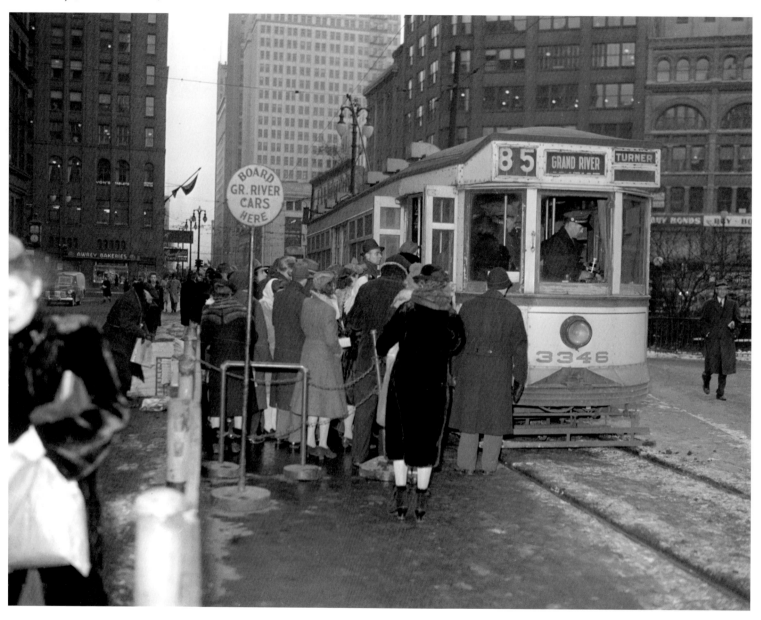

These Works Progress Administration workers dig up old street rails in Detroit for a World War II scrap metal drive (September 1942).

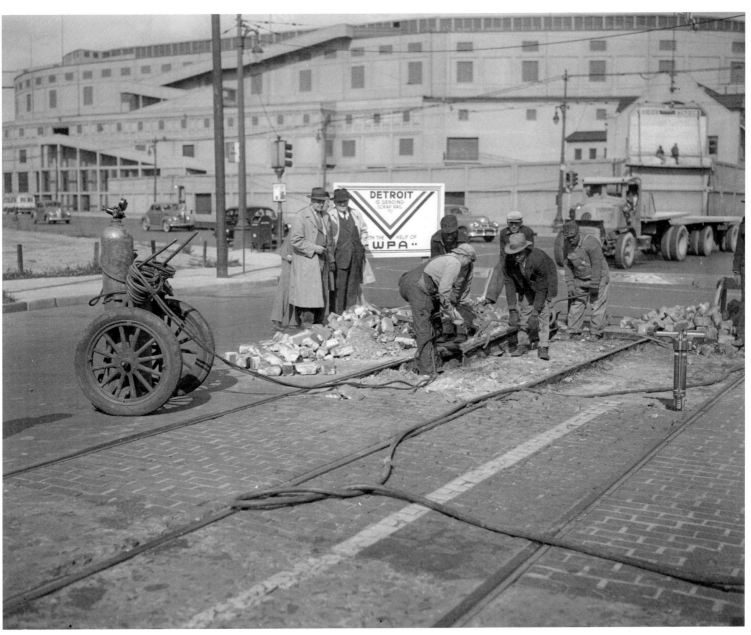

A parade downtown in June 1942 shows off an American tank made at the new Tank Arsenal north of the city, in what is now Warren. The arsenal was run by Chrysler and built M3 tanks and M4 Sherman tanks. By the end of the war, the Tank Arsenal had built one quarter of all the tanks produced in the United States during the conflict.

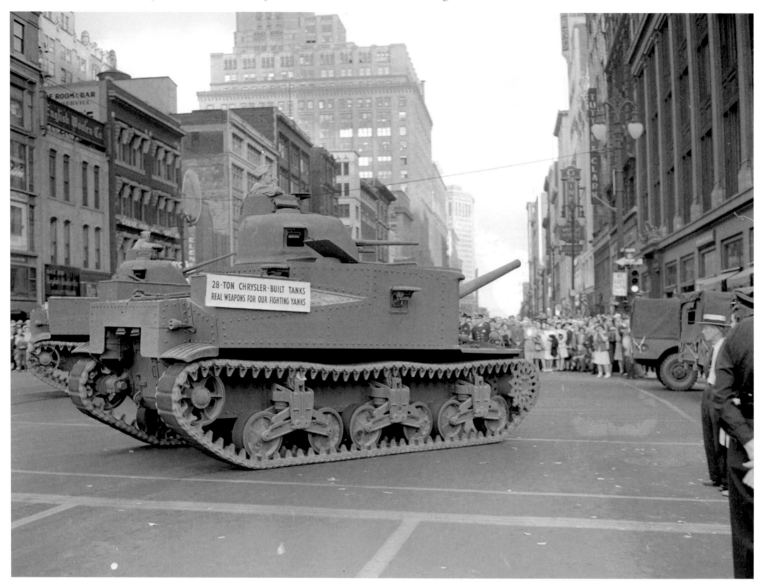

Army recruits walk to the Fort Street Induction Center in June 1942 to help defend their country. In the background at right, Fort Street Presbyterian Church is visible behind Fort Street's Union Depot.

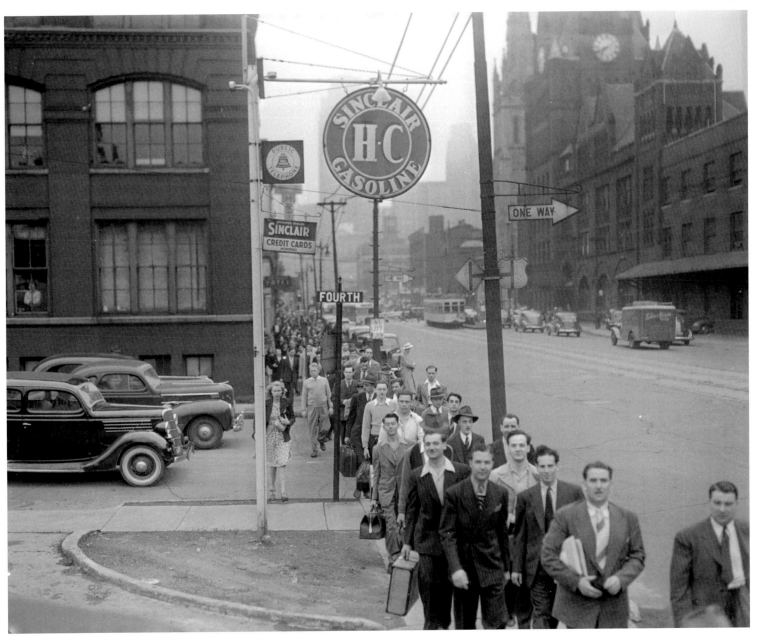

In an effort to conserve gasoline and rubber during the war years, Cunningham's Drug Store switched to horse-drawn wagons to deliver its goods (June 1942). In the background is the Greyhound bus station building, of which Cunningham's was a part.

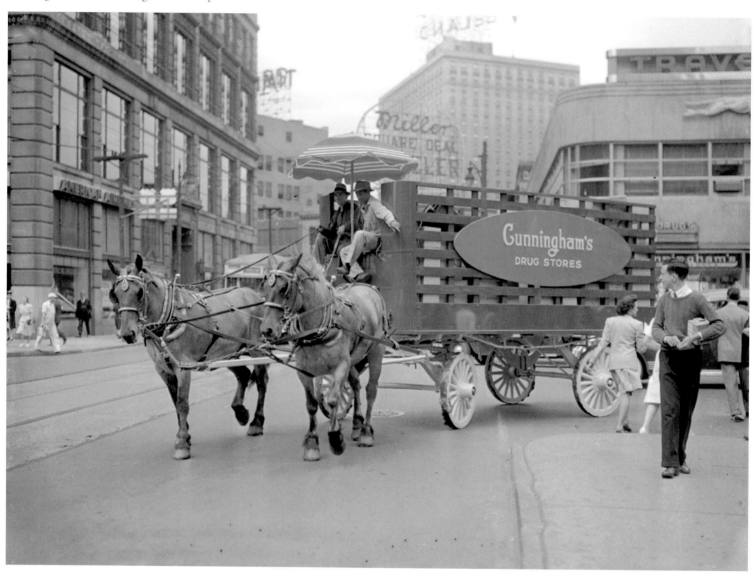

Detroit is not known for having a Chinatown, but in the early part of the twentieth century, it did. By the end of World War II, there were approximately 3,000 ethnic Chinese living in Detroit. Most were living in the area near Third Street and Michigan Avenue. This image shows a Chinese dragon dance during a festival celebrating the 32nd anniversary of the founding of the Chinese Republic. The money collected from the festival was donated for the relief of Chinese war orphans (October 10, 1943).

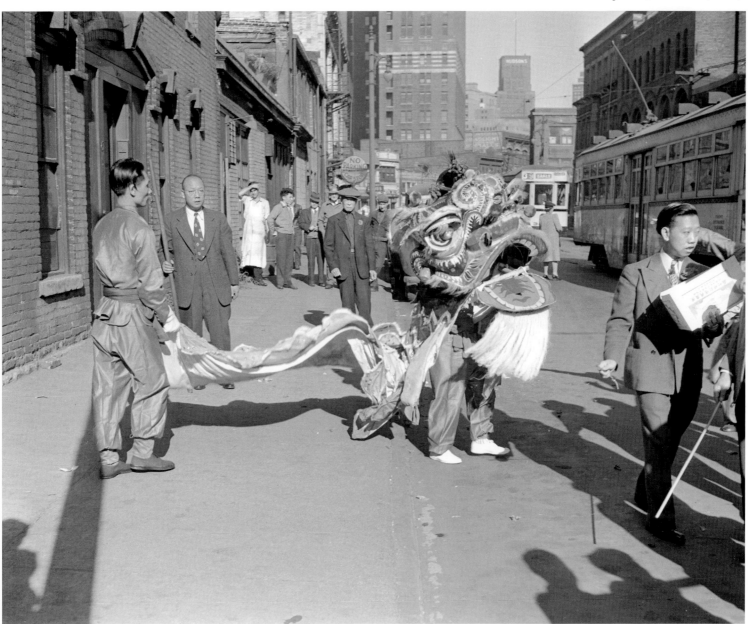

In front of the United Artist Theater on Bagley at Grand Circus Park, onlookers watch a captured Japanese suicide submarine parade past them (July 1943).

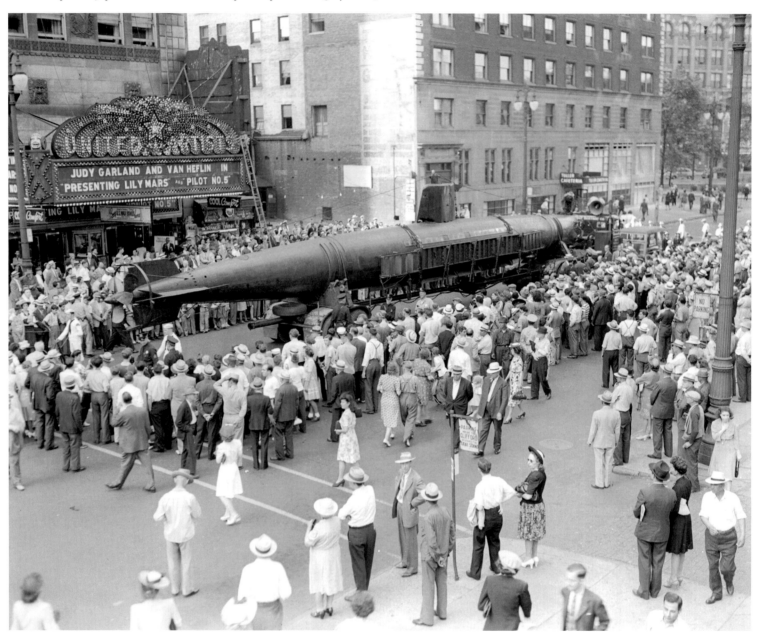

Navy recruits march down Woodward near Monroe Street. Their next stop is the Great Lakes Naval Training Station in North Chicago, Illinois (April 1943).

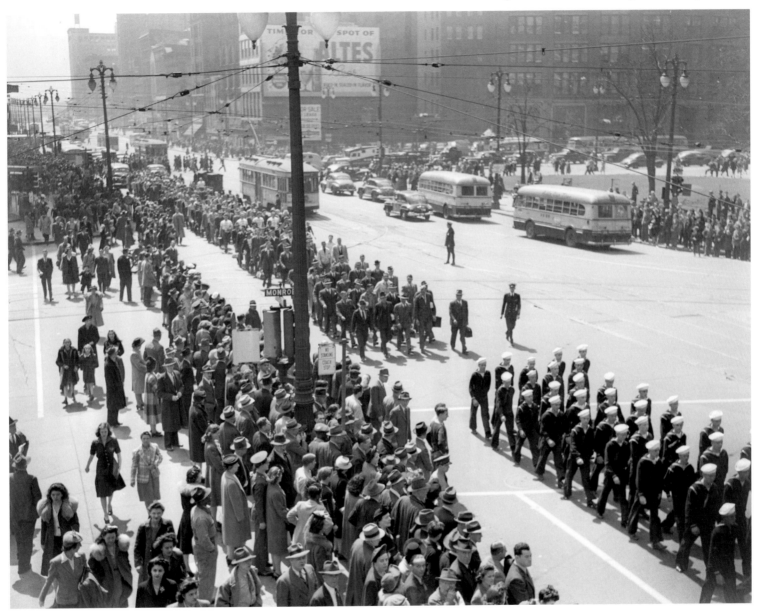

The *Memphis Belle* makes an appearance at Detroit City Airport on a public relations tour to thank Americans for their continued support of the war effort, July 1943. The *Memphis Belle* was the first B-17 bomber in the European theater to complete 25 combat missions without one serious injury to the crew. She flew from November 1942 to May 1943, shooting down eight enemy fighters and dropping more than 60 tons of bombs over Germany, France, and Belgium.

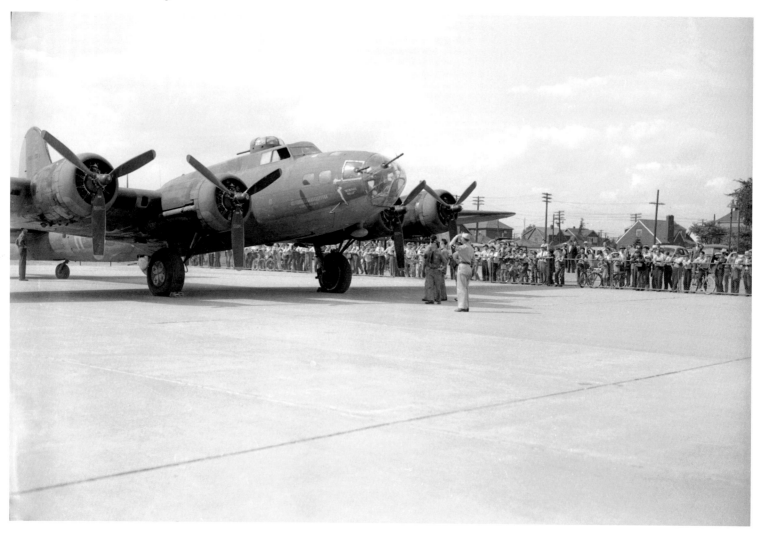

Evangelical Church on 12th Street near Davidson (1944)

Tiger catcher Bob Swift at bat against the New York Yankees in Briggs
Stadium (September 1944)

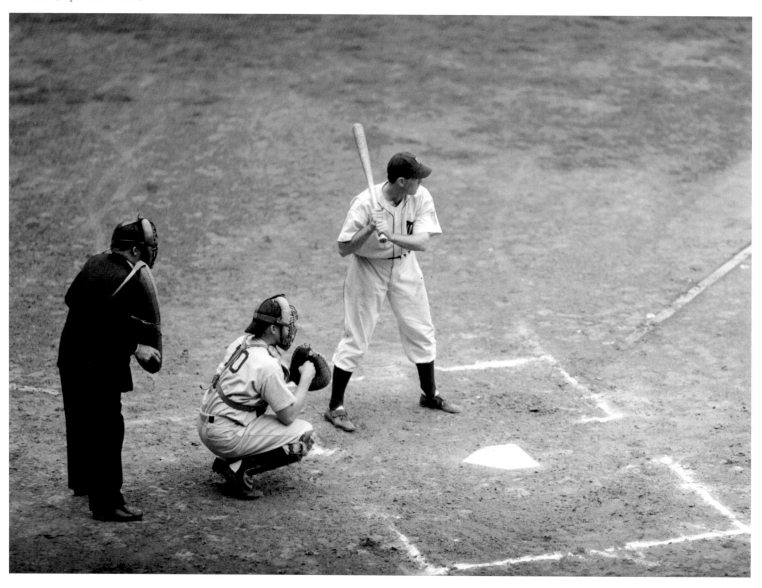

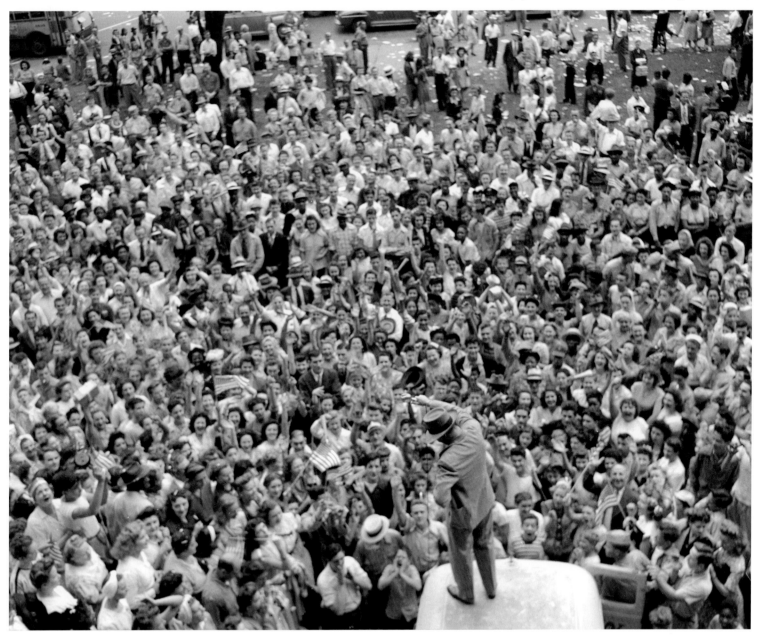

Detroiters gather downtown to celebrate the World War II victory over Japan and the end of the war (August 14, 1945).

United Auto Workers (UAW) picket outside General Motors Headquarters on Grand Boulevard in December 1945. The strike was fueled by GM's unwillingness to negotiate wage increases for UAW members despite the auto company's big profits.

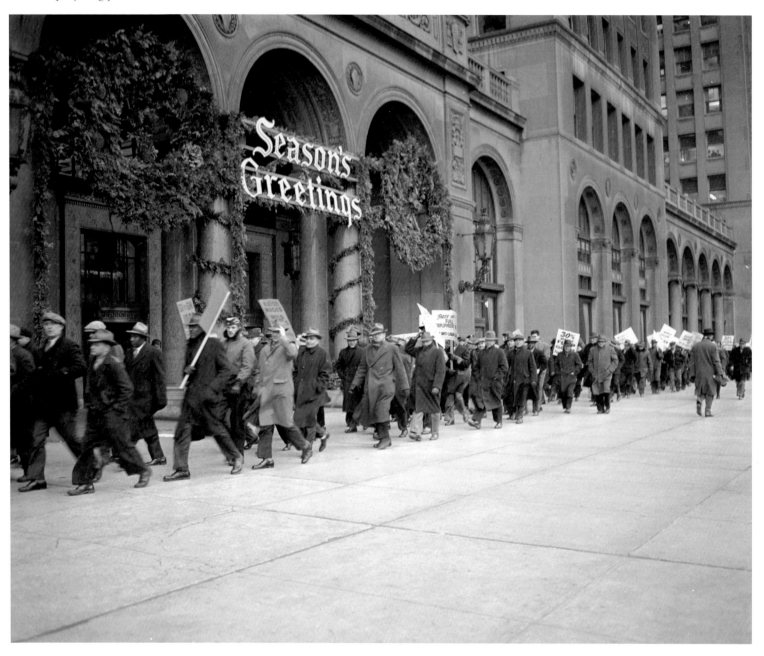

City Hall is decorated for Detroit's Automotive Golden Jubilee celebration, the 50th anniversary of the automobile, in 1946. Towering above City Hall from left to right are the Guardian Building, the Penobscot Building, and the Dime Building.

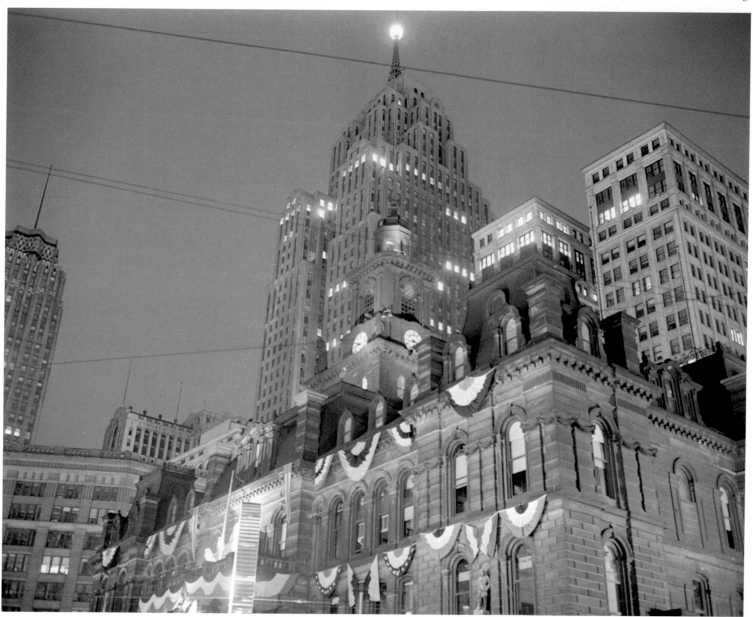

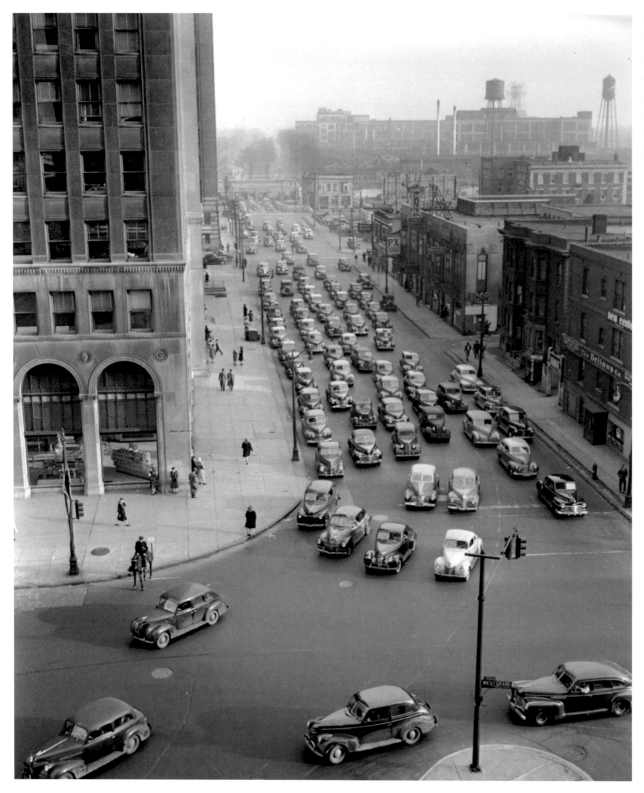

Cars crowd the one-way street, Second Avenue, as they come north from downtown in 1946. At the corner on the left is the GM building.

Detroiters in period clothing drive classic cars in the Golden Jubilee Parade down Woodward to celebrate the fiftieth anniversary of the automobile (June 1946).

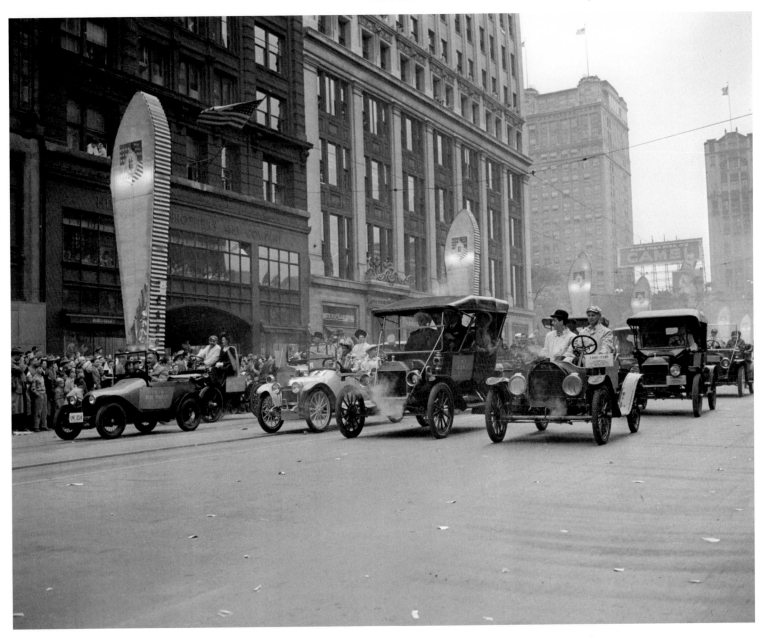

Ed Wynn, who played the Texaco fire chief on a national radio program promoting Texaco's Fire Chief gasoline, poses in a 1910 fire rescue truck in May 1946.

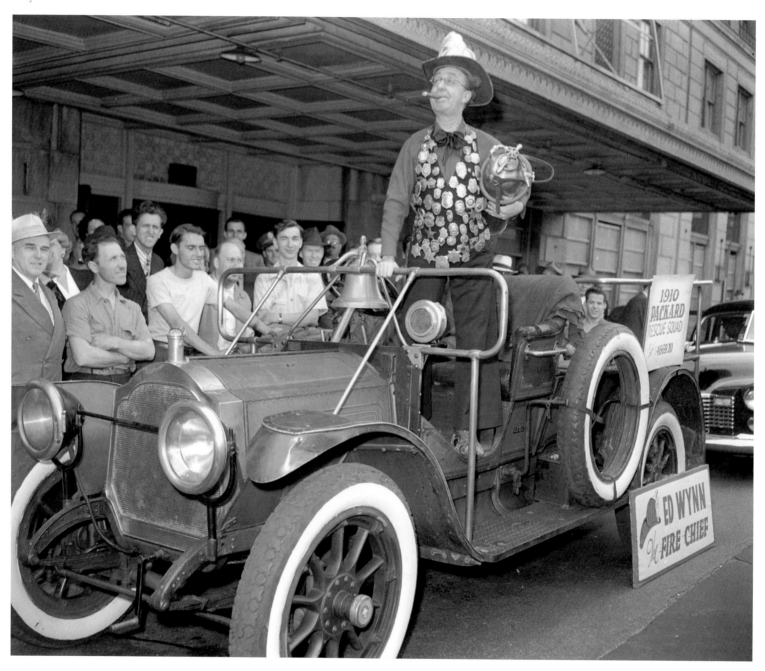

Workers leave the Hudson Motors plant in 1946. This factory was on Jefferson between the Chrysler plant and the Continental Motors plant.

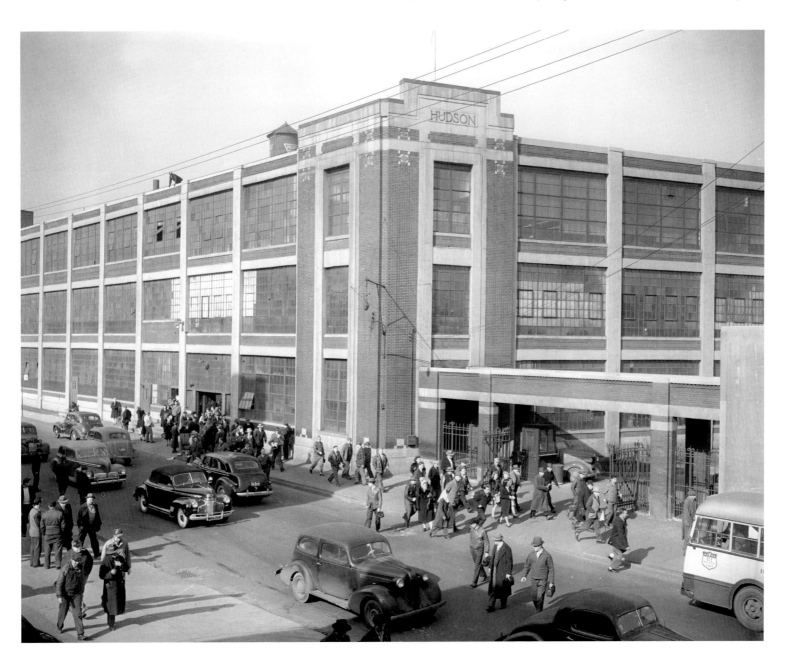

An overturned and burned car is one statistic of a race riot in June 1943. As the African American population in Detroit increased owing to migration from the south for wartime jobs, racial tensions came to the forefront, and in this case, ended in violence. Federal troops finally stepped in, but not before 34 were dead and more than 70 injured.

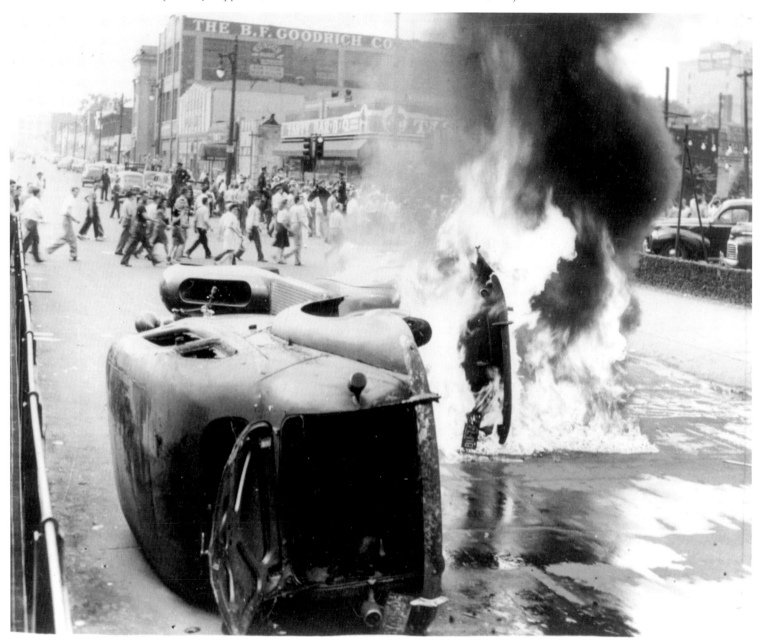

The Water Board
Building on the
triangular plot of
land surrounded by
Randolph, Bates, and
Farmer streets (1949)

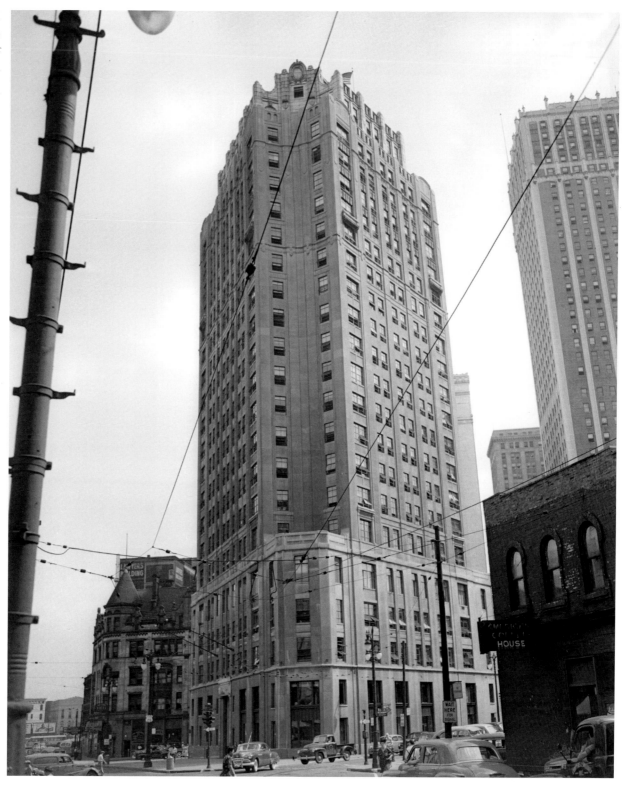

Santa Claus speaks to the Woodward Avenue crowd who brave the cold and snow to watch the J. L. Hudson's Thanksgiving Day parade, November 24, 1949. Hudson's sponsored its first parade in 1924, and ever since then Santa Claus has arrived on his sled (reindeer visible at lower-right) at the very end of the parade to receive the key to the city from Detroit's mayor (Eugene Van Antwerp in 1949). The parade marks the beginning of the Christmas Season and is a favorite among Metro Detroiters even today.

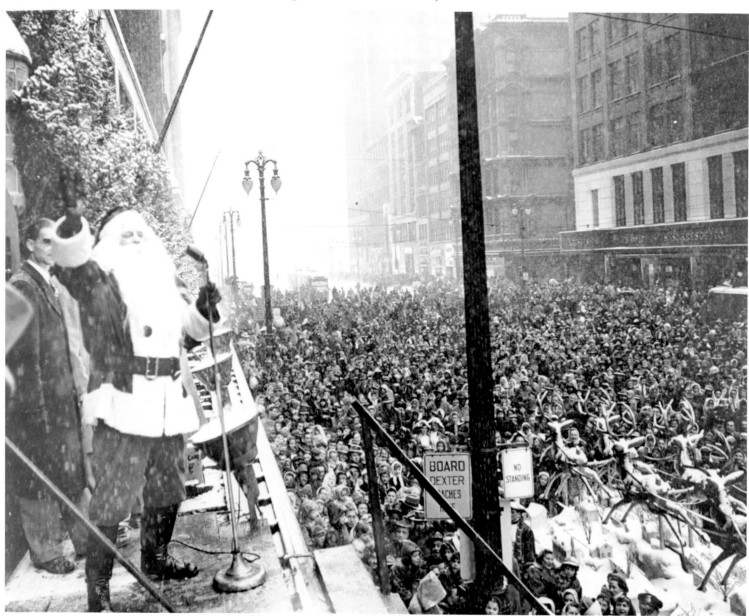

Chrysler's Jefferson Avenue plant at Connor on Detroit's east side in 1950.
Originally a Chalmers Motors plant, the Jefferson Avenue factory began
producing cars before the First World War.

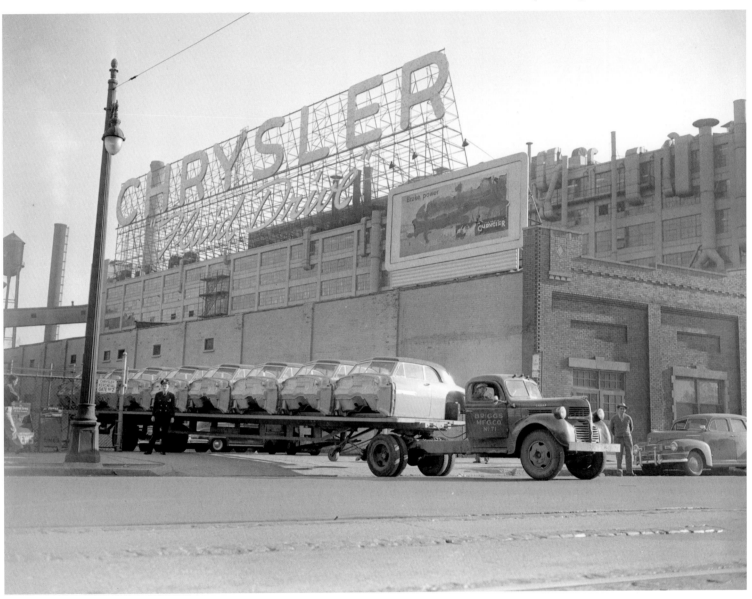

Workers at the Detroit Tank Arsenal install the engine in what appears to be an M4 Sherman Tank (1950). During the Korean War, the Tank Arsenal switched to the production of the M47 Patton Tank and built more than 3,000 of them for that conflict.

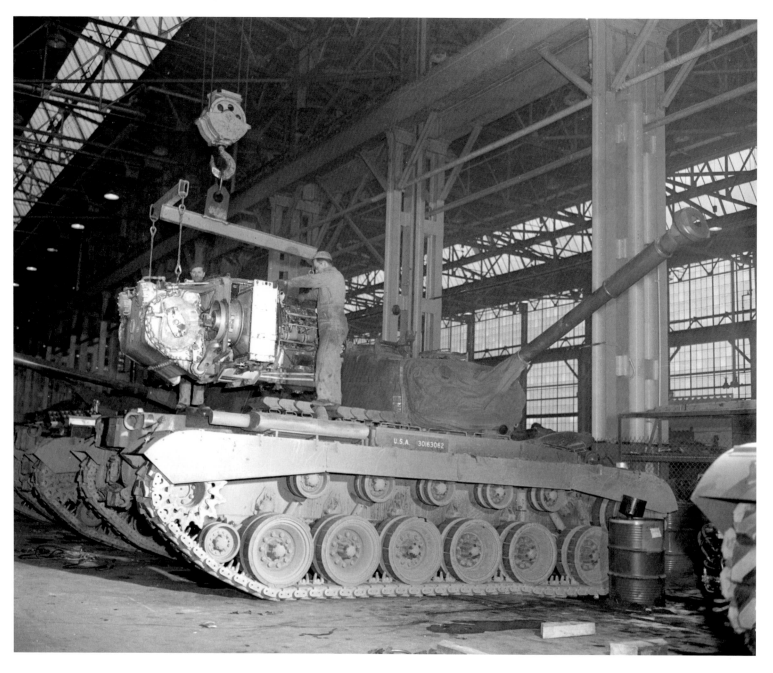

The railroad overpass above the newly completed north-south Lodge Freeway, December 1950. The expressway was named for Detroit's former mayor, John C. Lodge, who died in February of that year.

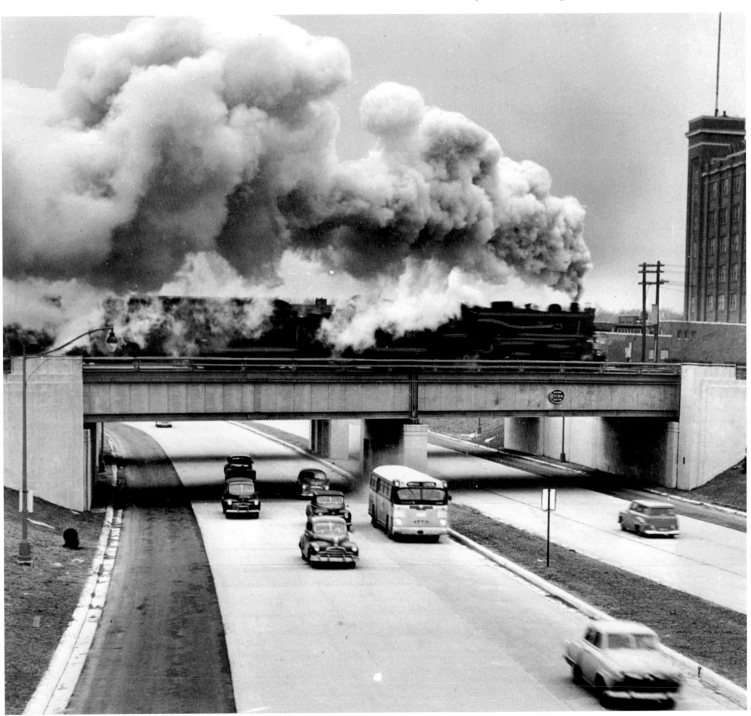

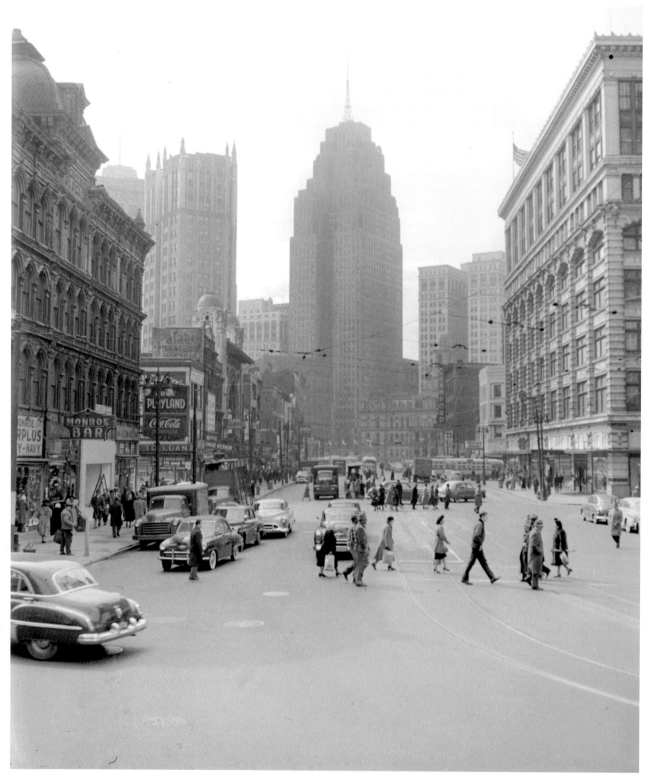

This view down Monroe Street shows the effects of air pollution on an otherwise clear spring day in 1951. The Cadillac Square, Penobscot, and Dime buildings are barely visible in the smog of the city.

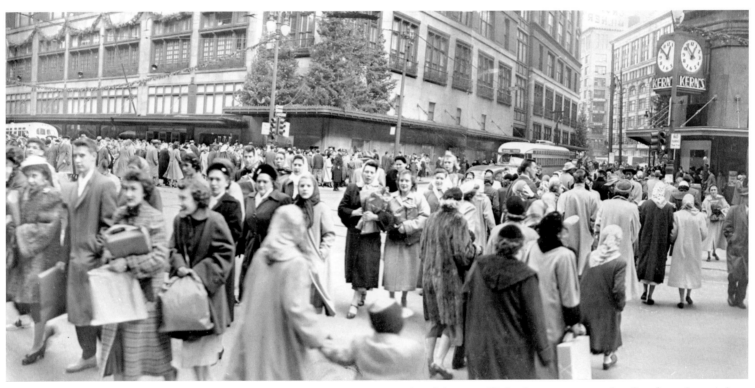

Hordes of shoppers fill the downtown streets hustling from shop to shop, hoping to finish their Christmas shopping early, November 28, 1952. On the right is the famous Kern's clock, which not only served as a timepiece for those on the street, but as a meeting place too.

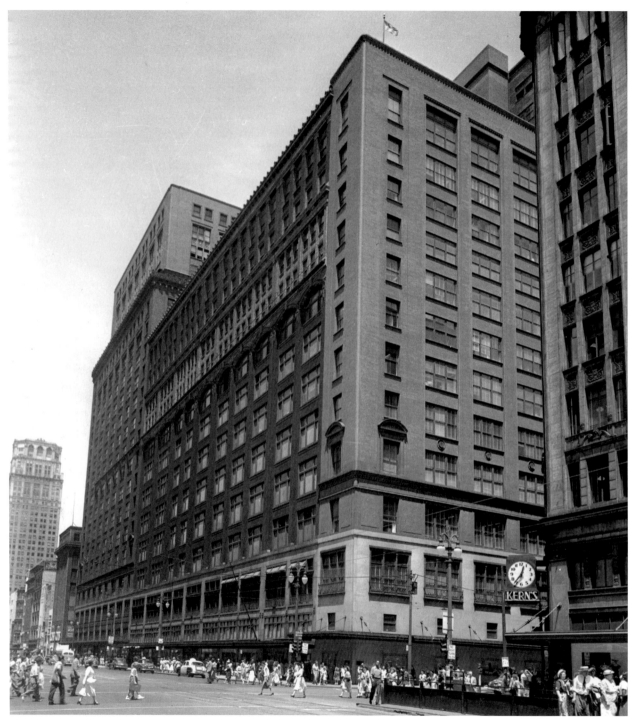

The 49-acre Hudson's Department Store sits on Woodward Avenue, in 1952. Pedestrians on Detroit streets loved Hudson's for its elaborate window displays, one of which was their spring display in which the blooming trees decorating the interior window spaces would reach through the glass out into the streets. To complete the illusion, Hudson's piped the smell of spring blossoms out to the sidewalks. In the early 1950s, Hudson's had approximately 12,000 employees making close to 10,000 sales a day. By the 1970s, however, suburban shopping malls were taking much of Hudson's business, and it closed the downtown building in January 1983. The structure stood empty for many years until it was demolished in October 1998.

Evangelist Billy Graham holds a mass revival meeting at Briggs Stadium as a part of his "Crusade" in Detroit (1953).

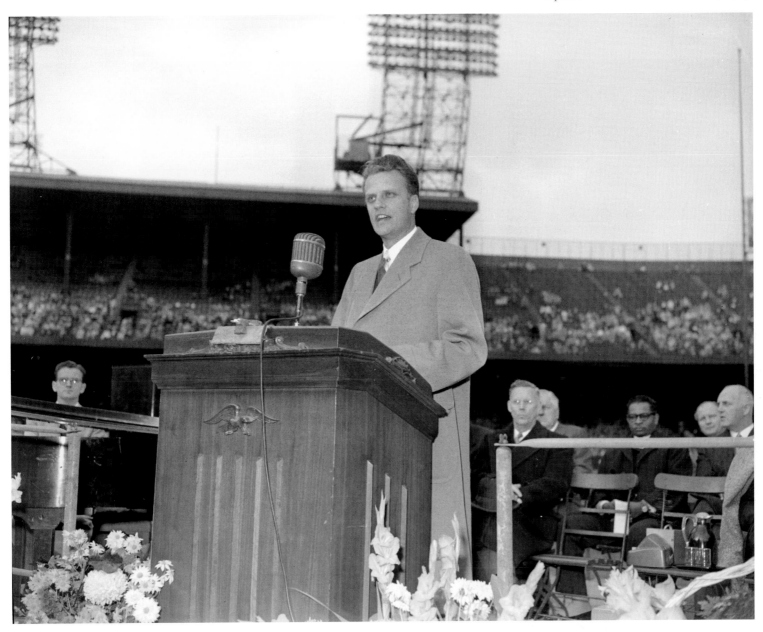

Legendary Baltimore Colts quarterback Johnny Unitas attempts a pass
while one half of Detroit's "Fearsome Foursome," Roger Brown (#76)
and Sam Williams (#88) reach for it, in a Lions game at Tiger Stadium,
October 1963. The Lions eventually lost the game 25-21.

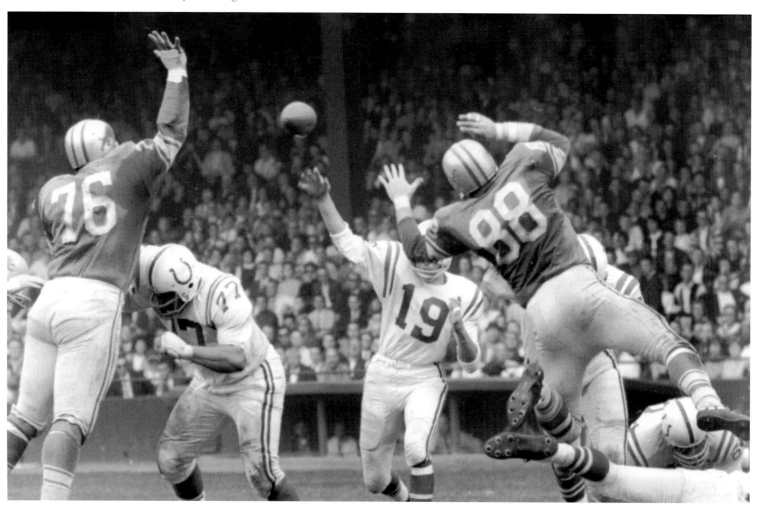

Aerial view of the 12th Street fires started during the July 1967 riot. What began as a police raid of an illegal after-hours drinking club on Detroit's northwest side escalated into violence, looting, and fires.

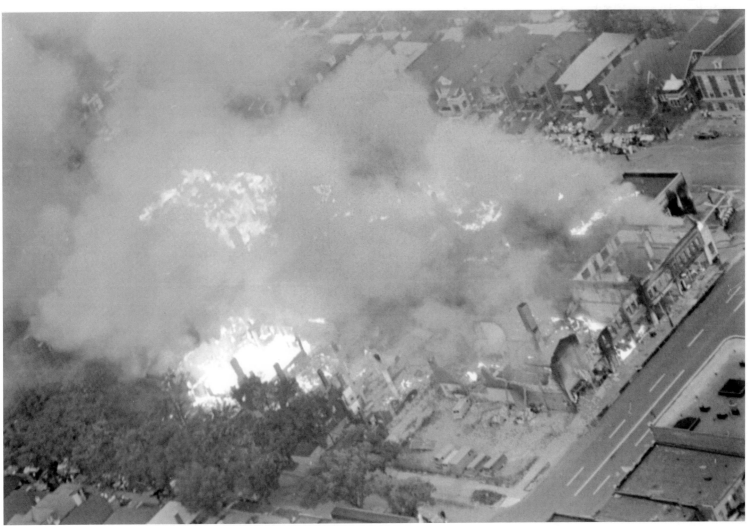

Jimmy Hoffa, president of the International Brotherhood of Teamsters, addresses a rally of his supporters at Cobo Arena, ordering the so-called wildcat strikers to go back to work (December 15, 1966). The Teamsters staged a walkout in support of their leader, whose conviction for jury tampering was upheld by the Supreme Court a day earlier.

Smokey Robinson, lead singer of the Motown group Smokey Robinson and the Miracles, in Kennedy Square (August 1969)

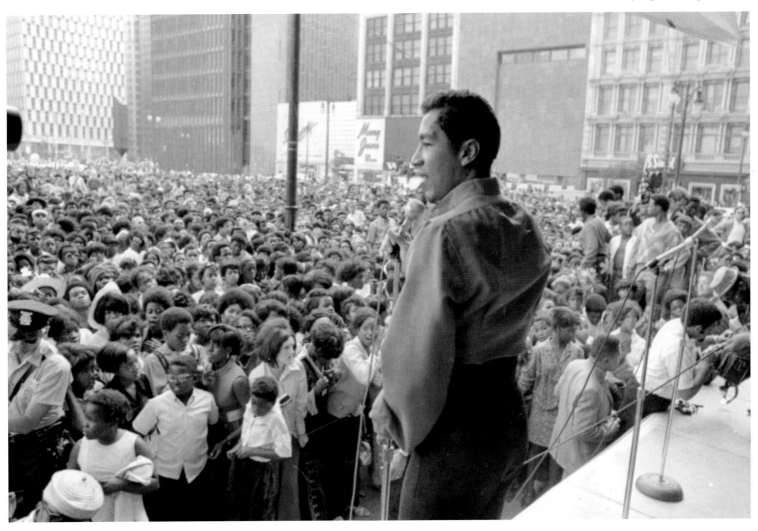

NOTES ON THE PHOTOGRAPHS

These notes, listed by page number, attempt to include all aspects known of the photographs. Each of the photographs is identified by the page number, photograph's title or description, photographer and collection, archive, and call or box number when applicable. Although every attempt was made to collect all available data, in some cases complete data was unavailable due to the age and condition of some of the photographs and records.

II **AMERICAN CAR AND FOUNDRY**
Reuther Library, WSU

VI **AMBASSADOR BRIDGE**
Reuther Library, WSU

X **WOODWARD AVENUE**
Detroit Public Library

2 **SAINT ANDREW'S BAZAAR**
Detroit Public Library

3 **FIRST MICHIGAN REGIMENT**
Reuther Library, WSU

4 **POST OFFICE**
Reuther Library, WSU

5 **STEPHEN SMITH'S BOOTS**
Detroit Public Library

6 **OLD RUSSELL HOUSE**
Detroit Public Library

7 **JEFFERSON AVENUE**
Reuther Library, WSU

8 **WOODWARD AVENUE**
Detroit Public Library

9 **JEFFERSON STREET**
Reuther Library, WSU

10 **WOODWARD AVENUE**
Detroit Public Library

11 **EARLY STREET CAR**
Reuther Library, WSU

12 **WOODWARD AVENUE**
Detroit Public Library

13 **WEBSTER SCHOOL**
Reuther Library, WSU

14 **SOLDIERS AND SAILORS MONUMENT**
Reuther Library, WSU

15 **GRAND RIVER STREETCAR**
Detroit Public Library

16 **CADILLAC SQUARE**
Reuther Library, WSU

17 **WOODWARD STREET**
Detroit Public Library

18 **FIRE DEPARTMENT**
Reuther Library, WSU

19 **CENTRAL MARKET**
Reuther Library, WSU

20 **SHARP'S CHOP HOUSE**
Reuther Library, WSU

21 **DETROIT FROM CITY HALL**
Reuther Library, WSU

22 **CHURCHES ON WOODWARD**
Detroit Public Library

23 **GRAND RIVER STREET**
Detroit Public Library

24 **MABLEY AND COMPANY'S BAZAAR**
Detroit Public Library

25 **STREETCAR EMPLOYEES**
Detroit Public Library

26 **WOODWARD AVENUE**
Reuther Library, WSU

27 **DETROIT OPERA HOUSE**
Reuther Library, WSU

28 **GAR REUNION**
Detroit Public Library

29 **OLD FEDERAL BUILDING**
Reuther Library, WSU

30 **GRAND ARMY OF THE REPUBLIC REUNION**
Detroit Public Library

31 **CAPITOL HIGH SCHOOL**
Reuther Library, WSU

32 **PUBLIC WORKS DEPARTMENT**
Reuther Library, WSU

33 **TRIUMPHAL ARCH**
Reuther Library, WSU

34 **PIETY HILL**
Detroit Public Library

35 **WOODWARD STREET**
Detroit Public Library

36 **MICHIGAN AVENUE**
Detroit Public Library

37 **GAR REUNION**
Detroit Public Library

38 **TROLLEY ON WOODWARD**
Detroit Public Library

39 **DETROIT OPERA HOUSE**
Detroit Public Library

40 **TELESCOPE ON WOODWARD**
Detroit Public Library

41 **1892 Arch**
Detroit Public Library

42 **Charles King**
Reuther Library, WSU

43 **Henry Ford**
Reuther Library, WSU

44 **Majestic Building**
Detroit Public Library

45 **Strolling Down State Street**
Detroit Public Library

46 **Tricycle on Woodward**
Detroit Public Library

47 **Sanders Confectioner**
Detroit Public Library

48 **Replicas of Columbus's Ships**
Detroit Public Library

49 **Union Depot**
Detroit Public Library

50 **Interurban Streetcars**
Reuther Library, WSU

51 **Russell House**
Detroit Public Library

52 **Belle Isle**
Detroit Public Library

54 **Cadillac Square**
Detroit Public Library

55 **Streetcars**
Detroit Public Library

56 **Detroit Parade**
Reuther Library, WSU

57 **Central Avenue**
Detroit Public Library

58 **West Side Of Woodward**
Detroit Public Library

59 **Roosevelt**
Reuther Library, WSU

60 **Pontchartrain Hotel**
Detroit Public Library

61 **Edwardian Fashion**
Reuther Library, WSU

62 **High Collar Dresses**
Reuther Library, WSU

63 **Monroe Avenue**
Reuther Library, WSU

64 **Campus Martius**
Detroit Public Library

65 **Society Women**
Reuther Library, WSU

66 **Bagley Fountain**
Detroit Public Library

67 **Lasalle Boulevard**
Reuther Library, WSU

68 **St. Clair Hotel**
Detroit Public Library

69 **Speeding Sleigh**
Reuther Library, WSU

70 **Gratiot Avenue**
Reuther Library, WSU

71 **Playing Shinny**
Reuther Library, WSU

72 **Central Presbyterian Church**
Reuther Library, WSU

73 **Detroit Auto Show**
Reuther Library, WSU

74 **Public Works Employee**
Reuther Library, WSU

75 **Barber-Green Snowblower**
Reuther Library, WSU

76 **Pontchartrain Hotel**
Reuther Library, WSU

77 **Upper Class**
Reuther Library, WSU

78 **Henry Ford Meets Hellen Keller**
Reuther Library, WSU

79 **Wright and Kay Jewelers**
Reuther Library, WSU

80 **Michigan State Fairgrounds**
Reuther Library, WSU

81 **Empire Theatre**
Reuther Library, WSU

82 **Traffic Light**
Reuther Library, WSU

83 **Edwardian Summer Fashion**
Reuther Library, WSU

84 **Roosevelt**
Reuther Library, WSU

86 **State Street**
Reuther Library, WSU

87 **Elephant Baseball**
Reuther Library, WSU

88 **Grand Circus Park**
Reuther Library, WSU

89 **19th Artillery Unit**
Reuther Library, WSU

90 **Armistice Day Parade**
Reuther Library, WSU

91 **Crowded Intersection**
Reuther Library, WSU

92 **Campus Martius**
Reuther Library, WSU

93 **Randolph Street**
Reuther Library, WSU

94 **Michigan Avenue**
Reuther Library, WSU

95 **Dime Building**
Reuther Library, WSU

96 **Detroit Public Library**
Detroit Public Library

97 **Fire Department Building**
Reuther Library, WSU

98 **Snow Storm**
Reuther Library, WSU

100 **Crows Nest**
Reuther Library, WSU

101 **October Flood**
Reuther Library, WSU

102 **Children in Flood**
Reuther Library, WSU

103 **Car in Flood**
Reuther Library, WSU

104 **Farmer Street**
Reuther Library, WSU

105 McArthur's Sign
Reuther Library, WSU

106 15-millionth Model T
Reuther Library, WSU

107 Jefferson Avenue
Reuther Library, WSU

108 Charles Lindbergh
Reuther Library, WSU

109 GM Building
Reuther Library, WSU

110 Christmas Shoppers
Reuther Library, WSU

111 Capitol Park
Reuther Library, WSU

112 Dodge Graham Bus
Reuther Library, WSU

113 Jefferson Avenue
Reuther Library, WSU

114 Penobscot Building
Reuther Library, WSU

115 Ice Fountain
Reuther Library, WSU

116 Men Building the Penobscot Building
Reuther Library, WSU

117 Spanish American War Veterans
Reuther Library, WSU

118 State Fairgrounds
Reuther Library, WSU

119 Griswold Street
Reuther Library, WSU

120 Ambassador Bridge
Reuther Library, WSU

121 Line at the Ambassador Bridge
Reuther Library, WSU

122 Children Cool Off
Reuther Library, WSU

124 President Hoover
Reuther Library, WSU

125 Ford Highland Park Plant
Reuther Library, WSU

126 Ty Cobb
Detroit Public Library

127 Railway Bus
Reuther Library, WSU

128 Vaccinations on Street
Reuther Library, WSU

129 John C. Nagel
Reuther Library, WSU

130 Detroit Police Officer
Reuther Library, WSU

131 Congress Street
Reuther Library, WSU

132 1930 Auto Show
Reuther Library, WSU

133 Detroit's Skyline
Reuther Library, WSU

134 Woodward Avenue
Reuther Library, WSU

135 Unemployment Demonstration
Reuther Library, WSU

136 Apple Vendors
Reuther Library, WSU

137 Wayne County Building
Reuther Library, WSU

138 Washington Avenue
Reuther Library, WSU

139 Federal Building
Reuther Library, WSU

140 Woodward Avenue
Reuther Library, WSU

141 Gratiot Before Expansion
Reuther Library, WSU

142 East Detroit
Reuther Library, WSU

143 DSR Trolley Pageant
Reuther Library, WSU

144 Eight Mile Race Track
Reuther Library, WSU

145 Unemployed Picketers
Reuther Library, WSU

146 Eleanor Roosevelt
Reuther Library, WSU

147 Sander's Confectioners
Reuther Library, WSU

148 Henry Ford's House
Reuther Library, WSU

149 David Stott Building
Reuther Library, WSU

150 February Wind
Reuther Library, WSU

151 Precarious Streets
Reuther Library, WSU

152 Detroit Day
Reuther Library, WSU

153 Widened Woodward
Reuther Library, WSU

154 Yale Cleaners and Tailors
Reuther Library, WSU

155 Penobscot Building
Reuther Library, WSU

156 Children's Parade
Reuther Library, WSU

157 Travelers Trunk Co.
Reuther Library, WSU

158 St. Andrews Hall
Reuther Library, WSU

159 Cadillac Square
Reuther Library, WSU

160 Light Guard Armory
Reuther Library, WSU

161 New Parking System
Reuther Library, WSU

162 Sam's Cut Rate
Reuther Library, WSU

163 Labor Day Parade
Reuther Library, WSU

164 Lock-out Protesters
Reuther Library, WSU

167 Christmas Shoppers
Reuther Library, WSU

168 Grand River Trolley
Reuther Library, WSU

169 Scrap Metal Drive
Reuther Library, WSU

170 TANK ON PARADE
Reuther Library, WSU

171 ARMY RECRUITS
Reuther Library, WSU

172 CUNNINGHAM'S WAGON
Reuther Library, WSU

173 CHINESE DRAGON DANCE
Reuther Library, WSU

174 SUICIDE SUBMARINE
Reuther Library, WSU

175 NAVY RECRUITS
Reuther Library, WSU

176 MEMPHIS BELLE
Reuther Library, WSU

177 EVANGELICAL CHURCH
Reuther Library, WSU

178 BOB SWIFT
Reuther Library, WSU

179 VICTORY OVER JAPAN
Reuther Library, WSU

180 UAW PICKETERS
Reuther Library, WSU

181 CITY HALL
Reuther Library, WSU

182 SECOND AVENUE
Reuther Library, WSU

183 GOLDEN JUBILEE PARADE
Reuther Library, WSU

184 ED WYNN
Reuther Library, WSU

185 HUDSON MOTOR PLANT
Reuther Library, WSU

186 RACE RIOT
Reuther Library, WSU

187 WATER BOARD BUILDING
Reuther Library, WSU

188 SANTA CLAUS
Reuther Library, WSU

189 CHRYSLER PLANT
Reuther Library, WSU

190 DETROIT TANK ARSENAL
Reuther Library, WSU

191 LODGE FREEWAY
Reuther Library, WSU

192 MONROE STREET
Reuther Library, WSU

193 KERN'S CLOCK
Reuther Library, WSU

194 HUDSON'S DEPARTMENT
STORE
Reuther Library, WSU

195 BILLY GRAHAM
Reuther Library, WSU

196 JOHNNY UNITAS
Reuther Library, WSU

197 12TH STREET FIRES
Reuther Library, WSU

198 JIMMY HOFFA
Reuther Library, WSU

199 SMOKEY ROBINSON
Reuther Library, WSU

204 ROBERT F. KENNEDY
Reuther Library, WSU

While campaigning for the Democratic presidential nomination, Robert F. Kennedy shakes hands with Detroiters on 12th Street during a visit to the area most affected by the 1967 riot. Less than a month later he was assassinated at the Ambassador Hotel in Los Angeles, after winning the presidential primary in California.